The Pen and Pencil
Technique Book

The Pen and Pencil Technique Book

by Harry Borgman/Foreword by Wendon Blake

WATSON-GUPTILL PUBLICATIONS/NEW YORK

To the memory of my father, and to my mother,
who is always supportive and encouraging.

Copyright © 1984 by Billboard Ltd.

First published 1984 in New York by Watson-Guptill Publications,
a division of Billboard Publications, Inc.,
1515 Broadway, New York, N.Y. 10036

Library of Congress Cataloging in Publication Data

Borgman, Harry.
 The pen and pencil technique book.

 1. Pen drawing—Technique. 2. Pencil drawing—
Technique. I. Title.
NC905.B68 1984 741.2 84-2292
ISBN 0-8230-3989-7

Distributed in the United Kingdom by Phaidon Press Ltd., Littlegate
House, St. Ebbe's St., Oxford

Manufactured in the United States of America

1 2 3 4 5 6 7 8 9/89 88 87 86 85 84

CONTENTS

Pen and Pencil Drawing. The pen and the pencil are the basic drawing tools that every artist has in the studio. They're so small, so simple, and so portable that the tools for drawing a masterpiece can be carried in a pocket. But their simplicity is deceptive. In fact, the pen and pencil are amazingly versatile. A sharpened pencil or a penpoint dipped in ink is actually capable of a vast range of technical effects—and a great drawing can be anything from a tiny scribble on a scrap of paper to a large-scale image that has the richness and complexity of a painting.

About This Book. Harry Borgman's *Pen and Pencil Technique Book* is the most comprehensive book I've ever seen about these two indispensable drawing media. Borgman, himself, is an artist of astonishing versatility, who can handle landscapes, architecture, portraits, figures, and still life with remarkable skill in every drawing medium—and every combination of drawing media. Scanning the pages of this book, you have the feeling that you're looking at the work of a dozen different artists, each one a specialist in a particular technique, style, and subject—but all these artists are Harry Borgman, who constantly reveals a new side of his talent as he creates new illustrations and demonstrations for these pages. The result is a book that constantly surprises and delights you as you discover new and unexpected ways to draw.

Learning by Doing. This book is divided into two parts: Part One is "Pencil Drawing" and Part Two is "Ink Drawing." Each part begins with a review of the basic tools and techniques of the medium; goes on to a series of step-by-step demonstrations that show how to put these tools and techniques to work on large, ambitious drawings; and concludes with a section on offbeat techniques and special effects. As you turn the pages of the book, you watch the artist draw many different subjects in many different ways; the demonstrations show every stage in the progress of the drawing, while the accompanying captions describe the exact drawing procedure. Having watched over Borgman's shoulder, you should then try the method yourself. Don't just copy the drawing in the book, but find a comparable subject and try a similar drawing, working with the tools and techniques of the demonstration. Use each demonstration to inspire a drawing project.

Pencil Drawing. Part One on "Pencil Drawing" begins with the fundamental strokes and tones produced by various pencils, and then demonstrates how to work with four different kinds of pencils: graphite, charcoal, chalk, and wax. Next, Borgman executes a series of eleven full-scale demonstrations that show, step-by-

step, how to draw landscapes, townscapes, faces and figures with varied combinations of strokes and tones. I think you'll be particularly fascinated by the demonstrations that show how to combine pencil with other media—in black-and-white and color—and that reveal the rich possibilities of colored pencils: water-soluble, wax, and pastel. The section concludes with a series of demonstrations of such offbeat pencil techniques as scribbling, hatching, dissolved tone, drawing on toned paper, and the substractive method—plus some suggestions for experimenting with different pencil drawing styles.

Ink Drawing. Part Two on "Ink Drawing" is organized in a similar way to Part One. Borgman starts by showing you how to build up varied tones and textures with different kinds of pens—and with two other ink drawing tools, the brush and the marker. Then he does a series of eleven step-by-step demonstrations that reveal the full potential of pen, brush, and marker in large-scale drawings of landscape, architecture, and people. These demonstrations are memorable for their lively combinations of lines, strokes, washes, and such multimedia as black and colored inks or markers and ink. The concluding section introduces unconventional and specialized techniques like scribbling, scratchboard, drybrush, dissolved tone, and drawing on toned paper with black *and* white. Once again, the author suggests some experiments with diverse drawing styles. By the time you reach the end of the ink drawing section, you've made the discovery that ink—like pencil—can be carried far beyond the borders of what we usually call *drawing*. Handled with creativity and technical skill, both mediums can produce images that we might just as easily call *paintings*.

Drawing Subjects. Finally, I think you'll find special magic in Harry Borgman's choice of subjects for the illustrations and demonstrations in *The Pen and Pencil Technique Book*. I began by saying that pen and pencil media are so portable that you can take them anywhere in a pocket and hope to dash off a drawing that you'll treasure. Harry Borgman has done just that, finding his subjects all over the globe: the cathedrals of France, the townscapes of Italy and Mexico, the forests of northern Europe, the mountains of the American west, the jungles of southeast Asia, the colorful Ghanian market. This panorama is the ultimate tribute to the versatility and expressive power of the pen and the pencil.

Wendon Blake

The Basics. Drawing can be a wonderful learning experience and can be done using the most simple, basic tools. Pencils are the best tools for beginners, as drawing with pen and ink is a little more complicated. If, however, you are more experienced and have done many pencil sketches and drawings, you might begin working in ink by using an artist's fountain pen, a convenient drawing tool that carries it's own ink supply. Then—with pencil or pen in hand and a small pad of paper—you're ready to start. As you progress you will want to explore other types of drawing tools that will expand your horizons.

Graphite Pencils. In this group are the most commonly used pencils for drawing. They are available in various grades, which are basically hard and soft. The hard grades are marked H and the soft grades are marked B. Pencils of both grades also have numbers that identify the degree of hardness or softness. This range extends from 9H, the hardest, to 6B, which is very soft. The HB grade is in the middle and is the best choice for general drawing. Separate leads are also available in various grades and can be used in specially made mechanical pencils or holders. You may find this type the most convenient as it eliminates sharpening pencils, because the lead is extended by pressing a push-button cap. Graphite also comes in the form of sticks and these, of course, create a much bolder line than pencils. They can also be used in specially made metal holders.

Charcoal Pencils. These pencils are excellentfor drawing, but are available in only four grades: HB, 2B, 4B, and 6B. They can create beautiful, dense blacks and are very good for tonal drawings making them a favorite of many artists around the world for many years.

Chalk Pencils. These are much like charcoal pencils but come in only one grade of hardness, which is similar to the 6B grade charcoal pencil. They are available in an extensive range of colors and work well on most paper surfaces.

Wax Pencils. There are several types of pencils in this group, including the lithograph crayon and china-marking pencil, which are paper wrapped and have a pull-thread for self-sharpening. Other wax pencils have a smaller diameter and harder lead, and some brands are available in many brilliant colors. Most of the wax pencils are waterproof, but some types are not and can be blended and dissolved with water and a brush, creating unique effects.

Pens. Because of the large number of pens available, you must familiarize yourself with a few basic types so that you understand their special advantages and limitations. Probably the best pen to begin drawing with is the crowquill, which has a flexible pen nib enabling it to achieve a wide range of line weight. Less flexible nibs create more uniform lines.

Brushes. I recommend that you use the finest quality red sable brushes, if you can afford them. However, there are white nylon brushes that can be used as a less expensive substitute. Other cheaper varieties do not respond well and wear out quickly. A number 3 or 4 will be sufficient for most brush drawings.

Markers. These are versatile drawing tools and you will enjoy having a few different types to experiment with. The fine line marker pens are excellent for line drawings and the broader felt pens are excellent for adding tones or color.

Drawing Papers. A vast array of papers are available for artists, but you can limit yourself to four basic types: common drawing paper, smooth surface paper, textured charcoal paper, and rough watercolor paper.

Drawing Boards and Tables. Small wooden boards can be used when sketching indoors or outdoors. Many kinds of artist's tables are available, and many are adjustable in height, with a control for changing the angle of the board. Some of the more expensive types have an automatic control for this operation. But, to get started, you don't need a professional drawing table; a simple wooden board will suffice.

Accessories. You will need a few other items, such as a kneaded rubber eraser, a razor knife with interchangeable blades for sharpening pencils and cutting paper, sandpaper pads, thumbtacks (drawing pins), paper stomps, and perhaps a T-square and a plastic triangle.

Developing Yourself as an Artist. While many of these drawing tools are important, the key to success in drawing lies in practice and in learning how to see. Drawing is really seeing and you can train yourself by doing a lot of sketching. You must also become very familiar with all of your tools, the various mediums, and the techniques that are used. Just knowing your tools can give you a measure of confidence, which will reflect itself in your work. Remember that your whole life as an artist should be one of constant growth and development; an exciting world of endless exploration. Discipline is probably the most important attribute an artist can possess, as much of what an artist does must be self-motivated. Drawing is one of the greatest exercises in this discipline, one that you will find to be a pleasure as well as a challenge.

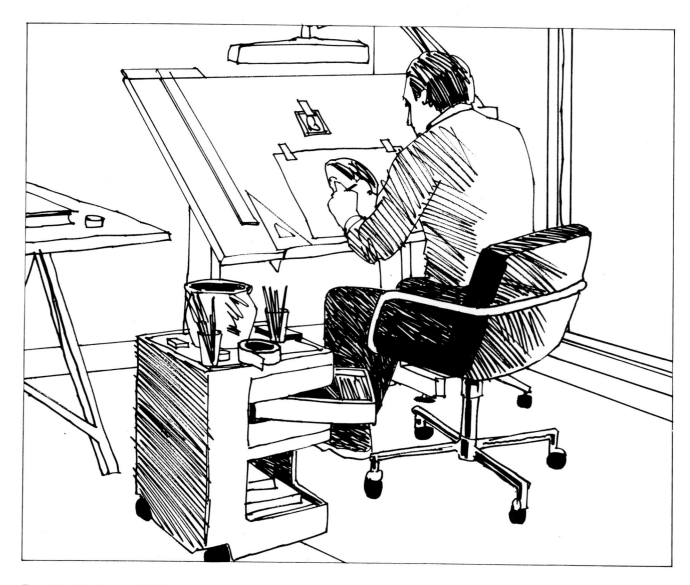

Drawing Equipment Indoors. A regular table or writing desk can be used to draw on, but the best type of furniture to use is an artist's drawing table, which is shown in the illustration above. It is much more convenient to draw on an inclined surface, and drawing tables can be easily adjusted to the proper working angle. Some of the more expensive drawing tables are equipped with an automatic control, not only for changing the angle of the board, but to adjust the height as well. Often, as when working with watercolor or wash tones, the board must be raised to a flat, horizontal position to control the spreading of tones, so the automatic control feature is quite useful. Drawing boards are available in every price range, but you could easily get by with a small, inexpensive, adjustable drawing table. Most drawing tables can be folded for storage. Your drawing table should be placed near a large window so you get lots of light, and positioned so that there is no shadow cast over the paper from your hand while drawing. This means if you are right-handed, the window should be at your left. The reverse is true if you are left-handed. A good, comfortable chair is a must—I prefer one with armrests and casters for ease of movement. For drawing at night or on dark days, you will need a specially designed artist's lamp. These can be clamped onto the drawing table or used on a floor stand, but I prefer the latter as it allows me to adjust the drawing table more easily. Remember to position the lamp so that your hand doesn't cast a shadow on the paper while you work. A short T-square and plastic triangle are handy tools. T-squares are available in wood, aluminum, or steel. A steel T-square is best if the edge is going to be used for cutting mats or trimming paper with a razor knife. You will need a small cabinet, usually called a taboret, with drawers so that tools can be stored. A water bowl is necessary for rinsing out brushes and pens or to mix wash tones. It can be a fancy ceramic bowl or an old pickle jar—whatever works best for you. Small, short glasses can be used for holding brushes and pencils, or you may prefer some kind of a tray with dividers for these items. I like to have a large table nearby so that reference material and sketches can be spread out, but this depends on whether your space is limited or not.

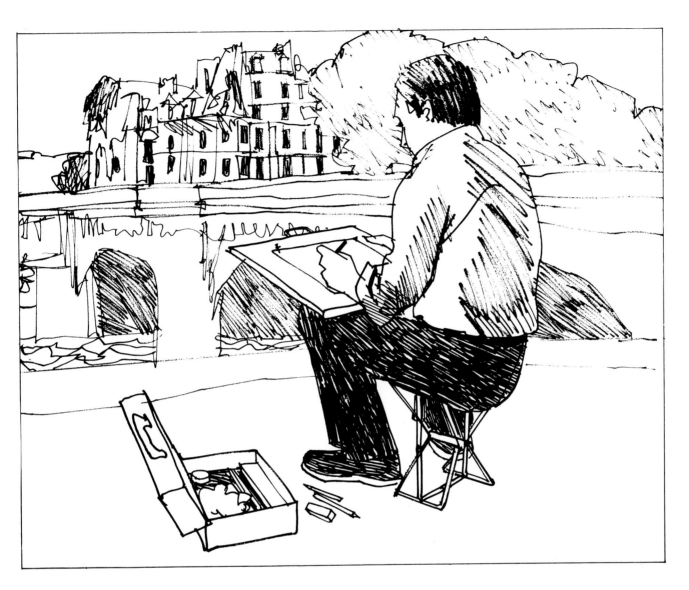

Drawing Equipment Outdoors. For outdoor sketching it is important to keep your equipment to a minimum and as simple and light as possible. If you use bound drawing pads with a sturdy cardboard backing, you will not need a drawing board, which eliminates one major item. If, however, you prefer to work on a drawing board, small sizes are available in wood and a small handle can be attached to the edge of the board so that it is easier to carry. Some kind of carrying case with a handle is also necessary for bringing along your tools. A fishing tackle box or small attaché case would be perfect for holding such items as pencils, brushes, ink, erasers, tape, tacks, a small water jar, a rag, and even a sandwich in case you get hungry. For seating you can just sit on the ground or on a rock—whatever happens to be convenient. You may prefer to carry along a small, handy folding seat, which can also be stored in the carrying case. You should of course be dressed comfortably and may want to take a hat or even suntan lotion with you. I was once badly sunburned on the island of Grenada because I was so interested in sketching I did not realize that I had been exposed to the sun for a long time. You might want to take along mosquito repellent if you are going to sketch in the woods or near a swampy area. Sturdy, comfortable walking shoes are highly recommended. An item I usually take along is my small 35mm camera for taking photographs that can later be used for ideas and reference when making drawing or paintings in the studio. Only you, of course, can decide just what and how much equipment you want to carry with you. If you have a car you can take much more, leaving what you don't need in the trunk after you decide on a location. If you want to keep your equipment to the absolute bare minimum, eliminate everything but pencils or pen and a small pad of drawing paper.

Wooden Board with Taped Paper. A small wooden drawing board can be purchased from your local artist supply store. These boards range in size from 16″ × 21″ (41 × 53 cm) to 31″ × 42″ (79 × 107 cm)—you can choose whichever size you personally find most convenient. A carrying handle can be attached to the edge of the board for easier transporting. You also can use a piece of plywood or hard composition board; both are available wherever wood is sold and can be cut to a convenient size. All of these boards are quite hard and you will have difficulty holding your paper in place with thumbtacks or drawing pins. The best way to attach the drawing paper to them is to use either paper or linen tape as these will hold your paper securely while you're working and are more easily removed than other tapes.

Fiberboard with Tacked Paper. Fiberboard is a surface that is softer than wood or composition board. On this surface the drawing paper can be held in place with thumbtacks or drawing pins. This board is also much lighter than the other types, which makes it more convenient and easier to carry. Fiberboard is also available wherever wood is sold. You can buy a small, steel-reinforced stand to allow the board to be used as a table-top. Whatever type of drawing board you prefer to use, the drawing paper will feel more responsive with several additional sheets of paper placed underneath.

Spiral Drawing Pad. One of the handiest types of drawing pads is the kind with a spiral binding. This feature is convenient because it allows the sheets to be folded flat behind the others after you've finished a drawing. The pads also have a stiff cardboard backing, which allows the smaller sizes to be used without a drawing board. The larger pads bend and buckle easily without drawing board support. They are available in a variety of sizes ranging from 9″ × 12″ (23 × 53 cm) to 18″ × 24″ (46 × 61 cm) and contain anywhere from 12 to 50 sheets. They are available in a full range of surfaces.

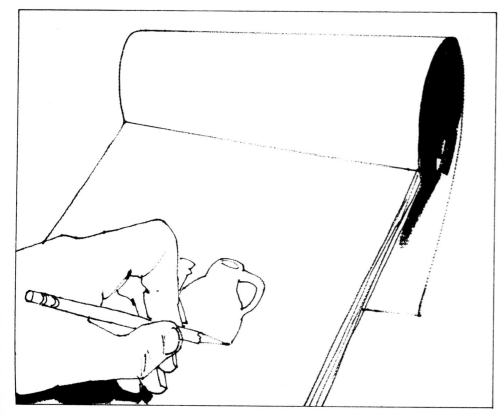

Bound Drawing Pad. Papers are available in bound pads, which also range in size from 9″ × 12″ (23 × 53 cm) through 18″ × 24″ (46 × 61 cm). When using this type of a pad, the sheet is torn off after each drawing has been completed. Again, on the smaller sized pads, the stiff cardboard backing is sufficient without the use of a drawing board. A good variety of paper surfaces is available in the bound pads.

Lamp. The best kind of lamp to use when drawing is a fluorescent light that is adjustable and can be mounted either directly on the drawing table or used on a floor stand. I prefer the floor stand as I often change the angle of my drawing table when working. Changing the position of the drawing table would be impractical if the lamp were attached, as the angle of its mounting bracket would also have to be changed. These lamps are equipped with two fluorescent tubes and the best light balance is obtained when a standard, cool-white tube is used with the warmer, daylight type: a combination closely approximating daylight.

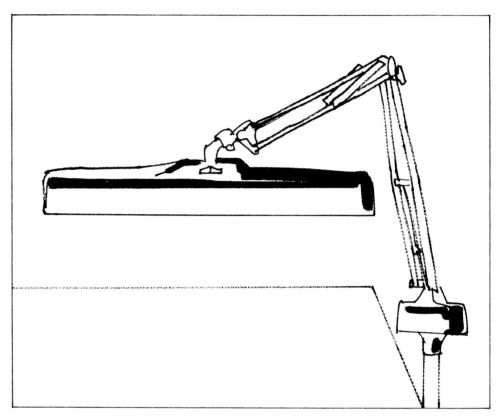

Knives. You will find a small razor knife, the type with interchangeable blades, handy for sharpening pencils as well as for trimming sheets of drawing paper. They can be used with several styles of blades, which are very sharp, so you must be very careful when handling them. A single-edge razor blade and a utility knife are also useful, the latter being perfect for cutting mats and trimming illustration boards. The second model from the top has a unique feature—a fresh blade edge is produced by snapping off the dull one. Some utility knives have a blade that can be retracted into the handle—an excellent safety feature.

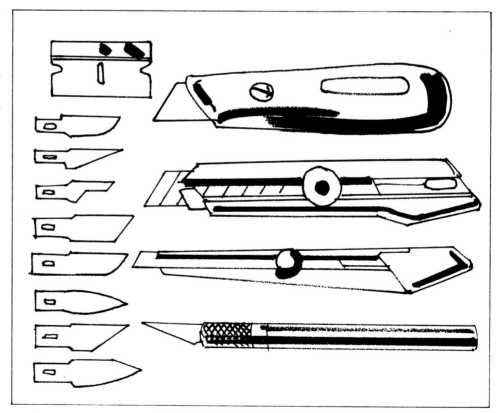

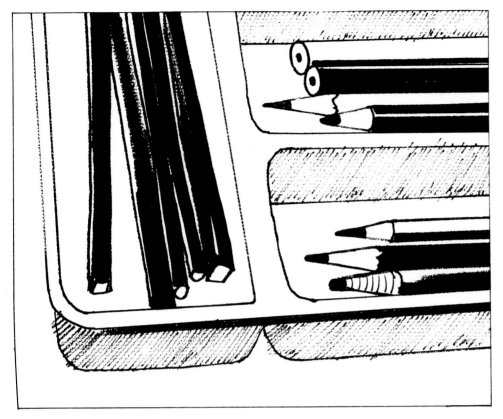

Storing Drawing Tools. It is wise to be well organized, so that you can easily find any tools that you might need quickly. The drawers of your taboret invariably become quite messy and disorganized unless you devise a method for separating your tools. One of the best ways to do this is to use a rubber or plastic kitchen tray—the kind that is used to store silverware is perfect. If the trays are too large, you can consider adding small wooden dividers to the drawers.

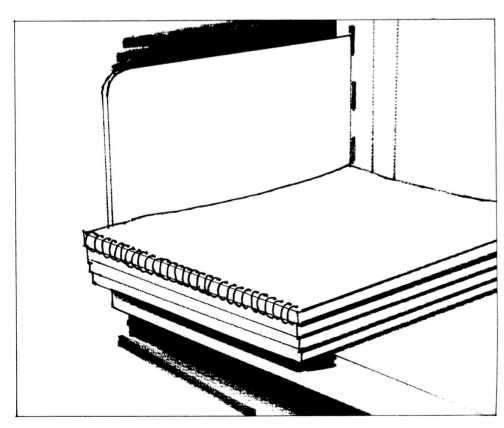

Storing Paper and Drawings. The best procedure is to always store your pads and finished drawings flat. A large, flat file would be perfect, but a deep bookshelf will work just as well. If you are quite cramped for space you can always store pads, paper, and drawings under your bed. Paper that is stored flat will not be curled or bent when you are ready to use it. Another way to store your finished drawings is to keep them inside of an artist's portfolio, which will keep them flat. These portfolios are constructed of stiff cardboard with cords attached that can be tied to keep it closed.

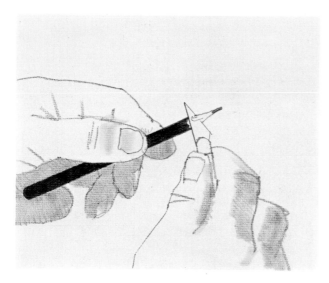

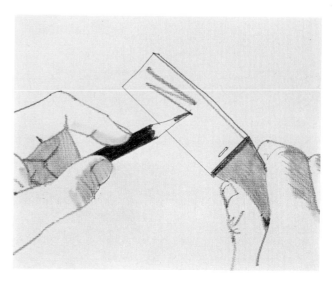

Sharpening Pencil with Knife. The razor knife is the handiest way to sharpen a pencil. The wood can be carefully cut away from the lead with the sharp edge of the blade. I prefer a long lead when drawing so I don't have to resharpen so frequently, and this is the best method for obtaining one. I must caution you again, these knives are very sharp and you must be careful when using them. A pencil sharpener is not advisable, as the resulting exposed lead is too short.

Sharpening Pencil with Sanding Block. After the wood has been carefully cut away with a blade, the lead can be pointed by using a sanding block or pad. The lead can be shaped to a fine point, a chisel point, a blunt point, a rounded point, or in any number of other ways, depending on which type of line you wish to produce when drawing. Experiment with different shaped leads to see the various kinds of lines that can be produced.

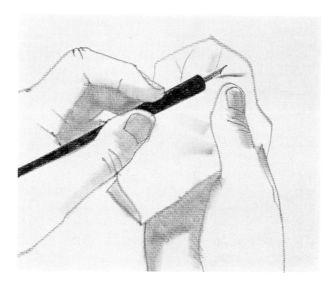

Cleaning Pen with Tissue. The pen should be wiped with a rag or paper tissue when you are finished with your drawing. They can first be rinsed in the water bowl, then wiped clean and dry. It is important to keep your tools clean so they function properly. A pen constantly left with ink that has dried will corrode and eventually deteriorate. Also, an ink-encrusted pen just will not operate properly—the clogged pen will create uneven, erratic lines.

Cleaning Brush with Soap. Brushes should always be rinsed well after being used with paint or ink and they should occasionally be washed with water and a mild soap. To do this properly, first twist the brush on a bar of wet, mild soap, then clean it by lathering it in the palm of your hand until all of the ink or paint particles are removed, as shown in the drawing. When the brush is thoroughly clean, rinse it in water, then shape it to a point before leaving it to dry.

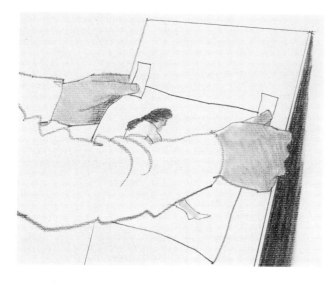

Aerosol Spray Can. The best way to preserve and protect your finished pencil drawings is to spray them with a varnish-like liquid known as fixative. If your drawings are not protected they might become smudged or otherwise damaged. I recommend that you use a spray fixative as this is the only way to apply an even coat. Tape your drawing to a drawing board or piece of cardboard, then set it up vertically against a wall, preferably in the basement or garage so that you won't damage the walls or other objects with the spray coating. If you are spraying more than just a few pieces, you should make sure that the area is properly ventilated.

Spraying with Aerosol Can. The can should be held as shown, in an upright position with your index finger on the spray nozzle. Incidentally, be sure that the nozzle is aimed properly at the drawing and not at yourself. There are different types of spray coatings: glossy, matte, and workable fixative, which is probably the best choice as it allows you to rework or add to your drawing after you have applied the fixative.

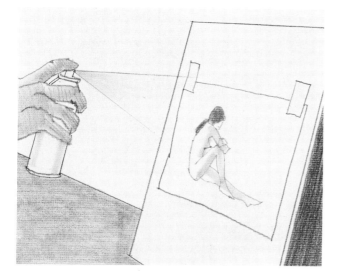

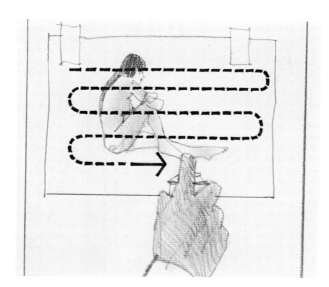

Proper Spraying Distance. When spraying, you should hold the can about 16–20 inches (41–51 cm) from the drawing. Closer distances are recommended by the manufacturer, but when you are too close there is a greater danger of overspraying. Practice spraying on your rough sketches first until you have learned to control the spray. Remember to be careful not to spray surrounding objects or walls. Some brands of fixative spray have a strong odor, so you may prefer the odorless type, as I do.

Proper Spraying Movement. Holding the can of fixative in an upright position, spray the drawing using a side-to-side motion as shown on the illustration. If too much fixative is applied at one time and the paper surface becomes flooded, the liquid will run down the drawing, ruining it. Try to apply only one light coat of fixative at a time; several light coats are better than one heavy one. Usually, two or three light coats of fixative are sufficient to protect a drawing. Fixative is only necessary for pencil, chalk, and charcoal drawings. It is not necessary for ink drawings.

Drawing in Mat. The method used for matting a drawing is shown in the illustration. The drawing is hinged with tape to a high-quality mount board. It should never be glued or taped completely around the edges—this can cause buckling as paper expands and contracts with moisture. If possible, no tape with animal or synthetic glue should be used, as this will eventually stain the paper. Cloth tape with a water-soluble adhesive is best. Mark the window opening of the mat on the board with pencil, then cut at a ninety-degree angle, using a mat knife or a special mat cutting tool and a straightedge. You should use acid-free or museum quality boards to ensure the preservation of your work.

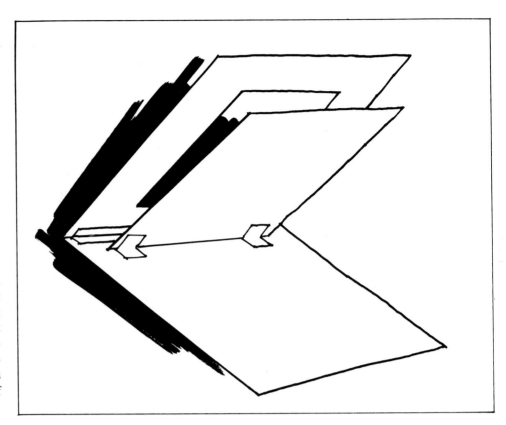

Drawing in Frame. When framing drawings, glass or Plexiglas should be used as a protection against dirt and pollution, but the drawing should never touch the glass and must be recessed. The best way to separate the drawing from the glass is to use a mat between them. The mat not only enhances the drawing but creates an air space between the drawing and the glass, lessening the possibility of moisture damage. Because of the trapped air, condensation may form under certain conditions. Incidentally, Plexiglas should never be used for chalk or charcoal drawings as the static electricity it generates attracts chalk and charcoal particles. The frame can be sealed at the back with paper or Mylar, which can be secured with tape.

PART ONE

PENCIL
DRAWING

Pencil Drawing. The pencil is known to everyone as a writing tool and as a beginning art student you will find it a familiar, natural drawing instrument. With a pencil and a sheet of paper you are ready to start drawing. Fortunately for artists and students there is a great variety of drawing pencils available as well as excellent paper surfaces to work on. The pencil can be used in a variety of ways and, by sharpening the lead differently, many kinds of lines can be drawn. There are various grades of lead, ranging from very hard to very soft, which also adds to the versatility of the pencil medium. Pencil drawings can be done using only lines or by using only tone without lines or any number of techniques in between. Pencils can be used on a wide variety of paper surfaces as well, from hard, smooth surfaces to very roughly textured papers. These different papers help to broaden the drawing possibilities as each surface responds differently to the pencil. And then, there is the most important aspect, the artist's own point of view, which adds further dimensions to this marvelous medium. The pencil is inseparable from art as most work, whether painting, drawing, illustration, prints, engravings, or even sculpture, invariably begins as a pencil sketch. The pencil is unquestionably well-suited for doing preliminary work, but the medium also offers great possibilities for highly finished drawings that can stand on their own. Unfortunately, most artists use the pencil for preliminary drawings and never develop pencil techniques to any great degree.

Types of Pencils. The traditional drawing tool is the graphite pencil. It is made of compressed graphite encased in wood and is available in grades ranging from very hard to quite soft. This range spans from 9H, the hardest, to 6B, the softest. The average and most useable grade is HB which is in the middle. Basically, the harder the grade, the lighter the line, with the softer grades producing a darker line. Charcoal pencils are excellent drawing tools and have long been a favorite with artists around the world. They are available in HB, 2B, 4B, and 6B grades. Charcoal pencils are a little more difficult to use than graphite pencils, as they are more fragile and also create more pencil dust, which can make a drawing messy looking. They are, however, more suitable for tonal work and for covering larger areas as they create pleasing black tones without the sheen found on graphite renderings. Chalk pencils are similar to the charcoal pencils, in that their leads are quite soft, but they are available in only one grade. However, they do come in a wide range of colors, with some brands offering as many as sixty different colors. Wax pencils are quite good. Most brands are available in only one grade. The leads are strong and can be sharpened to a fine point. Some types of wax pencils are water-soluble, which extends their range considerably.

Types of Papers. Common drawing paper has a medium surface texture and is very good for drawing with graphite, chalk, charcoal, and wax pencils. While smooth papers are excellent for use with graphite and wax pencils, they do not work as well when chalk or charcoal pencils are used, because these pencils require more surface texture. Charcoal paper, because of its interesting ribbed surface texture, has always been a real favorite with many artists. All pencils work well on this surface, which incidentally is available in an assortment of colors. Rough surfaced papers are also quite good, as their textures contribute additional interest to the drawings.

Introductory Demonstrations. In the demonstrations you will become familiar with what can be accomplished with pencils as well as the characteristics that make each type unique. The four-step demonstrations explain the use of graphite pencils to create lines; chalk and charcoal pencils for drawing with lines; strokes and blending; and building up tones with a wax pencil. The use of the paper stomp for blending tones is also discussed.

Demonstrations. Seven clear, concise steps are used in each of the eleven major demonstrations, with each demonstration explaining a different technique. The techniques include drawing with thin, broad, and varied strokes; line with blended tone; wash tones; and the building up of tone with pencil strokes. Line with color washes; water-soluble pencils; and colored pencils on colored paper stock are also demonstrated in detail. Besides the different techniques, various methods are shown for blending tones.

Special Techniques. Drawing from photographs and simplifying subjects into two, three, and four tonal values are covered as well as several off-beat techniques, including a subtractive technique in which the tones are removed with an eraser. Various styles used in pencil drawing are also thoroughly demonstrated.

DRAWING TOOLS

Pencils. There are four types of pencils available for artists: graphite, chalk, charcoal, and wax. Graphite pencils come in a variety of sizes and shapes, encompassing a range from the very soft 6B to the extremely hard 9H. Charcoal pencils come in only four grades: HB, 2B, 4B, and 6B. Chalk and wax pencils come in only one grade, but are available in a wide range of colors. Shown are the various types of pencils and a few ways they can be sharpened. A short stump, which is normally difficult to work with, can be made useful with a handy pencil extender.

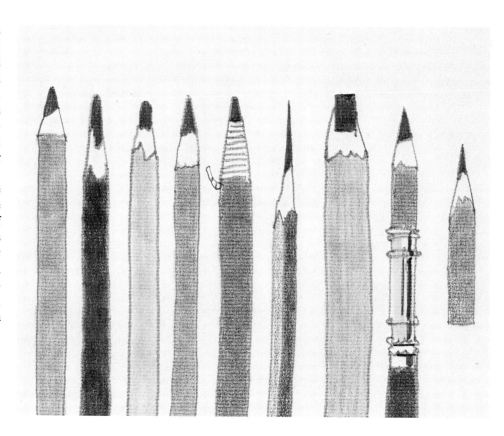

Mechanical Holders. There are several types of holders available for use with graphite leads that can be purchased separately. These holders eliminate the necessity of sharpening. A wide assortment of mechanical pencils, designed for use by artists, can also be purchased from your local artist supply store. A great assortment of refill leads, available in different thicknesses and grades of hardness, are also on the market. The lead holders are equipped with a clutch jaw, which is operated by pushing a button, enabling the leads to be extended as they are used. The refill leads come in various grades, ranging from 2B through 6H. Also available are very thick leads that can be used with the appropriate holders.

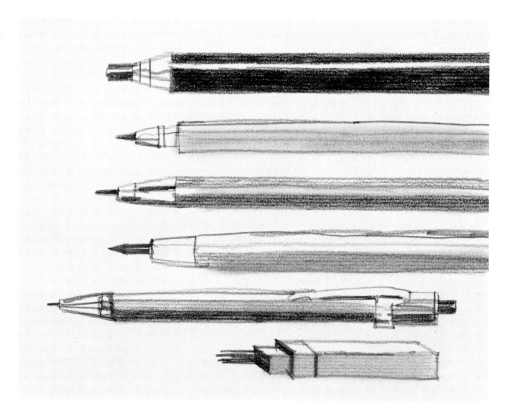

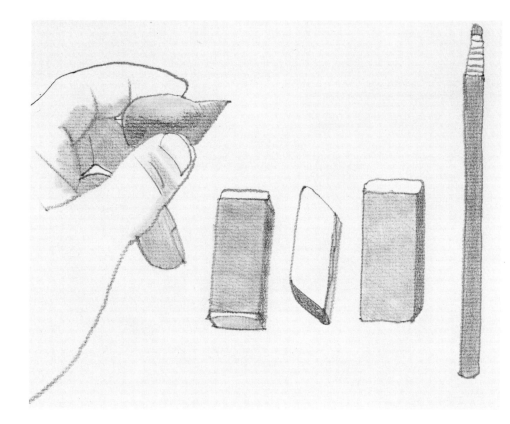

Erasers. The most commonly used eraser is usually made of soft rubber and is rectangularly shaped. It is also available in pencil form with a peel-off paper cylinder, enabling it to be extended as it is used. One of the most useful erasers is the kneaded rubber type. This is a very soft, pliable eraser, which can be formed into any shape for erasing. It is perfect for erasing very small, hard-to-get-at areas. The kneaded rubber eraser is also used to clean off charcoal, chalk, or graphite dust from drawings before they are sprayed with fixative. There are new vinyl erasers available, which are excellent for general erasures.

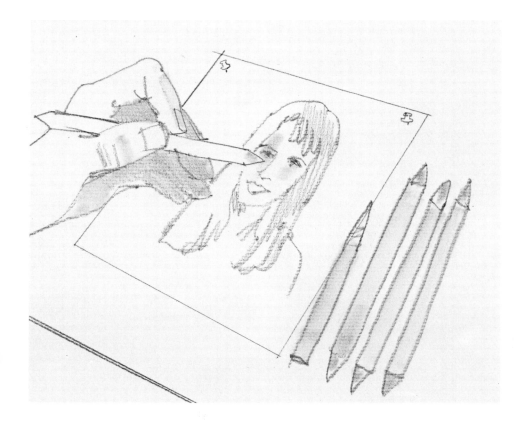

Stomps. Paper stomps, which are made from tightly rolled paper, are very handy tools. They are usually pointed at the ends and can be used to blend or shade charcoal, chalk, graphite, or even wax pencil drawings. Because of their pointed ends, very delicate blending can be accomplished using these tools. They can be re-pointed or sharpened with a razor knife and a sanding pad. The long, tapered side can be used for blending broad areas while the tip is ideal for blending smaller, hard-to-get-at areas. Wax pencils can be blended by first dampening the stomp with a solvent, such as the kind used for diluting rubber cement.

Common Drawing Paper. The most frequently used paper for drawing is common drawing paper, which has a standard medium surface texture. The British call this "cartridge paper." This paper is quite versatile as it can be used with pencil, pen, brush, and even for wash tones. The slight surface texture is excellent for pencil drawings and fine enough for use with pens, as they will not snag the surface. For this illustration, I use a 4B graphite pencil to draw a portrait of a young woman. Notice how well the pencil works on this surface, and while there is no blending on this particular drawing, it certainly is possible on this paper. There is a tonal variation in the lines drawn: the ones on the hair are lighter than those used for the outlining. This was accomplished by using different pressure on the pencil while drawing—the lighter the pressure, the lighter the drawn lines. Where heavier pressure was used while drawing, the lines are darker. If you practice drawing lines of various values, you will develop a great deal of control in the use of the pencil.

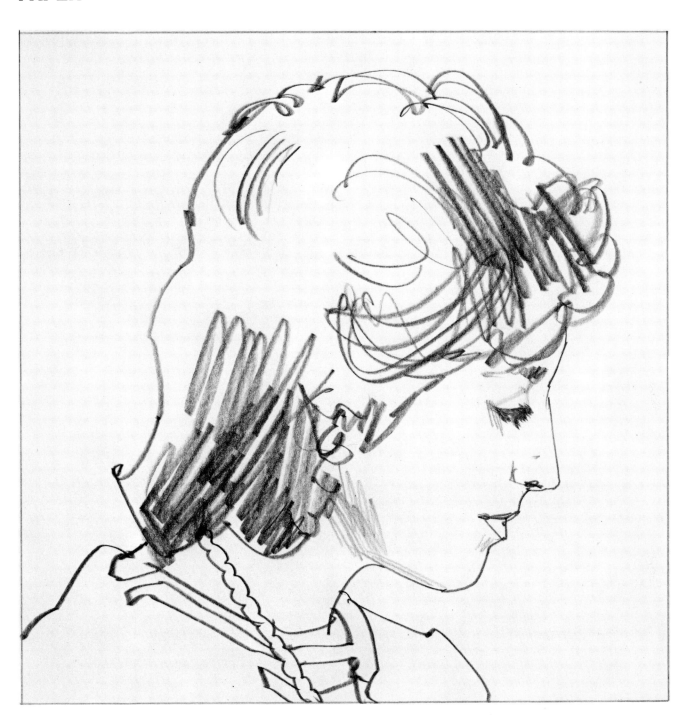

Smooth Paper. One of my favorite surfaces for graphite pencil drawing is smooth paper. The graphite pencil is especially compatible with the smooth surface as a full range of tones, from very black to very light, subtle grays, are possible. Wax pencils can also be used successfully on smooth paper, but chalk or charcoal pencils are not suitable, as the leads just don't respond to a surface without texture. Notice that the lines in this drawing do not appear to be as rough as those on the previous drawing. This is because of the lack of paper surface texture. This paper cannot be equaled for doing highly detailed drawings with subtly rendered gray tones. When using this paper, even the quality of the lines is different from those drawn on other papers. When comparing this drawing with the previous one, you can see that the lines appear more crisp because of the lack of surface texture. This results from the way the pencil easily moves across the smooth surface, unobstructed by surface textures.

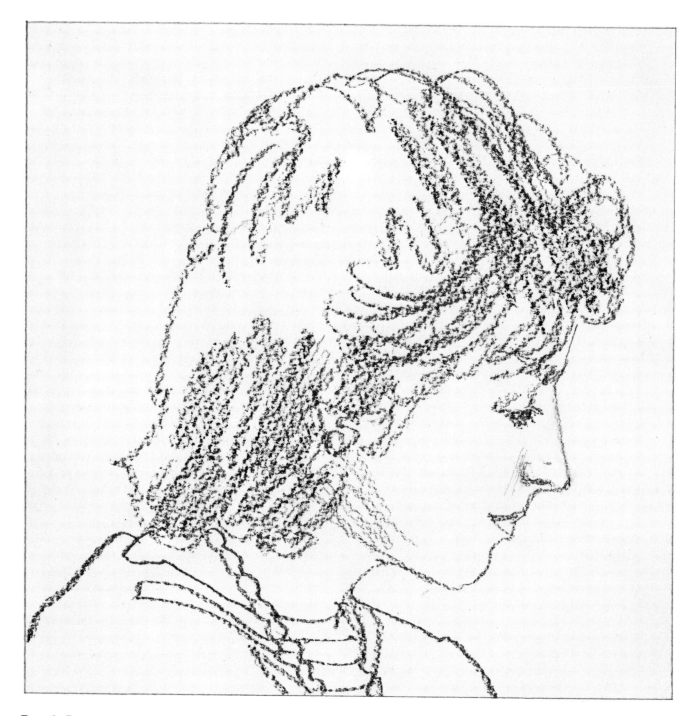

Rough Paper. The same drawing takes on a completely different character when drawn on a heavily textured surface such as watercolor paper. Notice how the lines themselves take on a texture and that even the darker tones on the hair and the details, such as the eye, are not solid black, but are broken up by the roughness of the paper surface. Very interesting drawings can be done on rough-surfaced papers, but creating solid black tones or lines requires the artist to bear down quite heavily on the pencil while drawing. Pencil leads tend to wear down rapidly on this type of surface, but the softer grades, such as the 4B used here, are more compatible for use on rough papers than the harder grades. Rough papers have a more delicate surface, and harder leads may dig into the paper. The finer lines, drawn with a sharpened pencil, are quite dark, while those drawn with a duller, broad point are heavily textured, which adds interest to the drawing.

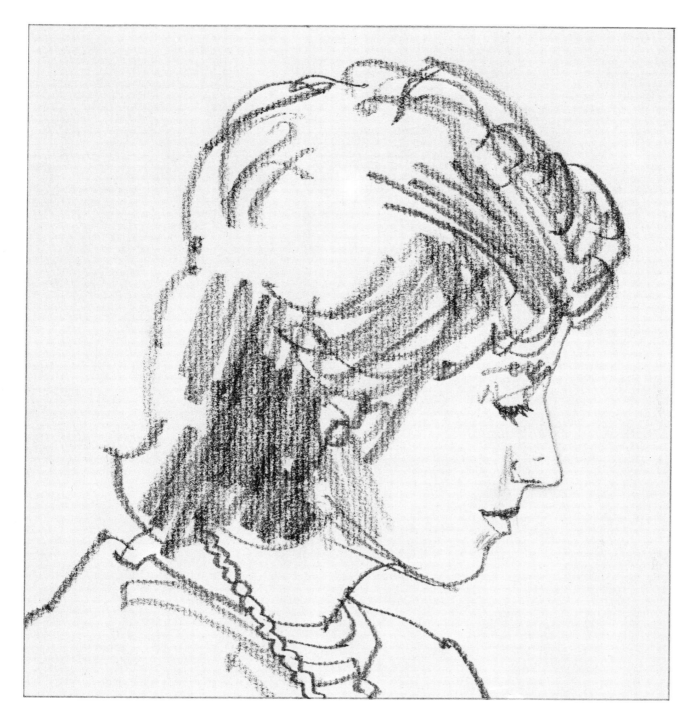

Charcoal Paper. Standard charcoal paper is a very popular paper surface, which has a ribbed texture and is known as Ingres in Europe. This paper, which has a mechanical, even surface texture, is a very fine paper for drawing with graphite, charcoal, chalk, or even wax pencils. A drawing done on this paper will tend to have a texture throughout that does not detract, but rather enhances the drawing. Most pencils respond very well to this surface, and charcoal sticks can also be used with excellent results. Charcoal paper is a delight to draw on and is a favorite of many artists the world over. On this drawing you can clearly see the overall textural effect that occurs when working on this surface.

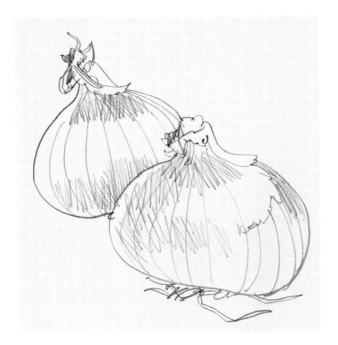

Working with Thin Strokes. A common technique for general drawing is to build up tones using thin strokes. These tones consist of drawn lines rather than blending or shading. Here I used an HB grade graphite pencil on drawing paper. The outlines were drawn first, then the tones were added using only thin pencil strokes.

Working with Broad Strokes. For this sketch I used a soft, 4B grade graphite pencil with a wide, flat lead on drawing paper. Notice how it is possible to vary the weight of the lines because of the flat shape of the lead used. The thinner edge of the lead was used to draw the finer lines and the wider portion was used to fill in the shadow areas.

Working with Varied Strokes. Here I used two grades of graphite pencils, an HB and a 2B, on common drawing paper. An outline drawing with the HB grade pencil was done first, then the lighter tones were sketched in. The darker tones and black accents were drawn with the 2B grade pencil. Zigzag and crosshatch strokes were used.

Working with Parallel Strokes. The tones used here are created through the use of lines drawn in the same direction, parallel to one another. This technique requires care while drawing as the lines must be spaced relatively even, assuring a flat tone. The outline drawing was done with an HB grade graphite pencil, as were the tones.

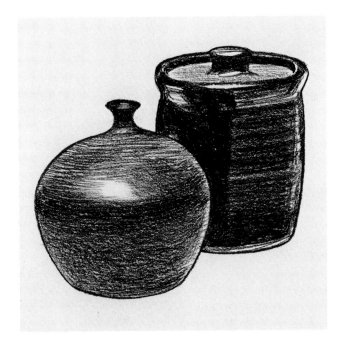

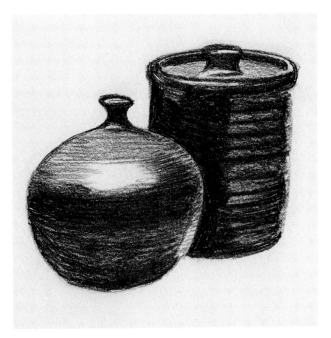

Outline and Blended Tone. This sketch is done on common drawing paper using three grades of charcoal pencils: HB, 2B, and 4B. The harder HB grade was used for drawing in the lighter values, the 2B grade for the medium tones as well as for the outline, and the 4B grade was used for the solid blacks. The blended pencil strokes used are visible throughout the drawing.

Blended Tone. This drawing, done with a chalk pencil, utilizes only blended pencil strokes without an outline. The pencil strokes are done just as they were on the previous drawing, using the same paper and blending the strokes by drawing them closely together. The edges of the jar and bowl are not outlined, but are formed by the gray tones.

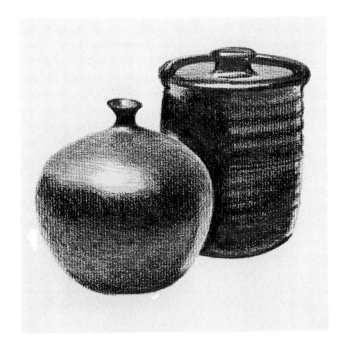

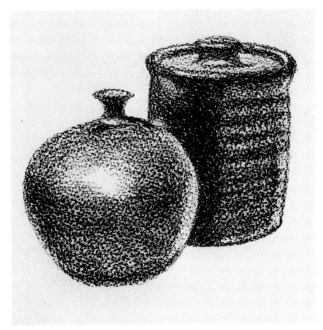

Built Up Tone on Charcoal Paper. HB, 2B, and 4B grade graphite pencils were used for this drawing, which consists of tones without visible strokes. The tones are built up smoothly, taking full advantage of the paper texture. When used lightly, the pencil deposits graphite only on the raised portion of the paper. When more pressure is used, the valleys are also filled in, creating solid black tones.

Built Up Tone on Rough Paper. This is the same technique as used on the previous example, but this time a 4B grade charcoal pencil was used on rough watercolor paper. The pencil strokes are not visible, as the drawing was done using only tonal gradations, which utilize the surface texture of the rough paper. Where the values appear solid black, more pressure has been used while drawing.

Step 1. Using a medium grade HB graphite pencil I do my basic outline sketch on common drawing paper, an excellent surface for general use as it has a slight surface texture. Notice that even though my sketch is loosely done and free, it is nevertheless accurate and the proportions are correct. As you gain experience and confidence in drawing through practice, you will be able to approach your own work in the same manner. Study the various types of lines that are used here to deliniate the different objects. Smooth, graceful lines have been used for the rocks and hills while the foliage consists of strokes drawn in a zigzag manner.

Step 2. I next indicate the very lightest tones in the scene using an HB grade graphite pencil. The 2B or 4B grades are not the best choice for drawing light tones, as their softer leads are more suitable for the darker tones. Using strokes drawn with the same pressure to ensure an even tone, I carefully draw in the light tones. The lines used to create the tones are varied—those used on the bushes are drawn with scribbled strokes, while those on the sky and desert area are done with horizontal lines. Some of the lines, such as those used on the rocks, follow the form, creating the illusion of depth.

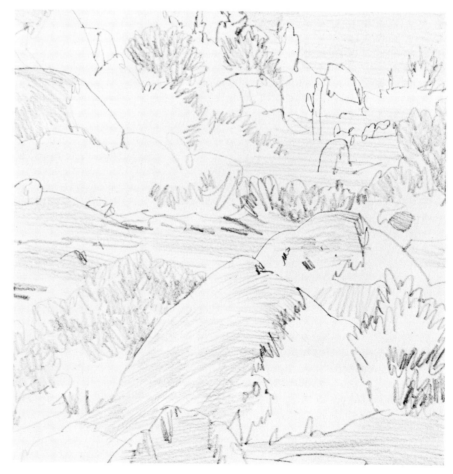

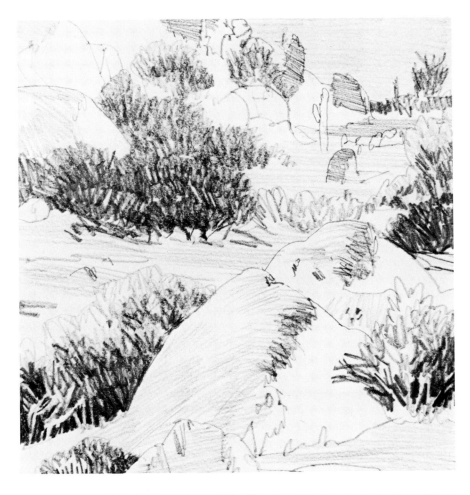

Step 3. I now draw in the medium tones with the 2B grade graphite pencil, starting with the background rock formations. I use strokes that are evenly drawn and close together, creating a flat tone. The same amount of pressure was used on the pencil while drawing these strokes. The background hill and trees are drawn using a zigzag line to simulate the leaf textures. Notice that on the foreground bushes I have been careful to draw around the branch shapes, leaving them as a light silhouette against the darker background.

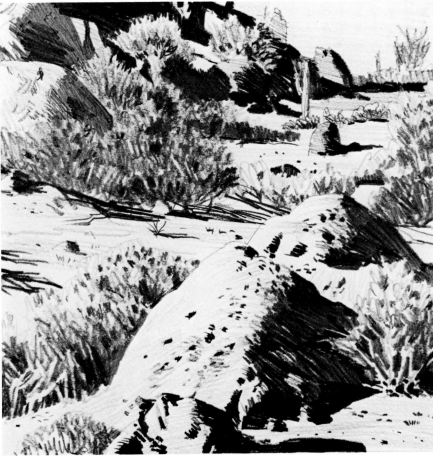

Step 4. The darkest tones are added now with a 4B grade graphite pencil, which is the best choice as it is capable of producing very black tones. The background rock area, which is in shadow, is drawn in with the solid black, but as I work I am careful to draw around the trees and bushes. I now add branches in the trees as well as a lighter tone on the rocks just forward of the background. I indicate darker accents over this area, suggesting the irregularities inherent to the rocky surface. After adding a few darks to the middleground trees, I render the shadows of the trees on the desert floor.

Step 1. I begin by freely drawing an outline sketch, using a 2B charcoal pencil on common drawing paper. This paper surface works well with charcoal as do the rougher surfaces. I draw in the larger foreground trees, then add the roots and foliage around them. Next I indicate the middle-ground trees. The background trees are done by drawing vertical strokes. I indicate the sunlit areas on the forest floor. This will help me when I add the tones to that part of the scene. The sunlit areas on the foreground trees are also drawn in. The basic drawing is now ready for adding tones.

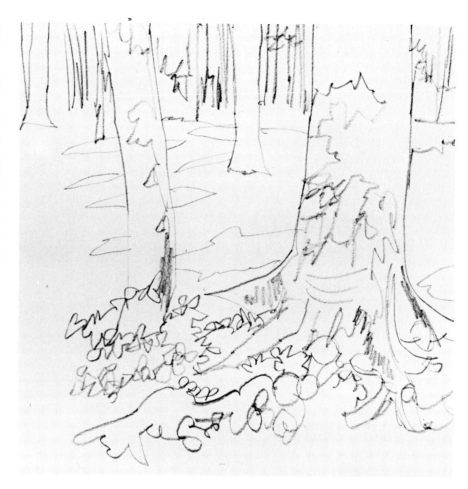

Step 2. With the 2B grade charcoal pencil I carefully add a very light tone to the background area using horizontal strokes. I next draw in a medium gray tone in the foreground area, drawing these strokes at slightly different angles to create a surface texture. Notice how I carefully work around the tree trunks and roots. A slightly darker gray tone is added to the middleground part of the forest floor. I draw around the tree trunks as well as the sunlit patches on the ground, using short pencil strokes. The difference between the two gray tones is quite evident.

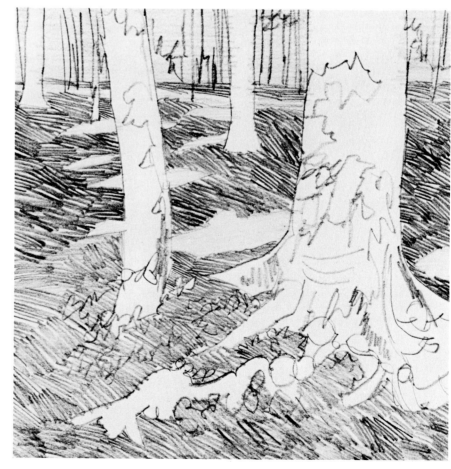

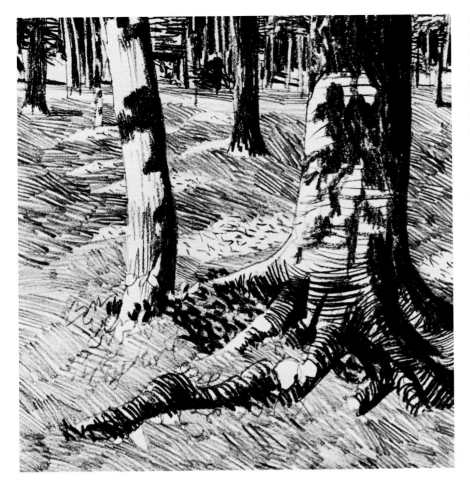

Step 3. The darkest tone is now added, using a softer 4B grade charcoal pencil. I draw the shadow areas on the tree in the foreground and indicate the bark texture with curving horizontal lines. The direction of these strokes helps to create the illusion of form and adds an interesting texture to the drawing. I fill in the shadow area on the other foreground tree and delineate the bark texture with vertically drawn lines. A slight texture is drawn into the sunlit part of the forest floor, using short strokes drawn at different angles. I next indicate small black areas in the background.

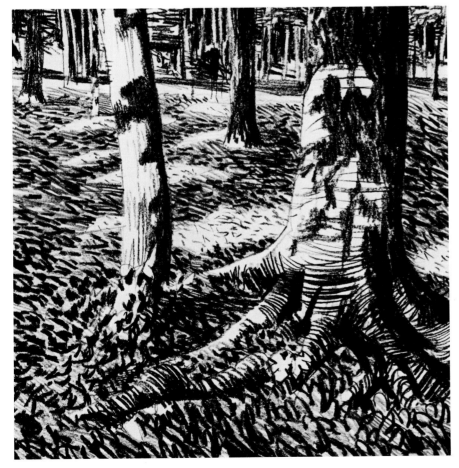

Step 4. Using the 4B grade charcoal pencil I begin to carefully indicate the shadows of the leaves on the forest floor. I use short, curved strokes drawn in different directions, creating a varied and uneven surface. Notice that the leaf texture in the foreground is much larger than those in the background, helping to create the illusion of distance and perspective. Great care must be exercised when working with charcoal as the drawing can be smudged or smeared easily. As I worked I frequently removed the surface charcoal dust by gently blowing it off the paper surface. The dust that remains can be removed with a kneaded rubber eraser.

Step 1. This drawing is done using a chalk pencil. Chalk pencils are capable of producing a good range of tones through blending and shading and also by using varied pressure while drawing. I begin this study by first doing a basic outline sketch on a sheet of drawing paper. Notice that because of the softness of the chalk pencil the drawn lines tend to vary in weight; a harder lead offers a more consistent line. I next indicate the highlight areas on the bottles, which will be used as a guide when rendering the tones.

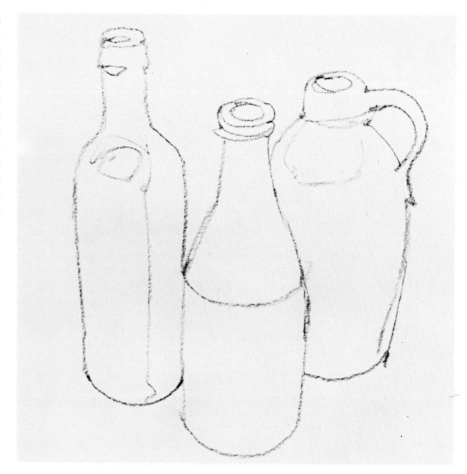

Step 2. I now begin to add the tones to the bottles by drawing individual pencil strokes, which are rendered to follow the general shapes and contours of the objects. Drawing in this manner helps to emphasize form. The bottle on the left has been shaded much darker by drawing heavier lines. The middle bottle has been shaded by using lighter strokes at the top and darker strokes as the tone goes down the side of the bottle. This control has been achieved by varying the pressure while drawing. I begin to draw in the darkest tones on the bottles.

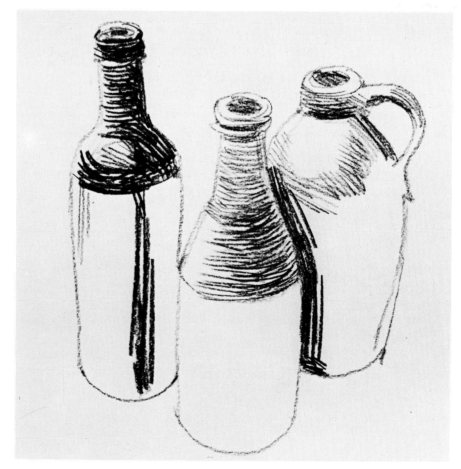

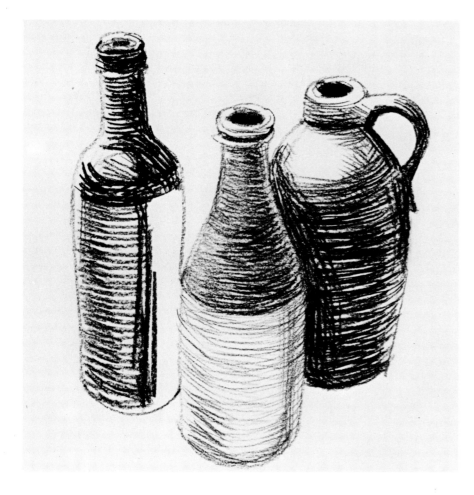

Step 3. Continuing to draw, I use linear strokes to draw the dark tones on the bottle at right, following the form as I work. The medium tone is drawn on the bottle on the left and the light tone on the central bottle is sketched in. I draw more lines on the upper section of the center bottle, darkening the tone. Notice that throughout I have used curved strokes while drawing. You can also see that there is a definite difference between each of the tones drawn.

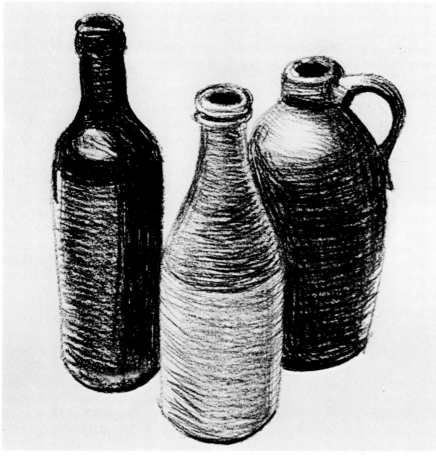

Step 4. I darken the tone on the lighter section of the center bottle by carefully building up strokes over those previously drawn. I bear down considerably on the pencil while drawing to darken the tones on the left-hand bottle, leaving a slight texture showing through for interest. The highlight area of the same bottle is darkened slightly with evenly drawn pencil strokes. The bottle on the right is darkened in the same manner, by carefully stroking a tone over the area. When working with a chalk pencil there is a tendency for chalk dust to accumulate. I carefully erase around my drawing, making sure this tone is removed before spraying the drawing with fixative.

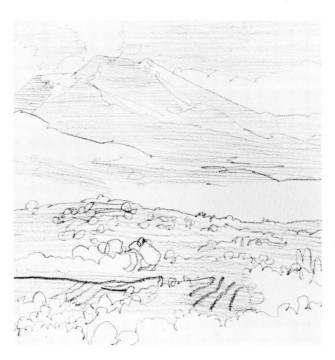

Step 1. I begin this sketch by doing a basic outline drawing with a wax pencil on common drawing paper. This drawing clearly defines the various planes in the landscape as well as the fields, foliage, and foreground hills. I have drawn in the cloud shapes and indicated the shadow areas on the mountain as well as the plowed field in the foreground.

Step 2. I continue drawing by adding the lighter gray tones, which are composed of carefully drawn horizontal lines. Notice that I make no attempt to blend these pencil strokes, yet they appear to form a solid gray tone. The tone is achieved by drawing the lines with equal pressure so they are even, and spacing them uniformly.

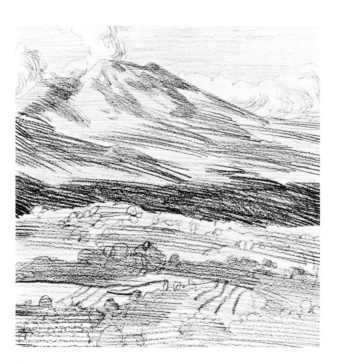

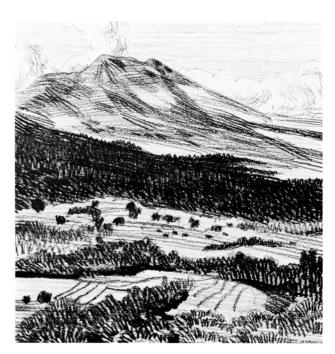

Step 3. Now I draw in the intermediate tones, using the same method and carefully drawing the pencil strokes evenly. Where I want the tone a little darker I bear down more while drawing. When lines are drawn closely together, as with those across the central portion of the drawing, the tone becomes quite dark. Notice that the underdrawing is still visible through the tones.

Step 4. The darkest areas are now drawn in using more pressure on the pencil while working. I also use various strokes, such as the zigzag lines used to indicate the foliage areas. Notice that in the foreground, short pencil strokes have been drawn, which appear as a leaf texture. I now darken the tree area in the middle of the drawing and the background mountains as well. Finally, shadows are added.

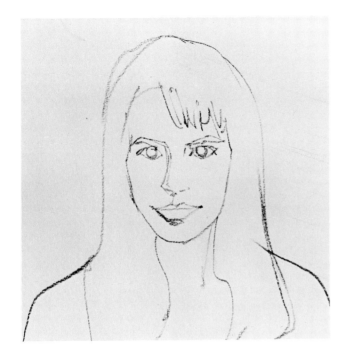

Step 1. On a sheet of common drawing paper I sketch an outline drawing of a young woman. The chalk pencil used is very soft, creating a line that varies in density, as you can see on this sketch. The strength of the line depends upon how much pressure is applied on the pencil while drawing.

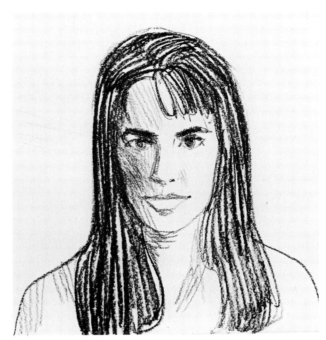

Step 2. A very light tone is added to the shadow side of the face, neck, and shoulder, consisting of pencil strokes that have been drawn closely together. The eyes, eyebrows, and the darker accents on the nose and mouth are drawn in. The hair is rendered next, using strokes that follow the form and are also more boldly drawn.

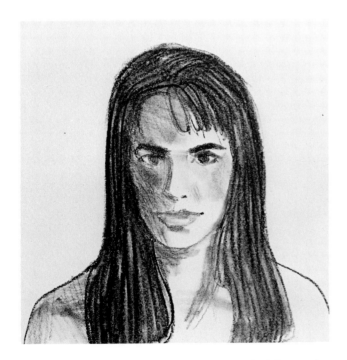

Step 3. Using a paper stomp I blend the facial tones by carefully stroking over them. I work on the shoulder and neck as well, blending these areas smoothly. Using the fine tip of the stomp, I very carefully model the lips, a crucial part of the drawing that could easily be ruined through clumsiness. The tone on the hair is blended next, but the original lines still show through.

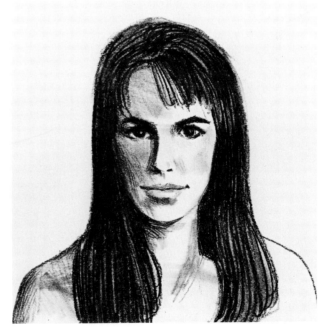

Step 4. I work very carefully on the eyes and surrounding areas. Notice the minute highlights in the eyes, which were created by using a kneaded rubber eraser formed to a fine point. I darken the eyebrows and the shadow side of the nose. The lips are defined with a tone, then the shadow under the chin is blended into the adjacent hair. I outline the highlight side of the face and darken the hair throughout.

Step 1. For this drawing I use HB and 2B grade graphite pencils on a smooth-surfaced paper. The smooth paper is an excellent choice as it is possible to achieve crisp, clean lines on this surface as well as a wide range of gray tones. The technique involves using primarily lines and strokes to produce tones, rather than blending or shading. I begin by carefully doing my basic drawing in outline form, starting with the leaves growing on the tree, then the large tree, and finally the trees in the background and underbrush.

Step 2. A light tone is added to the leaves on the central tree, indicating the shadow areas. Notice that I just use linear strokes to create these gray tones. The slight variation in this tone—lighter tones in the upper leaves and darker tones in the center and lower ones—is accomplished by varying the pressure on the pencil while drawing. I next draw short, random strokes on the ground area, indicating the grass and the weeds. While this is not a realistic rendition, it still simulates the texture of the grass and the pattern created by the lines adds some interest to the drawing.

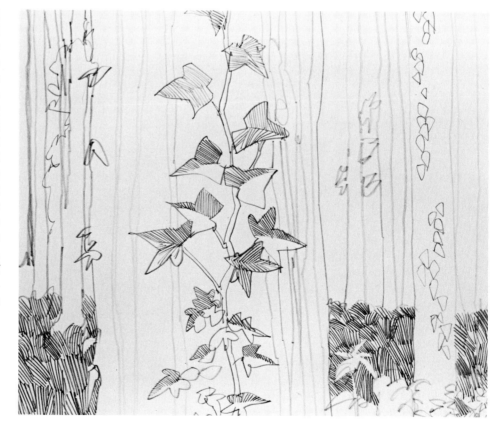

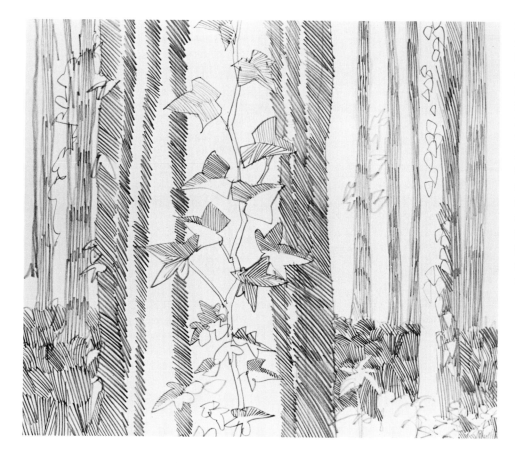

Step 3. A medium gray tone is added to the foreground tree by drawing in strokes at the same angle. Here I am not interested in creating a surface texture as on the grass in the last step, but just a tone. I draw vertical lines on the other tree trunks to add tones to these areas. The direction of the strokes used here was changed to help clarify the different elements in the drawing. Notice that all of the different parts of the picture separate quite well even though the drawing is only partially completed.

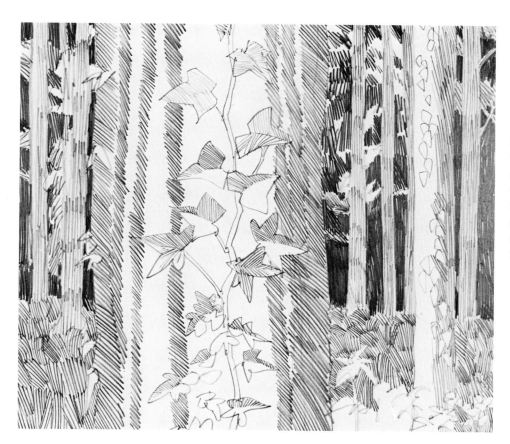

Step 4. I decide to add the dark tone in the background, as this will help me to determine the other tonal values in the drawing. I draw in the tone by using pencil strokes that are drawn very close together, keeping the tone quite solid in the lower area. For variation, I draw in the tone at the far right using the dark at the top and the lighter tone in the lower section. The lines are randomly drawn to add to the textural effect I was after.

Step 5. I render the darkest tone on the tree trunk on the right side, carefully drawing around the leaves growing on the tree. The lines are drawn closely together, but some paper has been allowed to show through to create a texture. I now add the black areas on the central tree trunk, drawing in the long vertical shapes that define the bark surface. Notice that I carefully draw around the leaf shapes, keeping these light against the darker background. The pencil strokes used here are short and drawn in different directions. The area at the top has been left unfinished so that you can see how these strokes were drawn.

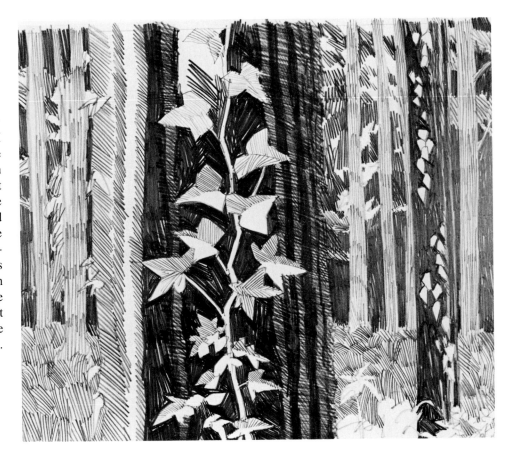

Step 6. After finishing the central tree trunk, I indicate the shadows cast from the leaves on the vine with pencil strokes drawn over these areas. The whole background is now toned down by going over the whole area with boldly drawn pencil strokes. This helps greatly to clarify the drawing and to accent the light leaves. Notice that I have been building up the tones in the drawing quite gradually, working in definite stages. I also work over the whole drawing rather than concentrating on any one area or object. This will ensure a uniform look to the finished drawing.

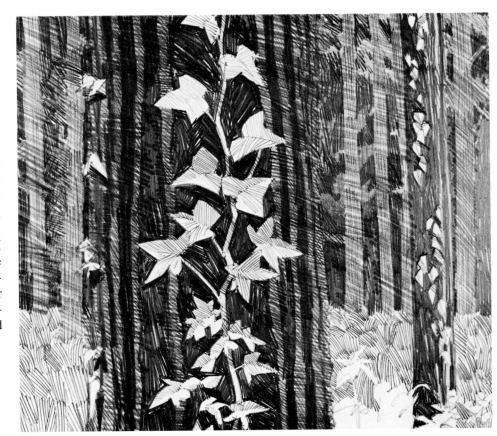

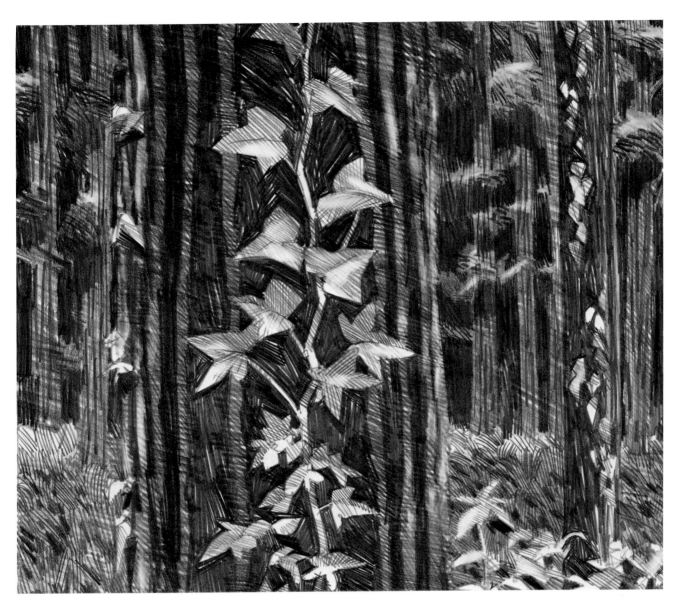

Step 7. Now tones are drawn in the foliage in the foreground, using simple strokes of the pencil without any blending. The grassy area is darkened using horizontally drawn lines, then a few shadows are drawn in with solid black. The leaves growing on the tree trunks are toned down a bit with pencil lines, with some of the strokes overlapping to create a crosshatch effect. The background area is darkened further and the foliage shadows are drawn on the trees. A bark texture is also drawn on the trees in the background, using vertical strokes. This darkens the tree trunks so much that the background must be drawn using solid black. A kneaded rubber eraser is used to erase lighter areas on the tree foliage in the background and also on some of the foreground leaves. This creates a smudged, soft effect, which contrasts nicely against the pencil strokes used in most of the drawing. This technique works very well for a wide range of subjects, especially those with great detail and textures. The graphite pencil is an excellent choice when using smooth-surfaced papers for drawing, as a wide range of tones and textures are possible. When using the smooth papers, the drawn textures become more important as no paper texture will show.

Step 1. Using a 2B grade graphite pencil, the type with a broad lead, I draw a diagrammatic sketch of the scene. This is done on common drawing paper, a good choice when drawing with a graphite pencil. Notice that in this diagram I have only drawn in the most basic shapes and lines, which divide the picture plane. The foliage shapes were drawn first, then the various ground levels and hills.

Step 2. I now begin to draw in some of the details in the upper portion of the scene. The trees are sketched in and the building shapes are defined by carefully drawing in the roof shapes and some of the shadow areas. The shadows are added to the trees as well and a tree with branches is drawn in the middleground area. Leaf textures are loosely indicated on some of the trees using boldly drawn pencil strokes. Notice that this drawing is not labored, but is done in a rather free, sketchy manner.

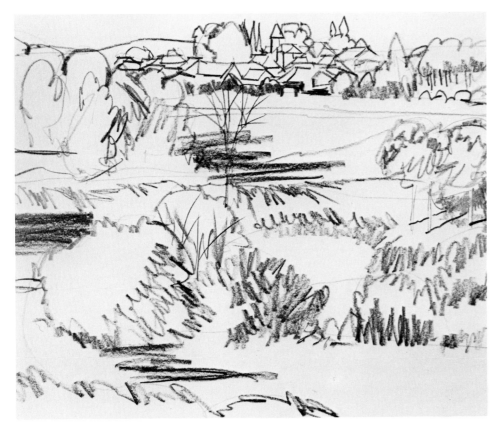

Step 3. Now, working on the lower section of the scene, I use strokes drawn to simulate the foliage texture. Notice that most of these tones are composed of quickly drawn, zig-zag strokes, and the direction of the strokes changes to add variety to these particular areas. A few dark shadow accents are added with bold horizontal pencil strokes.

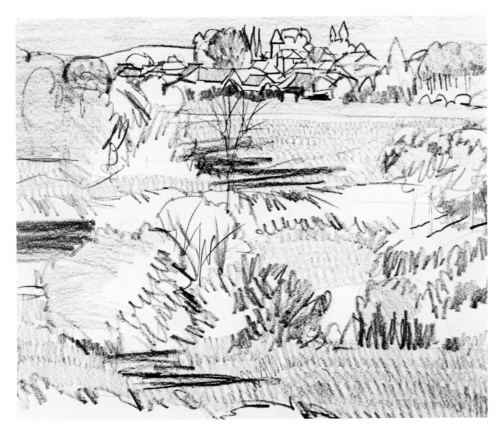

Step 4. Next, I add a very light pencil tone to the sky by lightly stroking the paper with the pencil. This is also done over the background trees. Using short up-and-down strokes, the textured grassy area in the background is drawn in. This same texture, which simulates grass, is used over the foreground areas, but these strokes are drawn larger, helping to create the illusion of perspective. Notice that the addition of a few well-placed grays helps to define the scene and separate the various planes.

Step 5. The middle gray tones are drawn in, utilizing the flat edge of the wide pencil lead and drawing with an even pressure. You can see that I have used different types of strokes while drawing. In the bushes and trees on the upper left, short, up-and-down strokes are used to create the tones, while the strokes used to depict the bushes in the foreground are composed of thinner, vertically drawn lines. In the center of the picture, where there appears to be a river or gully, the strokes used were drawn with the wide edge of the pencil lead and the pressure was changed while drawing to achieve variation in tone.

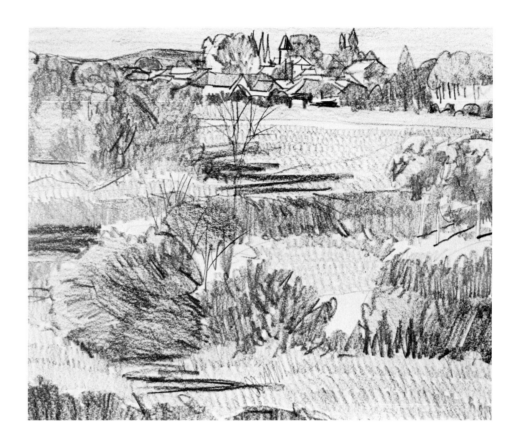

Step 6. At this stage I add the darkest gray tones by bearing down more on the pencil while drawing. I am still using the same 2B grade lead, so you can see that a wide range of tones are possible with only one pencil. I now darken a few of the background trees and houses, then draw in the strong shadow in front of the first row of buildings. More darks are added to the gully area and to the foreground trees with tones drawn using short, up-and-down strokes while holding the pencil at different angles. The black shadow is drawn under the foreground tree and the bushes at the foreground edge are darkened considerably to create a silhouette effect.

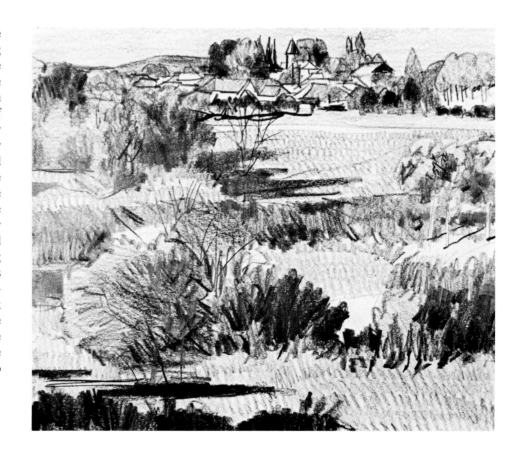

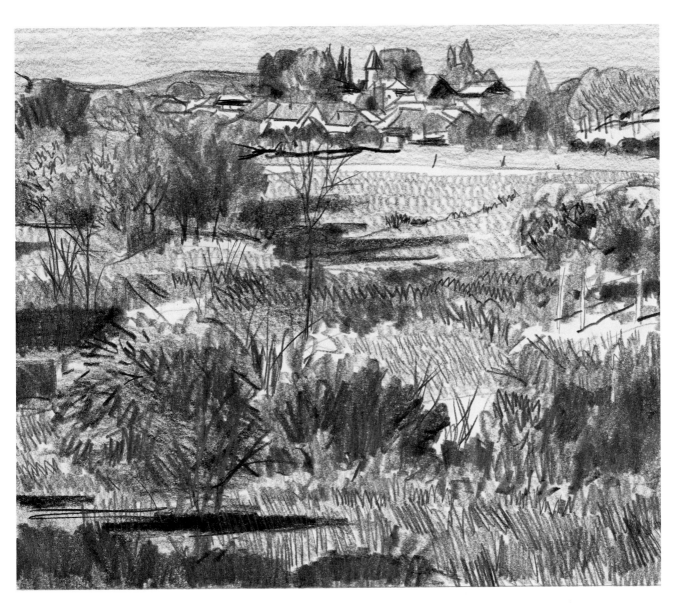

Step 7. Throughout the scene I add more details, such as the fenceposts in the background, tree trunks, and the branches of bushes. More darker foliage is drawn in the gully area using short zigzag strokes. Just below this area I draw in shorter, lightly drawn pencil strokes, indicating another type of grass texture. On the tree in the left foreground, I boldly draw the foliage texture using zigzag strokes. I render the grassy area in the foreground with longer, thinner pencil strokes, changing the direction frequently while drawing to create a variation in this tone. The details in the buildings are drawn in as well as more shadows in this area. The gully on the left is darkened and the trees in the central area are darkened as well by strengthening the tones in these areas. Every part of this scene has been rendered in a loose, sketchy manner and the overall drawing retains the same quality throughout. Nothing looks out of place by being overworked, an important thing to keep in mind when doing drawings in any style. Whether your drawing is rendered in great detail or is a simple, loose sketch, it should appear uniform, without any variation in the technique.

Step 1. I begin by doing a very basic, diagrammatic sketch of the head; a loose, but proportionally accurate drawing. First the large, circular shape of the skull is drawn, then the other features such as the chin nose, ear, and eyes are indicated with quickly drawn strokes. The drawing is done with a 2B grade graphite pencil on common drawing paper. It has been drawn very lightly, as it is only a guide for doing the finished drawing.

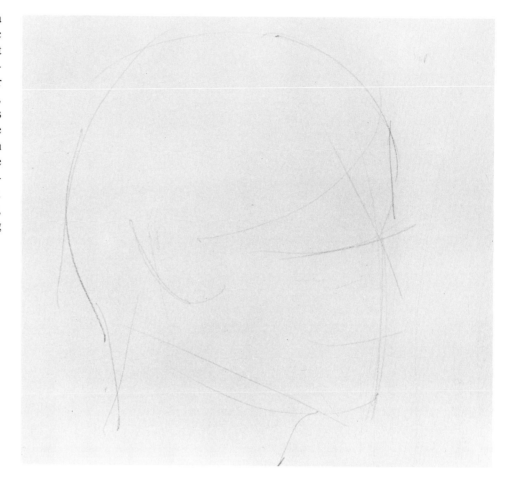

Step 2. I next begin to define the features as well as other details such as the hair. I work very carefully so the drawing will be accurate. The facial features such as the nose, mouth, and chin are drawn in, then the eyes and eyebrows are carefully indicated. The mouth line and the lips are added next, then the neckline. The hair is loosely sketched in, using pencil strokes that follow the general shape. The ear is drawn in outline form.

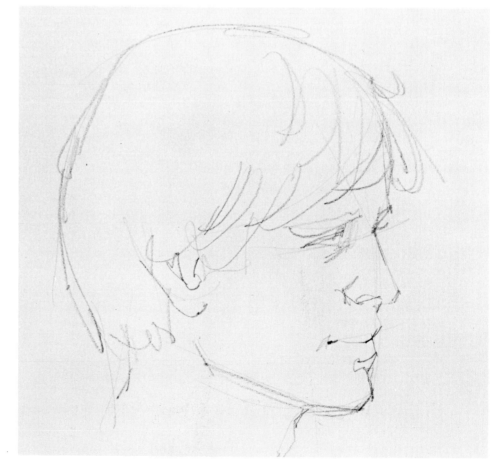

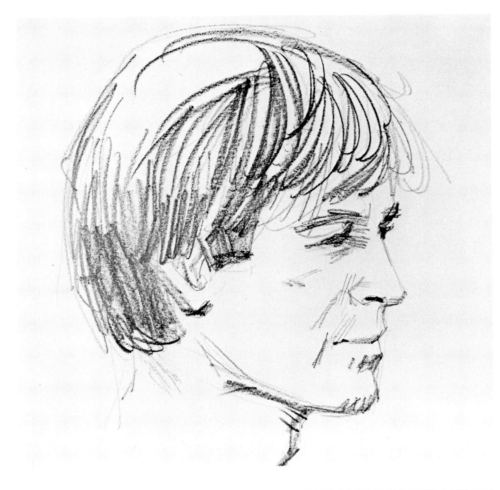

Step 3. Using a 4B grade pencil with a broad lead, the dark accents are drawn on the eyes, nose, mouth, lips, and neck. The hair is sketched in using roughly drawn pencil strokes that follow the shape of the head. I draw in some of the various planes on the face as well as suggest some of the bone structure. The drawing is shaping up nicely because the proportions and sizes of the various elements are correct.

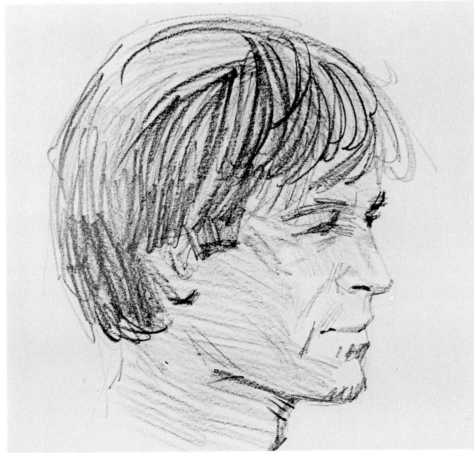

Step 4. Working with the 2B grade pencil, I carefully add the lightest gray tones to the face and hair using boldly drawn strokes. In some areas I follow the form while drawing, as you can see on the cheek below the eye and on areas around the nose and the mouth.

Step 5. I add the medium gray tones by boldly drawing with the 4B grade pencil, varying the direction of the lines while working. Some of the strokes are drawn over one another, creating a type of crosshatch effect. This technique helps me to build up the tones and yet retain a sketchy effect. I next darken the hair a bit, using the flat edge of the pencil lead to render a solid tone rather than one consisting of lines.

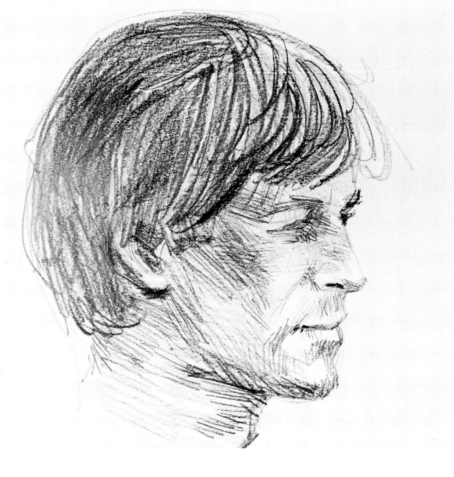

Step 6. The darkest tones are now drawn in using a much softer graphite pencil, a 6B grade. Notice the dark accents on the eyes, nose, and mouth, which have been clearly indicated and add contrast to the overall drawing. The darks are strengthened around the ear and under the chin. Care must be taken when adding accents such as these—if incorrectly placed they can ruin your drawing.

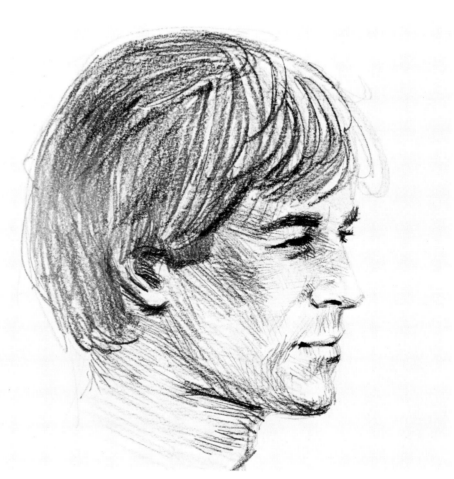

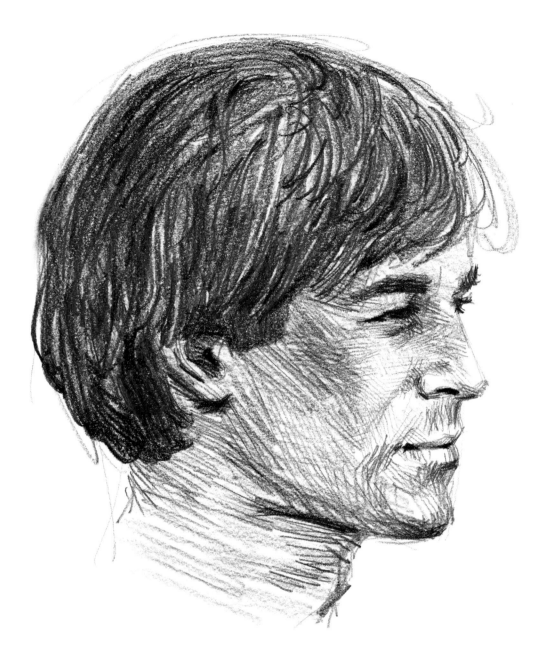

Step 7. With the face pretty well completed, I now work more on the hair. Working with a 6B grade graphite pencil, I draw in more strokes, following the direction of the hair. I slowly build up these tones and add shadow areas throughout, with the deepest tones added last. This is an excellent sketch technique, which can be used on a variety of subject matter. Be sure to notice that all of the blending used has been accomplished through drawn pencil strokes rather than rubbing or blending with a stomp. The most important stage of this drawing was the diagrammatic sketch done at the very beginning. This is the stage where the proportions and sizes are determined, and if they were not correct, it would have been reflected in the finished drawing. These simple diagrams are essential, as they are the basis for line or tone drawings and even paintings.

Step 1. This portrait of a young woman is done with a chalk pencil on common drawing paper. Chalk pencil works well on this surface, but care must be taken while working not to smear or smudge the drawn lines. This is also the case when doing charcoal drawings. I begin working by first doing a simplified linear diagram of the subject; just drawing the outline shapes with a suggestion of the features. The outline shapes are drawn with accurate proportions and the face is blocked in with pencil strokes. This type of a diagrammatic study is important to practice as it is the basis for all drawings.

Step 2. To refine the basic diagram, I start to draw in the important features and details. The eyes, nose, and mouth are very carefully delineated. The right side of the face is drawn, and I am careful to capture the subtle curves of the cheek and forehead. The hand is drawn next, again being very careful to duplicate the subtle shapes of the fingers. The hair is drawn, then a few accents, and the shaded areas below the hair, are added. Now that an accurate drawing has been made, I shape a kneaded rubber eraser with my fingers and erase the lines of the underdrawing carefully, so none of the drawn lines are smudged.

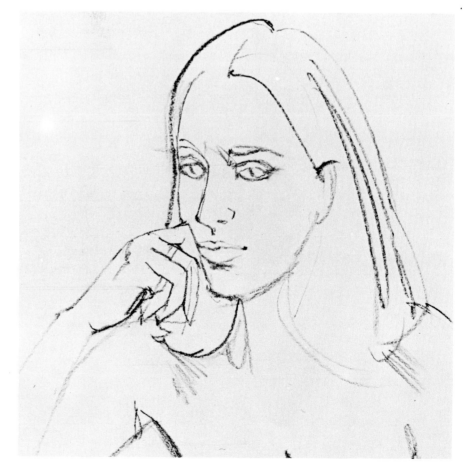

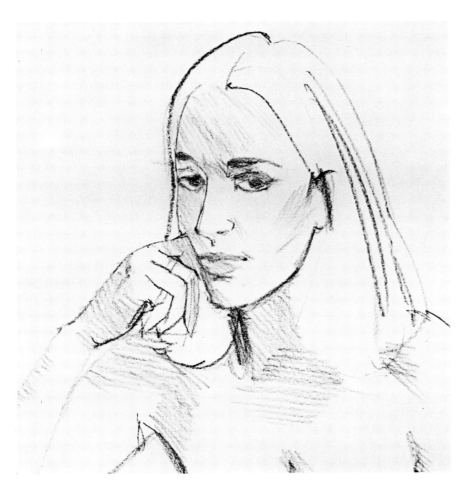

Step 3. I will now add some of the tones to the drawing. As a precaution against smudging the chalk lines, I use a piece of tracing paper under my hand while working. The lightest tone is added to the drawing using light pencil strokes over the appropriate areas. In some cases, such as on the hand, I follow the shape, enhancing the illusion of form. I next darken the eyes and eyebrows. Dark accents are drawn near the ear and on the neck. Notice that while the drawing is taking shape, the tones are being built up gradually.

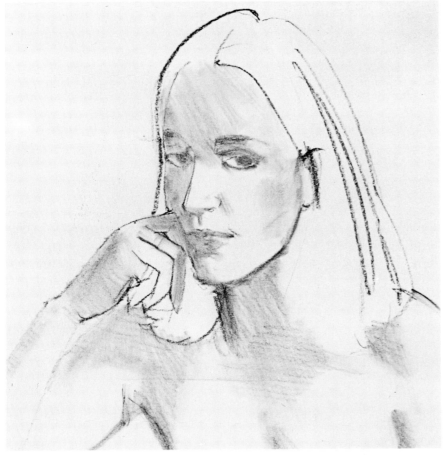

Step 4. I use a paper stomp to blend the pencil strokes into a tone, carefully rubbing it over the lines to smooth them out. This gives a pleasing softness to the drawing. When working with the paper stomp, I am careful not to blend the lines of the basic drawing. If lost, they would have to be drawn back in. The values of the tones are pretty much determined by how dark they are drawn in before the stomp is used. Keep in mind that you can always darken tones by adding more strokes and repeating the blending, but they are more difficult to lighten. Some tones can be lightened by rubbing them with a facial tissue, but often the only method is to erase the area with a soft kneaded rubber eraser.

Step 5. Next a medium gray tone is drawn on the right side of the face and on the forehead. Tones are also added to the lighter areas on the hair and blended with the paper stomp. Some of the darker gray tones are drawn on the face and hair. These are drawn by very carefully building up the tones using pencil strokes. Notice that the tones are being built up gradually and that I am working over the whole drawing, not concentrating on any one area. The facial features are very critical and must be drawn with care, with special effort taken to duplicate all of the subtle shapes and forms.

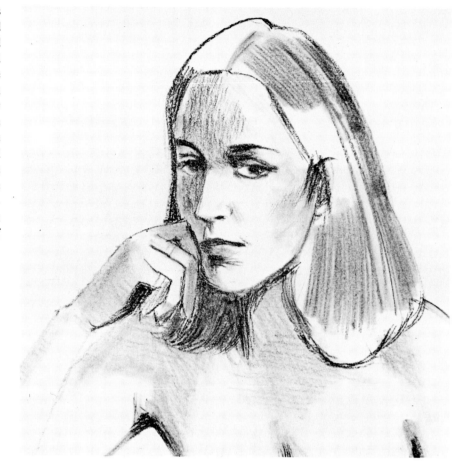

Step 6. The hair is darkened by drawing heavier pencil strokes that follow its shape. This darkened tone affects some of the other gray values, making them appear too light. The affected areas—the eyes, mouth, and some of the shadows—are now darkened with pencil strokes. At this point, there has been an accumulation of chalk dust on the paper. I erase the chalk dust with a kneaded rubber eraser. This dust is almost invisible, but, if not removed, it shows up as a gray tone when the drawing is sprayed with fixative. To erase close to the drawn lines, the kneaded rubber eraser can be formed into a pointed shape, which makes the job much easier.

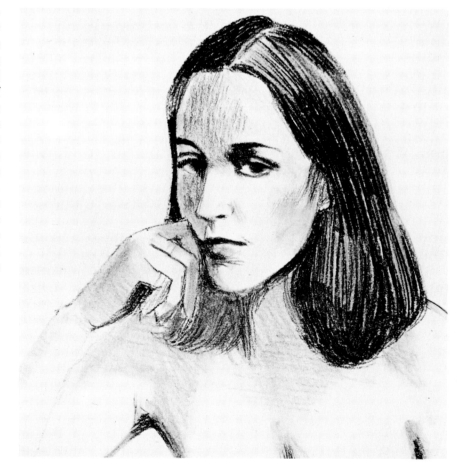

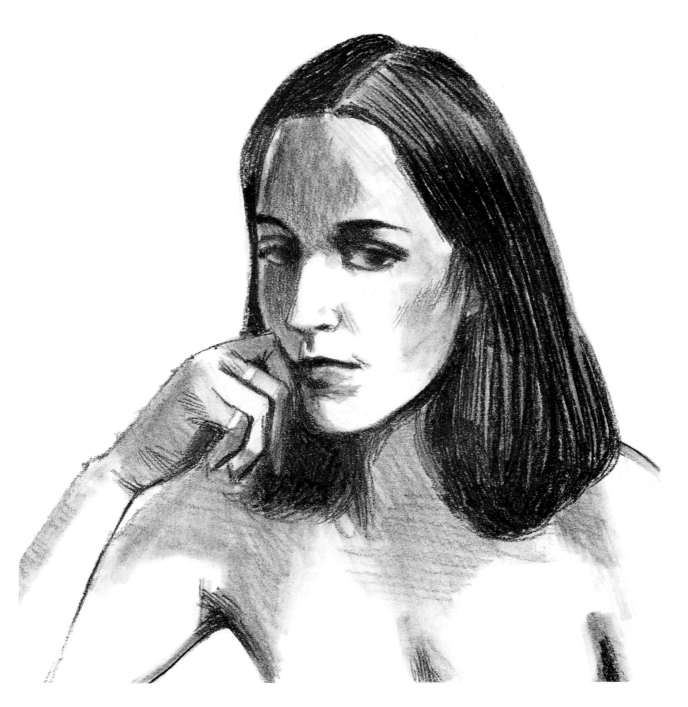

Step 7. I decide to blend the tone on the forehead, subduing the texture that was created by the drawn strokes. The shadow side of the face is now darkened as is the hair. Working carefully with a kneaded rubber eraser, I erase some of the tone on the right side of the face, creating the effect of reflected light. I add more details on the hand and cheek, using subtle pencil strokes. Before spraying the drawing with fixative, I go over the background again with the kneaded rubber eraser to remove any more chalk dust that might have accumulated. It is very difficult to see this accumulation of pencil dust until it is sprayed with fixative, something to keep in mind when working with charcoal or chalk pencils. The other important thing to remember is that chalk and charcoal lines can be smudged easily, so when working use a piece of tracing paper under your hand. Always build up your tones gradually, working from light to dark. If you don't have a paper stomp, a rag, paper tissue, or even your finger can be used to blend drawn pencil strokes into tones.

Step 1. Charcoal paper is a unique surface with a ribbed texture. For this demonstration HB, 2B, and 4B grades of charcoal pencils are used on charcoal paper. I begin my basic drawing with the HB grade pencil, which has been sharpened with a razor knife, then pointed using a sanding pad. Notice how simple lines have been used to define the various elements in the scene. Even though this drawing is done using a minimum of lines, the proportions are correct and the nature of the subject is quite clear.

Step 2. Details are added to the buildings and the lighthouse using the HB grade pencil. The rest of the scene is refined and clarified by drawing in the cloud shapes and filling in the details on the rocky cliff with the softer, 4B grade charcoal pencil. The shadow areas on the clouds are drawn in and a few tones are added to the cliff. Notice that the drawn lines have an interesting quality due to the texture of the paper surface.

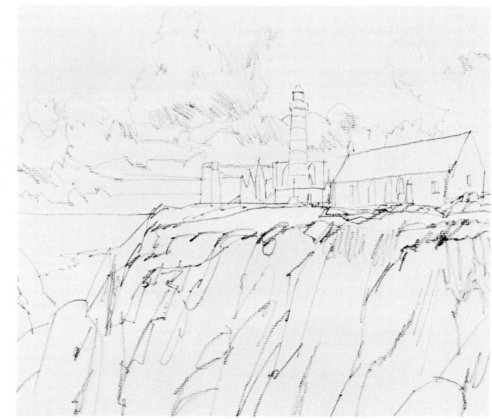

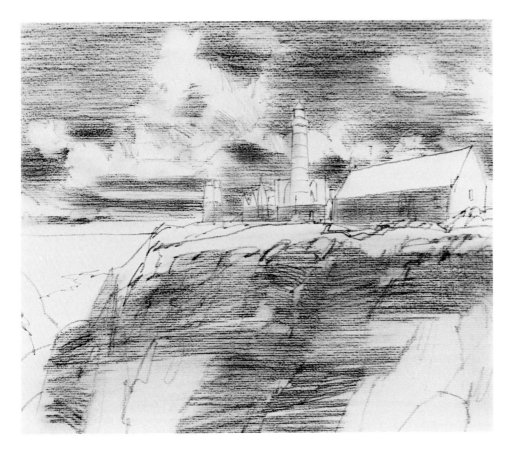

Step 3. Using a medium, 2B grade charcoal pencil, I draw the lighter tones in the sky area. This is done with horizontal strokes that follow the ribbed texture of the paper, because the tone can be drawn more uniformly that way. When drawing lines in the other direction, the paper texture becomes more pronounced. A tone is now added to the buildings, the pencil strokes again following the ribbed texture of the paper. When drawing the tone on the rocky cliff I use random strokes to achieve a more mottled effect. I used a small rag here over these tones to blend and rub them smooth, but you could use a stomp.

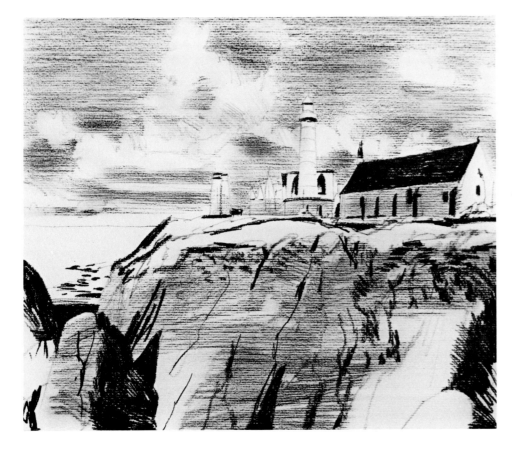

Step 4. To draw in the darkest tones, I use a soft, 4B grade charcoal pencil. This tone is drawn on the shadow areas and also is used to indicate the crevices and other details on the rocky cliff. The roof is drawn on the larger building and the windows are added as well. The smaller details and accents are drawn on the lighthouse and other buildings. On the beach in the distance I indicate rocks drawn with dark pencil strokes.

Step 5. A tone is added to the sea in the background, using a soft, 4B grade charcoal pencil. The strokes are blended smooth with a rag. More dark tones are drawn in the cliff to build up the form. These tones are also blended using a rag. The blending of charcoal tones can also be accomplished by using soft facial tissue or even your finger. The grassy area on top of the cliff is rendered using the same pencil, with more pressure to produce a near-black tone.

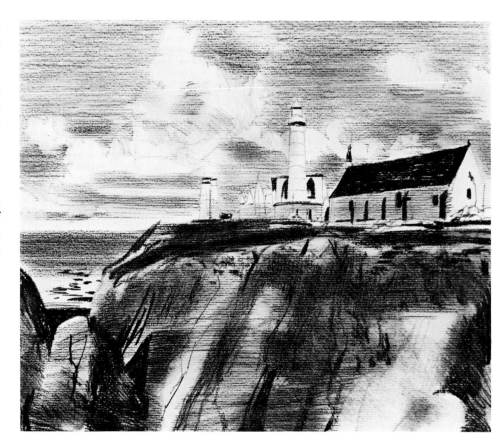

Step 6. I sharpen the 4B grade pencil, then shape the point finely with a sanding pad, and carefully draw in the darker areas on the clouds. I blend these strokes together as I draw so they are quite smooth. With a kneaded rubber eraser I carefully erase the pure white areas you see in the clouds. When this eraser is properly shaped, it can be used to lift out areas in the gray tones. Using the eraser, I carefully erase details such as rocks and highlight areas from the side of the cliff.

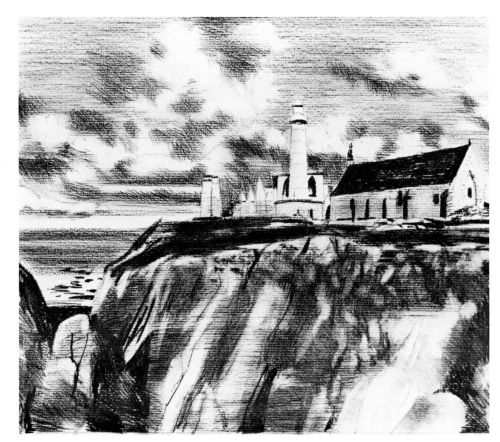

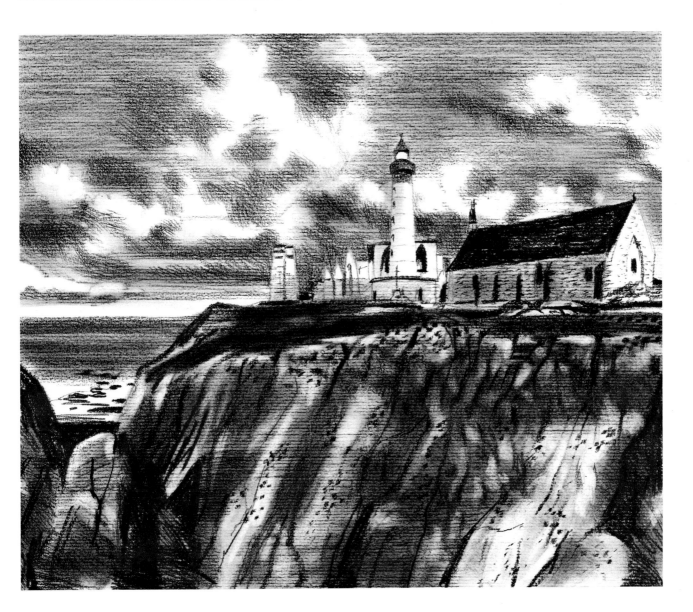

Step 7. The buildings are finished by drawing in details such as the brick textures and the windows. Working next on the cliff surface, I add more crevices and cracks using finely drawn strokes. Over this, I indicate small bushes using spots of black. Notice how the ribbed surface texture of this paper shows throughout the drawing, creating a very distinctive look. This is another basic pencil drawing technique that can be used for most any type of subject. The paper is especially compatible for use with charcoal pencils, but chalk, wax, and graphite pencils will also work well on this surface. When using charcoal or chalk pencils, tones can easily be removed or lightened with the kneaded rubber eraser. Remember too that tones can be lifted out by using the pointed end of a kneaded rubber eraser that has been shaped to a point with your fingers. The other thing to keep in mind is that charcoal and chalk lines smudge easily. This can be avoided through the use of a piece of tracing paper under your hand while drawing. On this drawing, I carefully removed the charcoal dust that had accumulated before spraying it with fixative. This dust was removed from the white areas of the drawing with a kneaded rubber eraser. As I have mentioned before, this dust is almost invisible, but becomes quite noticeable when sprayed with fixative.

Step 1. A lithograph crayon looks much like a china marking pencil and is used primarily for drawing on lithograph stones. Lithograph crayons are also useful for doing drawings as they can achieve very smooth, even tones, are excellent for general drawing, and can be used on a variety of paper surfaces. As you draw with the lithograph crayon, you can peel away the paper covering, extending the crayon as it wears down from use. The papers that work the best for drawing with litho crayon are those with a slight surface texture, such as common drawing paper. To begin this drawing, I first sketch in all the elements, defining the buildings and foliage areas. The drawing appears quite loose at this stage, but will be tightened up as I progress.

Step 2. The lightest gray tones are added by carefully filling in the areas using blended strokes of the litho crayon. To achieve flat, uniform tones, it is necessary to use the same pressure when the strokes are drawn. In the central area you will notice that the tone is a bit darker. This was accomplished by bearing down more while drawing the strokes. The drawing is taking shape even though only a few simple tones have been added.

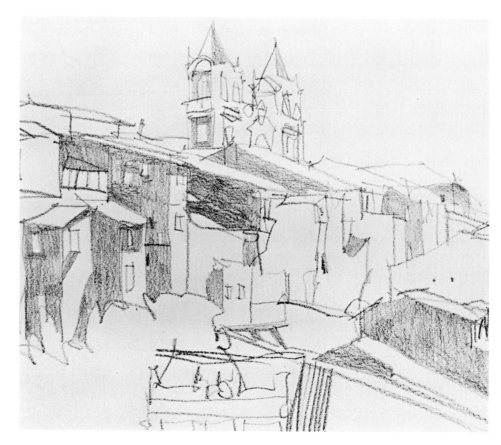

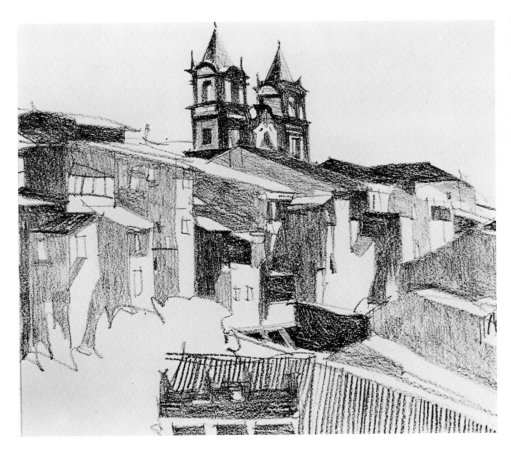

Step 3. I next draw in the medium gray tones, again working quite carefully to achieve uniform tones. Notice that there is a distinct difference between this tone and the previously drawn one. The drawing consists of only two tones of gray and the white of the paper at this stage. The darker tones on the church towers have been carefully drawn around the lighter areas. To accomplish this delicate work, I first sharpen the litho crayon with a razor knife—the fine point is more suitable for doing detailed work. The tile roof in the foreground is drawn in using bold vertical strokes.

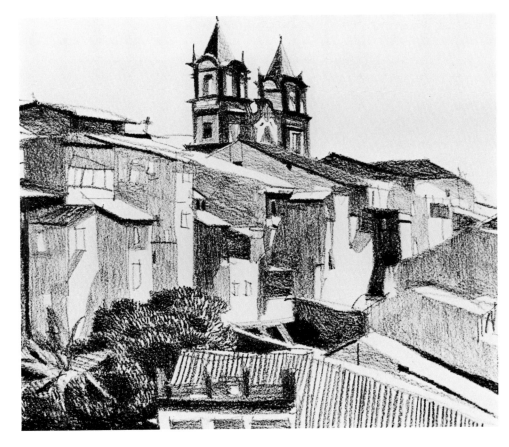

Step 4. Using zigzag strokes, I indicate the leaf texture in the foliage areas, then the black shadows. I add more details to the buildings, such as roof lines and some windows, using the pencil sharpened to a fine point so these details are easier to draw. A few of the tones on the sides of the buildings are built up using rendered strokes. If you compare this stage with the previous one, you can see how the addition of the darks has improved the drawing. I should mention that care must be taken when working with litho crayon, as the lines and tones can be smeared easily. To alleviate this problem, I use a piece of tracing paper under my hand while working.

Step 5. I now add the subtle tones on the walls of the buildings. Using vertically drawn strokes, I carefully add lines over previously drawn tones. I slowly build up the tones so that they do not become too dark as it is difficult, if not impossible, to lighten or remove tones. Using horizontally drawn strokes, I add a tone over the tile roof in the foreground. You can see that this technique requires a great deal of patience and control.

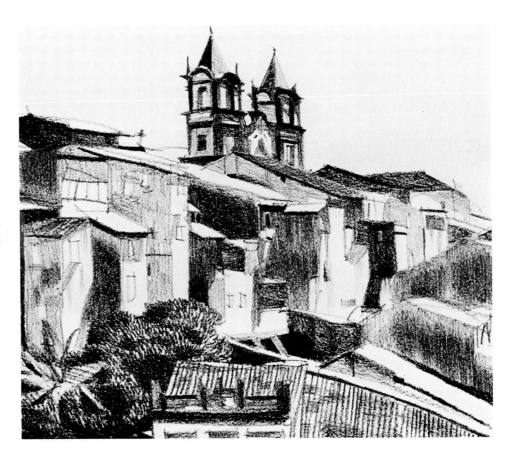

Step 6. I again sharpen the litho crayon to a fine point with a razor knife. With this fine point, I am able to draw in the tiles of the roof in the foreground. I next draw in the tile roof on the church in the background. Then a very light tone is added to the sky, using very carefully drawn horizontal lines that are blended together. A large area such as this cannot be rendered in a hurry as it is time consuming to maintain an even tone. The cloud areas are left white by drawing around them. A few slightly darker tones are rendered around the clouds to indicate the shadow areas.

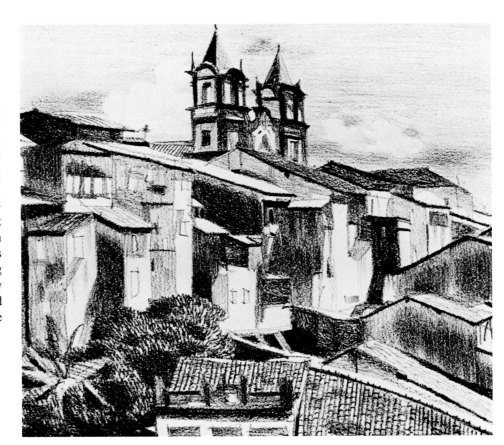

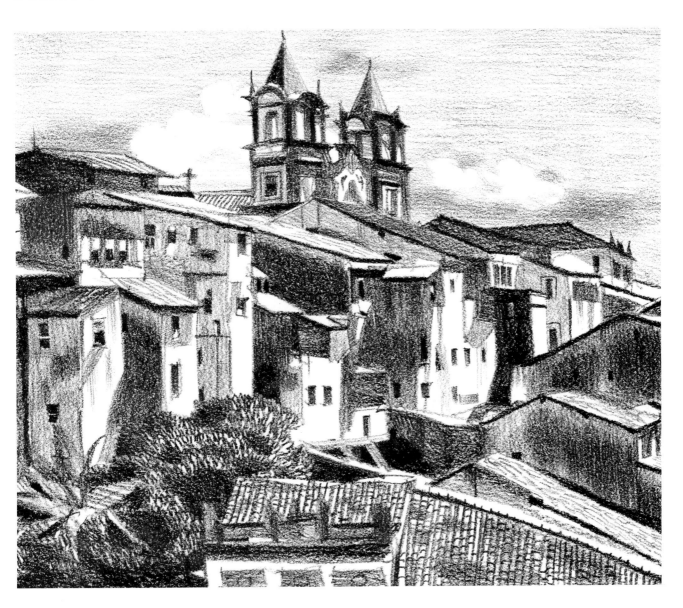

Step 7. I now add all of the details to the buildings, working with a finely sharpened litho crayon to make the job easier. The windows are carefully filled in with tones and some of the buildings are darkened with blended strokes. This is a very crucial stage in the rendering, as I must be careful that the tones do not become too dark. I build up all of the values slowly until I am satisfied that they are correct. A great degree of control is required when working with this technique, so it is best for the beginner to practice doing simple studies of simple subjects, learning to render tones and how to blend strokes. Try still life subjects first, then gradually progress to the more complex subjects. Because of the effort involved with this technique, careful planning is essential. Always do a preliminary drawing or tone sketch to use as a guide before beginning a litho crayon drawing. This is not a technique that is suitable for drawing on location. It should be done in your studio, preferably using photographs as reference material. Black-and-white photographs are perfect as the gray tones have already been established, solving one of the major problems encountered when attempting this type of a drawing.

Step 1. Charcoal pencil drawings combine quite well with other mediums, especially with watercolor washes. Usually the basic drawing is done with the pencil, then the tones are painted in using washes of lamp black. This technique works best when used on watercolor paper, which has a rough surface, but other types of surfaces can also be used. You will achieve the best results with this technique by using textured paper, but even smooth surfaced paper can be used with practice. I begin my sketch by first drawing the obelisk, then the church behind it, adding the various details as I work. A 2B grade charcoal pencil is used to do the drawing.

Step 2. I continue drawing, completing the church. The people in the foreground are drawn next, then the crowds in the background are indicated. The figures are drawn quite roughly without much detail, as my primary aim is to focus on the buildings and keep the people as a secondary element. I next draw in a few of the tones, using closely drawn pencil strokes to indicate the dark areas on the church. A tone is also added to a portion of the crowd. These tones are part of the planning necessary to help guide me when the wash tones are added.

Step 3. Using a soft, flat brush, I wet the sky area with clear water. Over this, I paint a light gray wash mixed from water and a small amount of lamp black. I wash the tone over the area, working around the cloud shapes so that they remain white. The paper must be the right dampness or the washes will blend right into the cloud areas. With practice, you will learn to determine the correct amount of dampness for your own paper. I paint in a light tone over the obelisk, then add darker tones to the crowds in the background.

Step 4. I mix a medium gray tone in a ceramic mixing tray, using water and lamp black. This tone is spotted throughout the crowd to create an interesting pattern in this area. The shadows on the buildings are painted in and I begin to darken the tones on the church. This is all done using a number 8 red sable watercolor brush. You can use a white nylon brush as a less expensive substitute.

Step 5. Using the same number 8 watercolor brush, I paint a medium gray wash tone over the street, leaving the paper showing through in areas to indicate the division lines. This wash was painted in very rapidly so it would be a flat tone without variation. I now draw in some of the details at the base of the obelisk, using the same brush. I paint the darkest shadow tones on the church and also a few of the windows.

Step 6. I mix up a very dark gray tone, using this wash to paint in most of the building details and windows with a smaller, number 5 red sable watercolor brush. These details are freely indicated so that they are in keeping with the rest of the drawing. Since this technique is more of a sketch than a detailed rendering, it requires a spontaneous flair when indications or washes are painted in. When doing drawings like this, no areas or objects should be rendered in great detail, but rather indicated to give the general impression of the scene.

Step 7. I finish the sketch by spotting in a few solid black accents throughout the crowd. With the number 5 brush, I indicate the shoes, pants, jackets, and the pattern on a woman's dress. This finished drawing has the feeling of having been done on the spot, but it actually was done in my studio, using a photograph as reference. I have done sketches using this technique while traveling. I sometimes just do the basic pencil sketch, then add the washes later in the comfort of the hotel room, as it sometimes is inconvenient to carry a water bowl and mixing tray when exploring a new place. Notations about color or tones can be made in the margins of the drawing to serve as a guide. This type of sketch technique can also be useful as preliminary studies from which more finished drawings or paintings can be done at a later date. Practice developing your skills in this technique by first working in black and grays. Later you can attempt the same style of sketching in color.

Step 1. One of the best methods for adding color to pencil drawings is to combine this medium with watercolor. The pencil is used for the outline drawing and a few tones, while the watercolor washes are used for the color tones. The watercolor washes can be painted in very flat with no variation in tone, or blended from light to dark in a more realistic manner. This is one of the best techniques to use for doing outdoor sketches on location. Watercolor paper with a rough or medium surface works best when using this technique because it responds well to washes and stays damp longer, but other papers will also work well. The least desirable are the smooth surfaces. Here I use a dark gray wax pencil on watercolor paper, drawing a simple sketch of the scene.

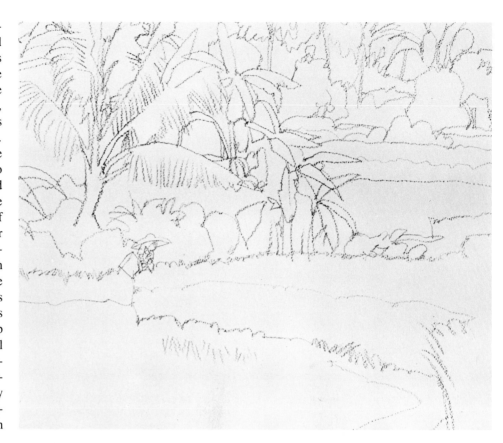

Step 2. I decide to add tones in the foreground that indicate the grass texture as well as the shadow areas. This planning will make the job of adding the color tones much easier. It is very important to draw in these tones, because once these problems are solved I can concentrate on the colors and values when painting. The shadow indications are done with a uniform, medium gray pencil tone. The tone drawn in the foreground area on the shadow side of the field is indicated using curved lines to simulate the grass texture. When comparing this stage with the one above, you will notice that the addition of just a few simple tones has helped to create definition.

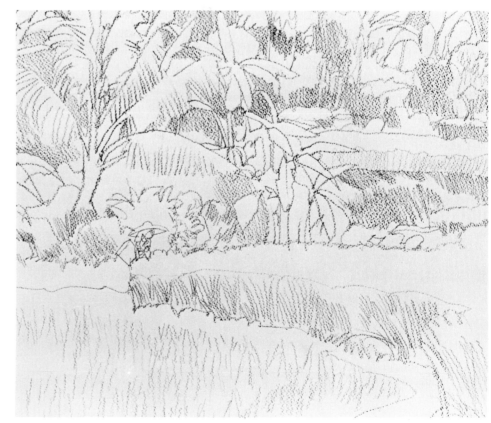

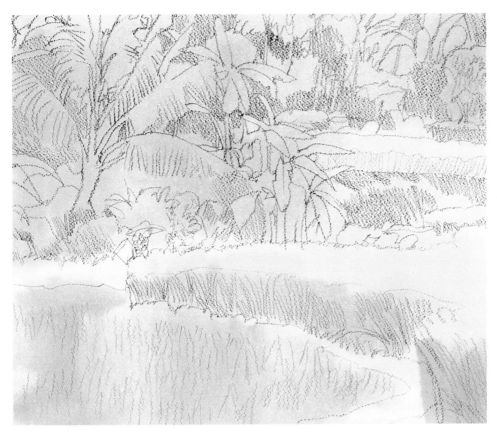

Step 3. I mix a light, lemon-yellow wash in a mixing tray, then paint this tone over the whole background, using a number 8 red sable brush. While the tone is still wet, I paint washes of veridian green over it. I mix a brighter green, using viridian and lemon yellow, which is painted over portions of the background jungle as well as over the foreground grassy area. Before proceeding, I allow these tones to dry thoroughly. Notice that even though these washes have blended together a bit, there are still distinct tone and color differences. Had the paper surface been too damp when the tones were added, the colors would have blended more. If the surface had been too dry, the tones would not have blended at all.

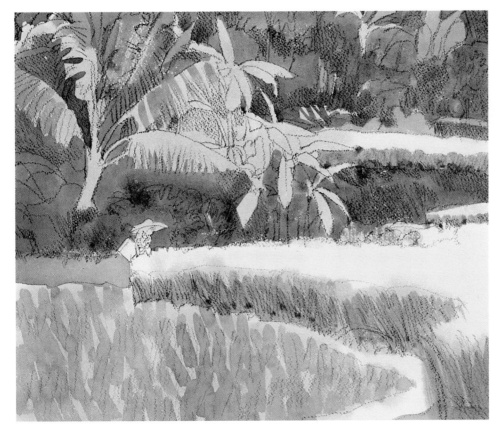

Step 4. I mix Winsor green with lemon yellow, creating a medium green tone, which is painted on the background with a number 8 brush. Notice that I am careful to paint around the leaves and tree shapes so they will be silhouetted against the background. This color was painted in quite flat, but where I have washed it back over certain areas, the tones appear darker. I mix more lemon yellow into this same color and use the resulting lighter green to paint in a wash over the background field, and then spot this same color on some of the sunlit trees in the background. A wash of olive green is used over the shadow edges of the fields in the background and foreground.

Step 5. At this stage, it is important to add the darker tones, so that I can determine whether my color values are correct. The dark tone is mixed from olive green and French ultramarine blue. This color is painted into the background, and as I work I draw with the number 6 brush, indicating shadow areas and indicating tree leaves and foliage to create the jungle effect. As I work, I try to create a feeling of depth while retaining the sunlit effect. Care must be taken not to paint over the areas that are to be lighter so that they are silhouetted against the darker background. Darker accents are painted into the shadow edges of the fields in the foreground and background.

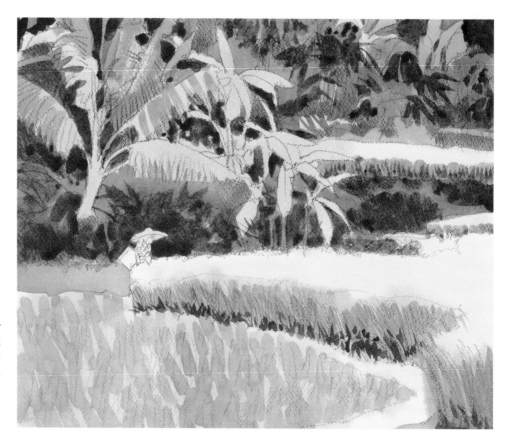

Step 6. Using a mixture of viridian, lemon yellow, and a bit of French ultramarine blue, I paint strokes over the foreground field, accenting the texture. I mix a brighter tone of green from lemon yellow and viridian, and brush it over some of the background leaves and on the field just behind the figure. Using a lighter value of this same color, which I obtained by adding water to the original mixture, I paint over the field in the background and on the field in the right foreground, indicating grass textures. Notice how I tend to work over the whole picture rather than on one area. This prevents overworking and assures unity throughout the rendering.

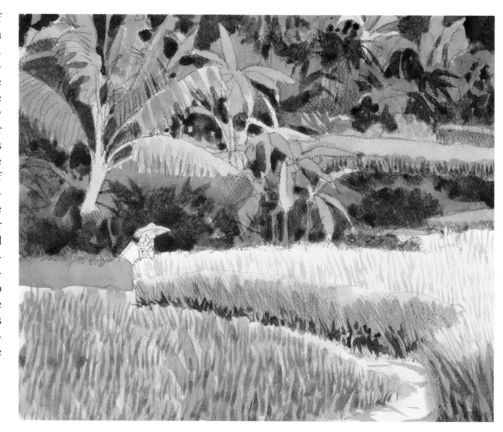

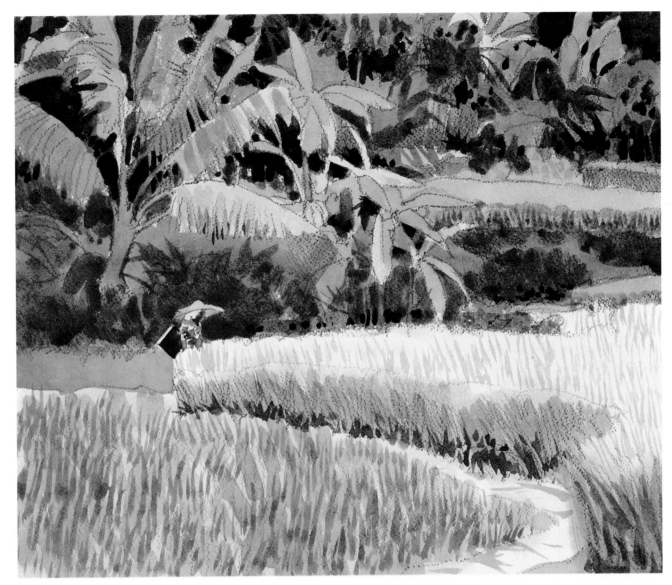

Step 7. I now work on the figure, using vermilion to paint her dress. A tone is mixed from vermilion and lemon yellow, which is used to paint in the hat. A tone is painted on the face, using burnt umber, and the basket is rendered with a dark tone mixed from French ultramarine blue and burnt umber. This near-black tone is painted into the background jungle areas, creating deep shadows that help to accent the sunlit portions of the foliage. Notice how clean the colors are, not overworked or muddy. It is important to try to keep the colors fresh when working with this medium. Much of the jungle foliage has been created through careful work around the leaf and tree shapes, which keeps them silhouetted against the darker background. Notice that the pencil drawing is still an important part of the picture and most of the pencil indications are still visible. The key to doing a successful color sketch like this is to analyze your subject matter carefully and use a limited color palette. Most scenes can easily be broken down to only six or seven basic colors. Too many colors on the palette can be confusing, especially for the beginner. In this scene only seven colors were used, Winsor and viridian green, French ultramarine blue, burnt umber, lemon yellow, olive, and a small amount of vermilion red. With these seven colors I was able to create all of the colors and tones used here by mixing some of them together. This is a very good technique to use when doing outdoor sketches on location. An alternate method would be to do the basic pencil drawing on the spot, then add the color wash tones in the comfort of your studio, using color notes or even a marker color sketch as a guide to work from. It is important that you practice washing color tones on dampened paper, so that you will be able to determine which effects you will want to utilize in your work. Colors blend more when the paper surface is wetter, and blend less as the paper dries. Each type of paper will react differently under similar conditions of dampness. The only way to understand the advantages and limitations of these different paper surfaces is to work on them by practicing painting wash tones. This scene was not painted on location, it was done using photographs taken while traveling as reference.

Step 1. Certain types of colored pencils are not waterproof, so the drawn lines can be dissolved into tones by washing clear water over them. These pencils can be used the same as other types of colored pencils, but their unique quality can be used to advantage. In this demonstration, I use the water-soluble pencils on a rough watercolor paper, which is a good surface for this technique. I start by doing a sketch with a dark gray pencil, drawing in all of the outlines as well as the details on the bridge. Notice that the outlines are quite accurate as far as shapes and proportions go.

Step 2. Using a yellow pencil, I draw a tone over the sky and on the river. I keep the tone uniform using strokes that are about the same weight and fairly evenly spaced. A slightly different yellow, a warmer ochre color, is drawn over the bridge and its towers.

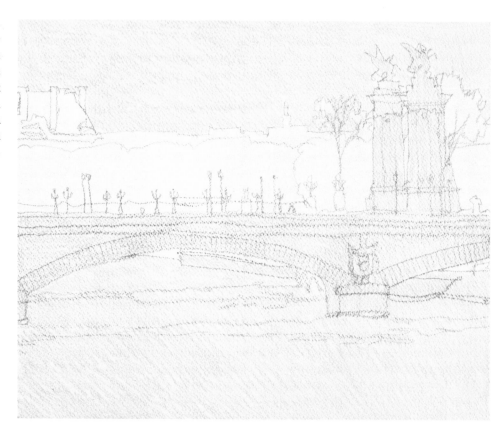

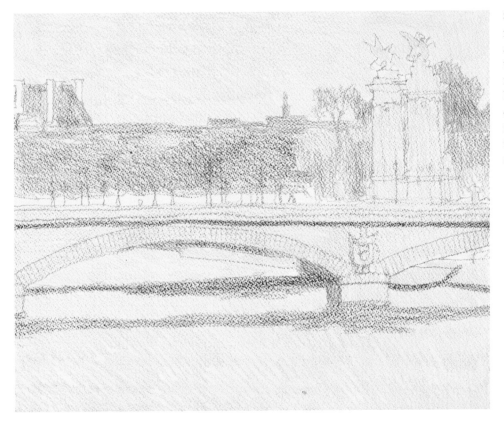

Step 3. A light green color is now drawn over the trees, then an olive color is used over this to indicate the shadow areas. I next draw a gray tone over the background buildings. A darker warm gray is used to indicate the shadow details on the bridge and to define the shadow on the water surface.

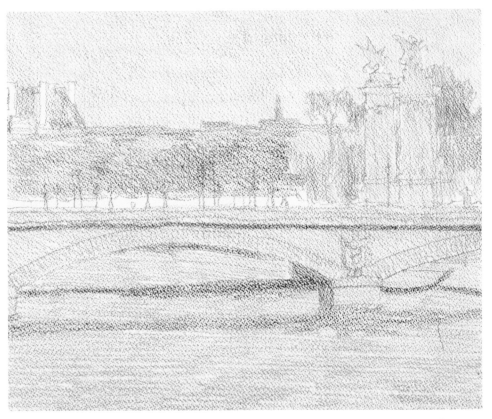

Step 4. I now add a light gray tone over the sky and on the bridge with the pencil. This is done to build up the tones and to subdue the overall yellow cast of the drawing. The tones must be dissolved at this point in order to see if they are the proper values. It is difficult to judge what the values will be after the pencil lines are dissolved, so it is best to build up the tones gradually.

Step 5. Using a number 8 red sable brush, I brush a wash of clear water over the sky area, dissolving the pencil lines into tones. I am careful to work around the buildings and bridge towers, so as not to dissolve them into the sky tone. The river tones are dissolved next, using the same brush with water. The brush is cleaned after each use. After these wash tones have dried completely, I work on the bridge and then over the trees. The tones on the buildings in the background are dissolved last. Notice that I work on the various sections separately, being careful that the tones do not blend together.

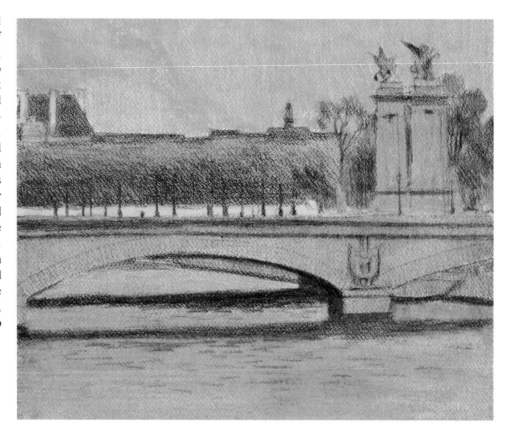

Step 6. More gray pencil tones are added to the sky and the bridge. I strengthen the shadows in the scene, then draw a tone over the bridge with a white pencil, darkening the tonal value and subduing the color somewhat. The details of the bridge have been obscured because of the tonal change, so they are drawn back in with a dark gray pencil. This same pencil is used to strengthen the tones on the roofs of the buildings in the background. The shadows on the bridge and on the tower are also darkened. I work more on the trees by building up and darkening the shadow tones.

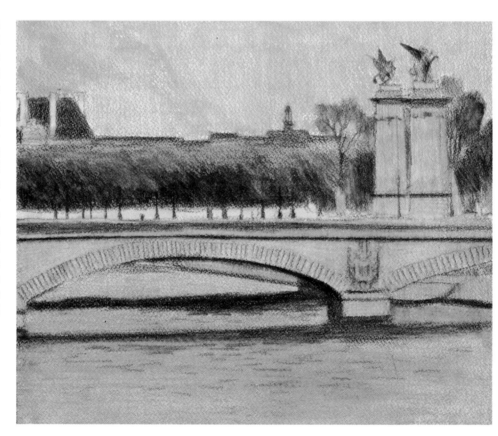

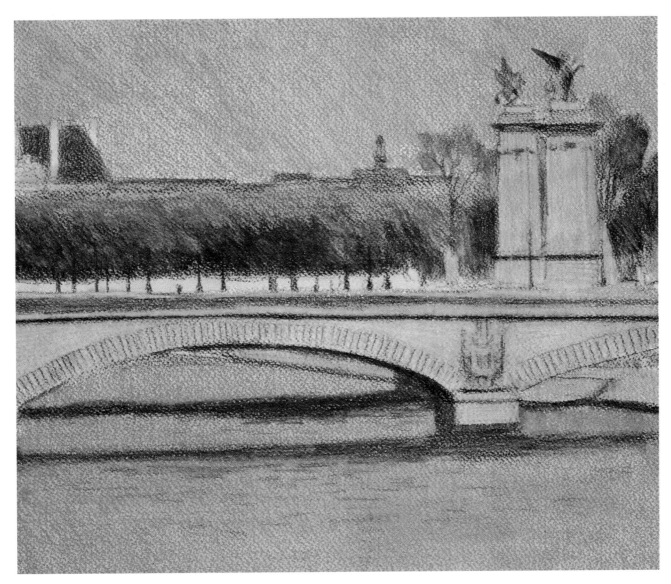

Step 7. To further subdue the overall yellow cast of the scene, I draw in a blue tone over the sky area. The same blue is drawn over the river. Then, over this, I add a subtle pink color, which successfully neutralizes the dominant yellow cast. The blue is also drawn over the area of the trees, and some of these lines are accented strongly. This method of working offers more latitude than one might think. Tones can be removed by dissolving them, then new colors can be drawn back in. How much you can work over the tones on the paper really depends upon the quality of the paper surface. The finest quality papers can take more of a beating than the cheaper varieties. The mounted papers or illustration boards are more suitable for use with this technique as they will not wrinkle or buckle when the surface is dampened.

Step 1. Charcoal paper is very compatible for use with colored wax pencils. The paper's surface texture is appealing and offers a great deal of control when building up tones. When you draw lightly on this surface, the pencil strokes touch only the very top of the surface, creating light tones. When more pressure is used while drawing, more solid tones result because the pigment is forced into the valleys of the paper surface. These effects enable an artist to achieve a great deal of control when building up tones with a pencil. To begin, I draw in the woman's head, keeping the sketch very simple by concentrating on the basic outline shapes and proportions.

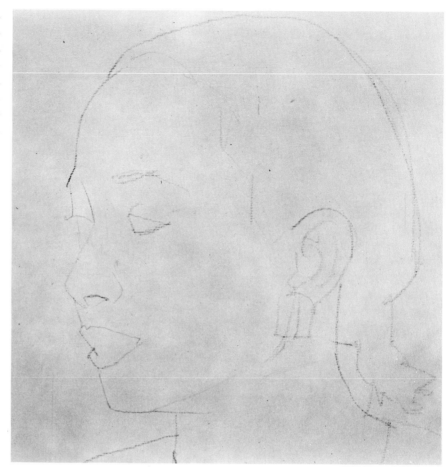

Step 2. To define the facial details, I accurately draw in the eyes, nose, mouth, and ear, using a dark gray wax pencil. The drawing is now more refined, but these important details could not have been positioned accurately without the original blocked-in drawing, which was used as a guide. Now that the proportions and forms have been established, I can concentrate on the colors and rendering without worrying about the basic outline drawing.

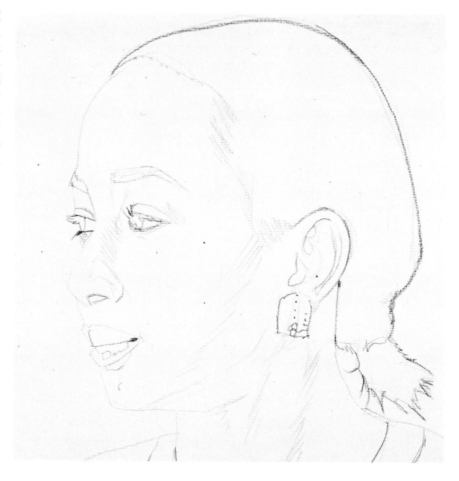

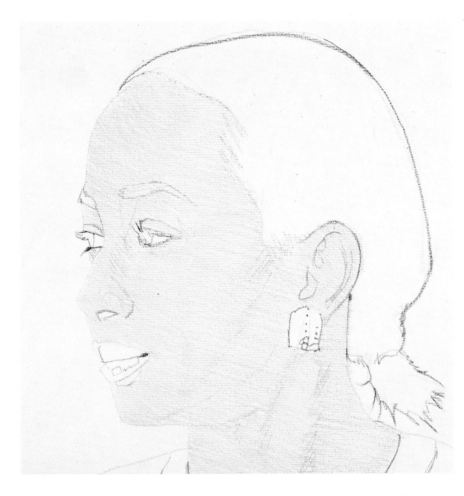

Step 3. The color rendering is begun by first drawing an even tone over the face and neck. This is done with a sand-colored pencil, using horizontally drawn strokes that follow the ribbed texture of this particular paper. Over this tone I use a flesh color, gradually building up the tone. I repeatedly stress the importance of building up tones carefully because working this way will eliminate the possibility of being heavy handed and overworking your drawing. Keep in mind that if the tones are too light, they can always be darkened without any problem, but the lightening or removal of tones is not possible with this technique.

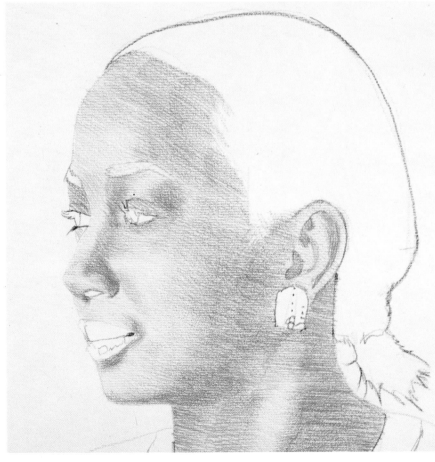

Step 4. With a burnt ochre colored pencil, which is like a dark reddish-brown, I carefully draw in the medium tones, working slowly and using horizontally drawn strokes. Notice that the medium tones have been drawn on the areas of the face that are in shadow. Before drawing in these tones I had to determine just where they should appear. Since this is not a spontaneous technique, but a well-thought-out rendering, more planning is required to accomplish a successful drawing.

Step 5. I add all of the darkest values next, first working on the hair using strokes that create the proper textural effect. These strokes are drawn in with a dark gray, as a jet-black would appear too harsh. The shadow under the chin and on the back of the neck is drawn in with the dark gray pencil. The details are drawn on the ear, mouth, and eyes using the pencil with a finely sharpened point. Details such as the eyes are very difficult to render, especially for the beginner. If the eyes are drawn in only slightly askew, it will be very apparent in the finished drawing. I now color in the lips, using pink with accents of carmine red.

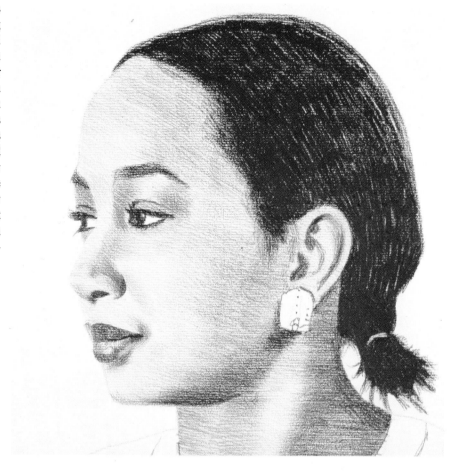

Step 6. The addition of the dark tones and accents has altered the other tones on the drawing, making them appear too light. I darken the shadow tone on the face by using a dark brown pencil. This color is also used on the rest of the face and neck, except where the brightest highlights are, such as the cheek, nose, and chin. An orange color is used over all of these tones to add warmth to the drawing. To further strengthen the shadow tones, I go over these areas with the dark gray pencil, drawing with horizontal strokes until the value has been built up properly. The areas around the eyes and nose are gradually darkened using the same pencil.

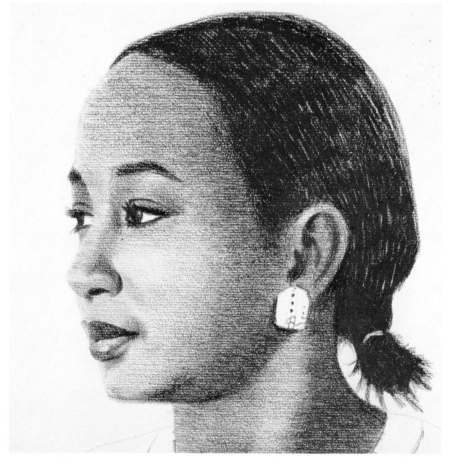

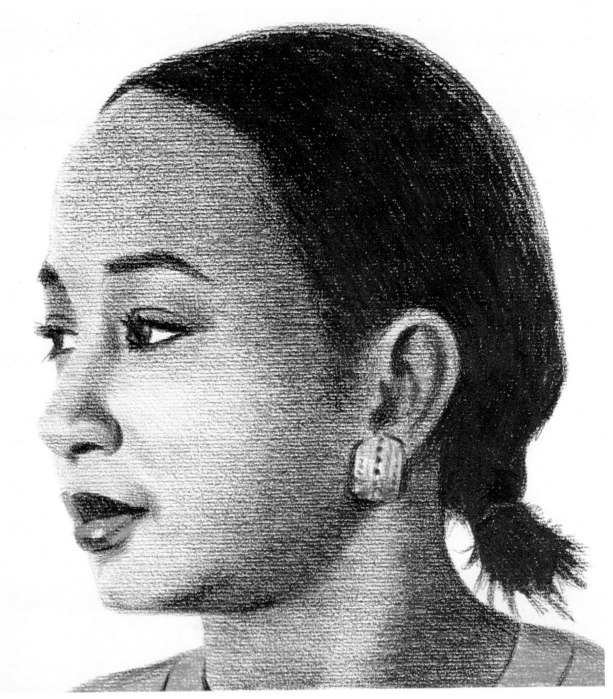

Step 7. The dark gray pencil is sharpened to a very fine point with a razor knife, then used to clean up edges and details around the eyes. This is a particularly crucial stage, as it is quite easy to distort these shapes, which would ruin the drawing. The lips are now brightened using a rich red color, and the area where light reflects on the face is drawn in with a mauve tone. The hair is darkened considerably by bearing down on the pencil while working. A bright yellow and yellow ochre are used on the earring, then its details are indicated with a dark gray pencil. A sky blue color is used on the blouse; the dark accents drawn in with an ultramarine blue pencil. Notice that most of this drawing, except for the hair, has been drawn using pencil strokes that follow the direction of the ribbed texture on the paper. It is easier to render uniform tones by drawing in this direction, as vertical strokes tend to emphasize the textural quality of the paper. I mentioned earlier that pencil strokes can only be built up and not lightened. While this is generally true, sometimes dark tones can be lightened slightly by scraping off the color with the point of a razor knife. To do this properly you must scrape with the knife in the same direction as the ribbed texture to make the scratches less apparent.

Step 1. When doing a drawing on a tinted paper, the choice of the color paper stock is most important. You must determine just what color dominates the scene. On a sunlit scene it might be the blue of the sky or possibly the green tones of the landscape. On an urban city scene it could be gray or tan, but the choice must be made carefully. In the scene that inspired this particular drawing, the sun was quite low nearing sunset, creating an overall warmth in the scene. I decided that the best choice for the background would be a warm, tan-colored charcoal paper. I draw with a dark gray pastel pencil, using a light yellow for the sun.

Step 2. The sun is filled in with the yellow pencil and the reflections are drawn on the water. I smudge and blend these tones slightly with a paper stomp, and then add a few bold strokes of the yellow over the smudged tones. Now I draw in a light blue tone on the water surface, creating the effect of waves. The combination of the blue and tan works very well for the water, as the color of the paper allows me to do less actual drawing. I always try to keep my renderings and indications quite simple, preferring this approach to an overworked or labored drawing.

Step 3. The next important part of the scene is the background buildings. I use a medium gray pastel pencil to draw a flat, even tone over them. Then I use a paper stomp, smoothing out these tones a bit. The pencil strokes remain primarily on the raised texture of the paper surface and with the paper stomp I am able to blend the tones into the paper more. Notice that some of the lines in my basic drawings have been smudged; these can be redefined at a later point. With a light gray pastel pencil I add a light tone to the roof and accent some of the other buildings.

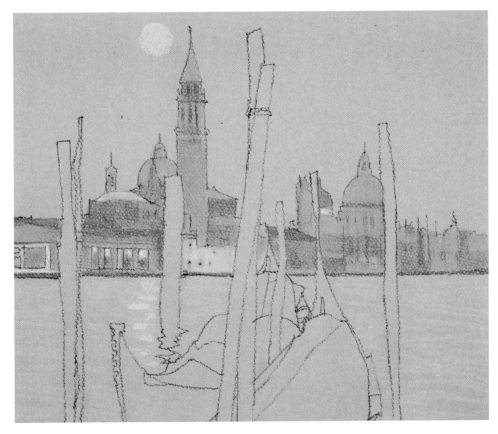

Step 4. With a reddish pastel pencil I render the brick areas on the buildings, using a paper stomp to blend these tones. The stomp can also be used to draw with for soft effects, as after a time the color builds up from use. The darker roofs and shadow accents are drawn in with a dark gray pastel pencil. I blend these tones to soften them. I draw a line across the bottom of the buildings, defining the water edge more clearly. I feel that the color on the sun is too cool, so I go over this with a warmer, cadmium yellow. I also warm up the water reflections with the same color.

Step 5. I now draw in highlights on the mooring posts. This is done using the cadmium yellow pencil. These kinds of accents must be carefully planned, as it is difficult to erase colors from this type of paper. The boats are covered with tarpaulins and I draw in the highlighted areas using a white pencil. Cadmium yellow is used for a few accents. Notice that I am working over the whole picture and not completing any one area. This is the best method to use for drawing—developing the picture overall, rather than finishing individual areas. This way you will be assured that no one element will appear out of place.

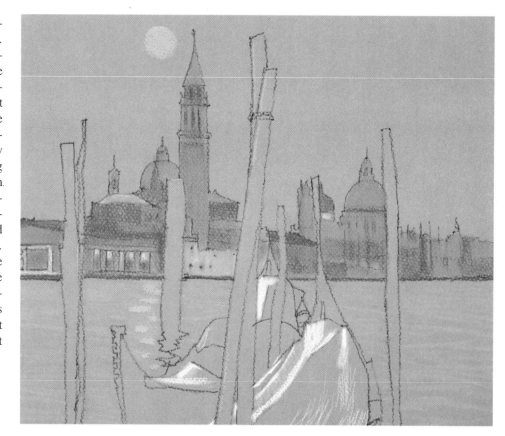

Step 6. I want the foreground portion of the drawing to be silhouetted against the background, so I must darken this area considerably. With a dark brown pastel pencil I draw in the mooring posts, using a black pencil for the shadows and details. I sharpen the black pencil to a fine point so I can draw in the boat shapes more accurately. I first draw in the outline of the boats, filling this in with solid black, leaving a little paper texture showing through. A darker gray is added to the tarpaulin on the middle boat and this is blended slightly with the black pencil.

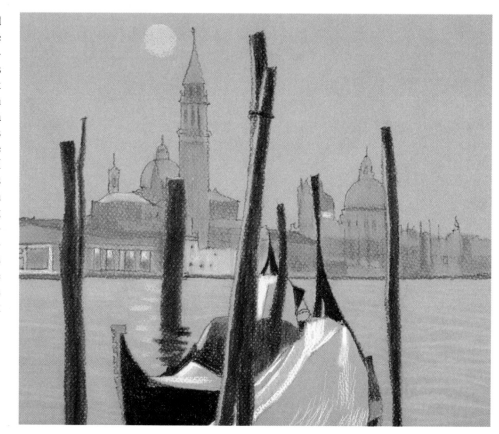

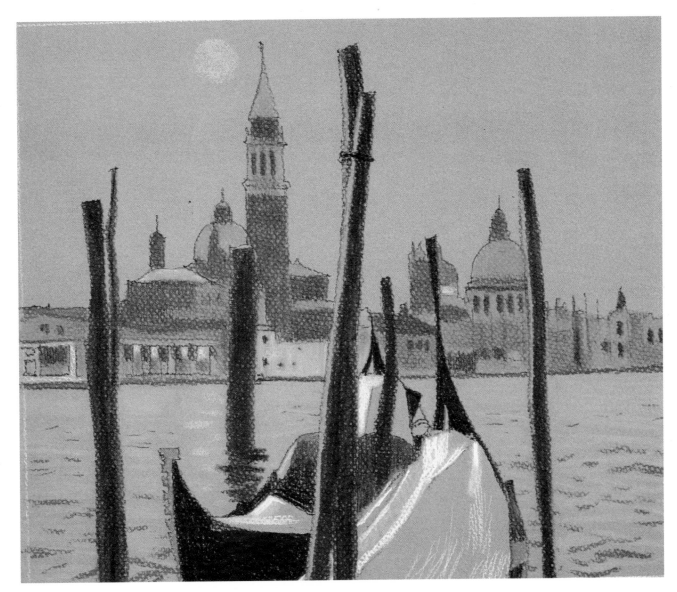

Step 7. Now the finishing touches are added to the drawing. This can be a critical stage for any drawing, as all of your efforts on the various areas of the drawing are now pulled together to form a whole. This is why it is important to gradually build up the tones and values in a drawing. It is much easier to add more tones or to darken certain areas than to lighten or remove them. Also, as you finish more of your drawing, especially a pastel drawing, there is more danger of ruining it through smearing or smudging. Care must be exercised while working; a piece of tracing paper can be used under your hand while you work to prevent smudging. I sharpen a black pastel pencil with a razor knife, then sand it to a point with a sandpaper pad. This is done so that I can render in the finer details on the buildings. The windows and other details are drawn in quite carefully, but now the shadow areas on the buildings appear too light. More often than not, adding tones and accents to drawings will affect other tones, which then must be adjusted by either lightening or darkening them. I use a dark gray pencil to darken the shadows to the proper value. The drawing is completed by adding a few darker reflections to the water surface. Since this kind of drawing will smudge easily, I spray it with fixative, which adds a protective coating. This is a very effective technique and can be used for a variety of subjects. It is especially suited for subjects that appear to have an overall color tone. Determining just which color or tone you choose for the background is a major factor in the success of this technique. Almost any kind of scene is possible as there are many shades of colors available in fine charcoal or pastel papers. These papers also can be used for drawing with colored wax pencils, markers, or even ink. There are other smooth-surfaced papers available in a vast color range, which are also quite suitable for color pastel or wax pencil drawings.

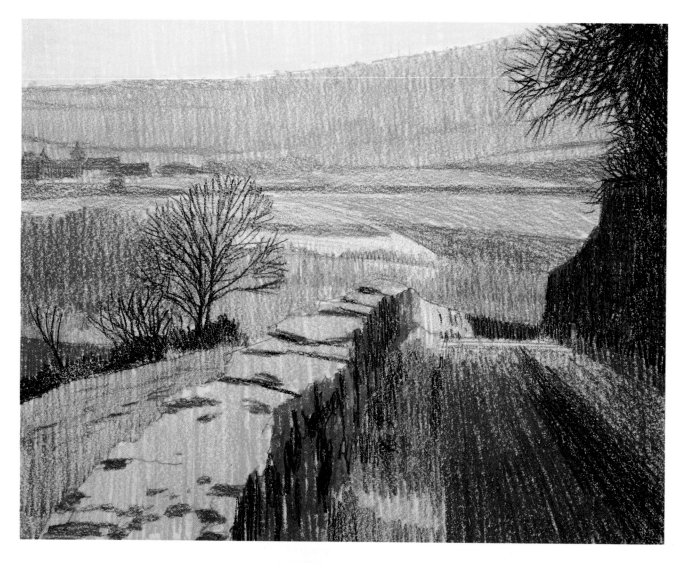

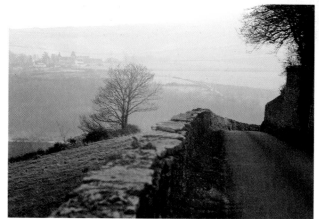

Finding Dominant Colors. Many subjects that you will choose to draw may consist of a wide range of colors as well as many subtle tones. You can begin to learn to simplify colors by first working from color photographs, and as you improve your ability to see you can move outdoors and sketch on the spot. In analyzing this photograph I felt the most important factor was the contrast of the sunlit background against the foreground shadow area, which created an interesting play of warm colors against cool ones. My simplified sketch captures the basic feeling of the scene through careful choice of the colors that were used. Notice that my drawing consists of only seven basic colors: a light warm green, light blue, warm yellow, medium warm gray, dark cool gray, black, and a slight touch of orange. The drawing is enhanced through subtle tonal gradations as well as the blending of some of the colors. For instance, I have used the light blue over the warm green to create the tone on the background mountain. The neutral warm gray color over the foreground area helps to achieve the shaded effect.

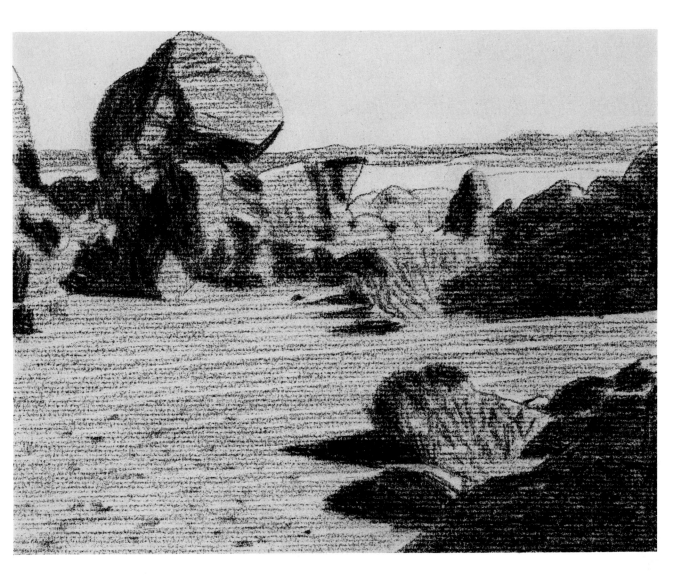

Two Values plus Paper. This drawing consists of two simple tones of gray, a medium and a darker shade. Of course, the white of the paper itself is another important element in the drawing. This sketch demonstrates how a relatively complex scene can be greatly simplified through careful analysis of the reference material or the actual scene. The drawing is done on charcoal paper with a chalk pencil, using the black-and-white photograph as reference material. The lighter tone value was first added to my basic pencil drawing, using evenly drawn horizontal strokes. Then the darker areas were indicated with flat tones, creating a simple, poster-like effect on the finished drawing. A great deal can be learned about drawing and seeing by separating a scene into two or three values. This procedure can also help to make you aware of what *not* to draw, as this type of simplified rendering necessitates omitting many details. Practice this kind of exercise on scenes, still life objects, portraits, and figure studies. When breaking a picture down to simplified tones, remember that the white paper is as important a part of the drawing as the gray tones.

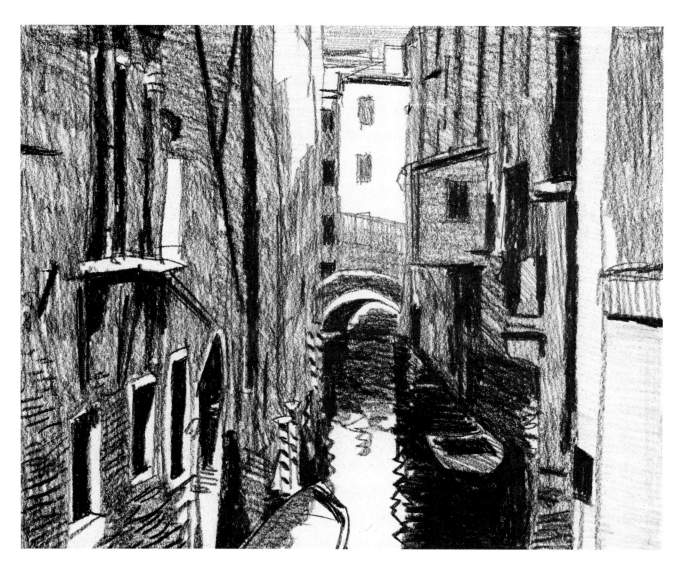

Three Values plus Paper. Here is a complex scene that has been broken down into four distinct values: three tones of gray and the white of the paper. I use a 2B grade charcoal pencil to do the basic outline drawing, then shade in all of the lightest tones on the buildings. This tone is made up of carefully drawn, even lines. The medium gray, which is the dominant tone in the scene, is added by using strokes drawn randomly, changing direction frequently while drawing. Notice that this is a different method of rendering than the technique used for the lighter tone. The darker tone, while still quite uniform, has a different textural quality that adds interest to the drawing. Next, the black tones are drawn in, as are the ripples in the water and the different building details. Just where these different tones are drawn has been determined by carefully studying the snapshot. This kind of planning must be done before any of the tones are rendered on the basic drawing.

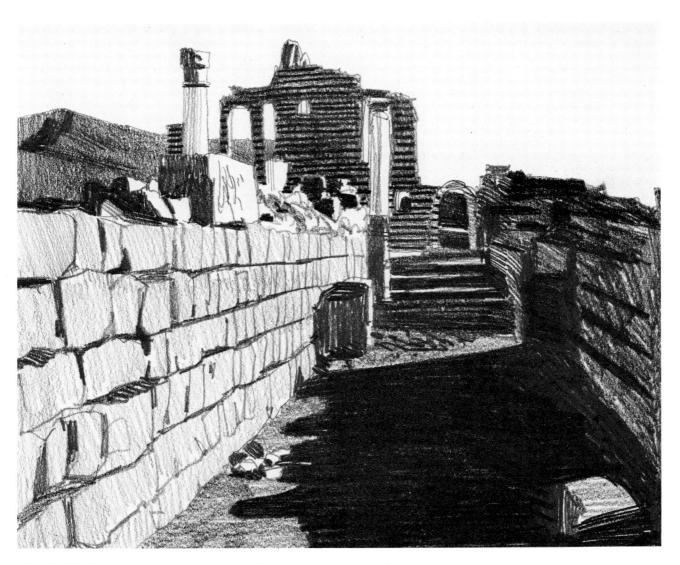

Four Values plus Paper. This drawing is more complex than the previous ones because there are more gray values to deal with. This means even more planning and careful analysis of the photograph or scene. Black-and-white photographs are much easier to translate into simple tones of gray and black, but as you gain experience through practice, you will be able to interpret color scenes into black and gray values. Notice that all of the tones in this drawing have been rendered quite simply and that they separate well. The addition of the stone and brick textures makes the drawing appear more complex than it really is. The drawing is done using HB, 2B, and 4B grade graphite pencils on common drawing paper. The lighter tones were added first with the HB grade pencil; the medium tones, darker tones, and blacks were added next using the 2B and 4B grade pencils. The white sky and other white accents are quite important in this drawing, as they add contrast. Remember that careful planning as well as perceptive analysis of the scene assures a successful drawing.

Step 1. This drawing is done using graphite pencils on charcoal paper. It is a relatively complicated scene that I will break down into three distinct tone values, as well as utilizing the white of the paper. Before beginning the rendering, I must plan just where the various tones will appear, leaving nothing to chance. I start to draw the scene in a diagrammatic form using a 2B grade graphite pencil, sketching in the various elements quite simply.

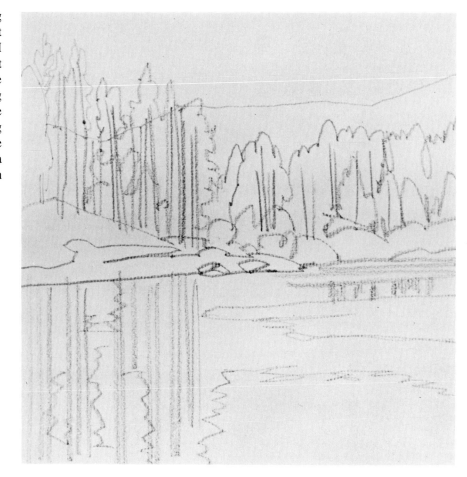

Step 2. My basic drawing, while correctly proportioned and clearly defining the various elements, is nevertheless devoid of any details. These will be added as the drawing is refined. The first tone drawn is the lightest value, which appears on the background mountains. Tones should always be gradually built up from light to dark. I carefully stroke an HB grade pencil over the area, maintaining an even pressure on the pencil while drawing so the tone appears even. I add a few lighter tones to some of the areas on the water surface, using the same method of drawing.

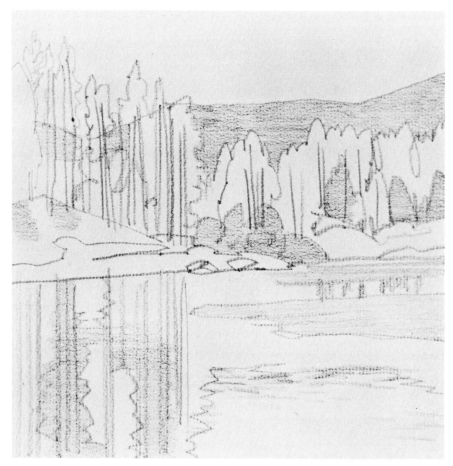

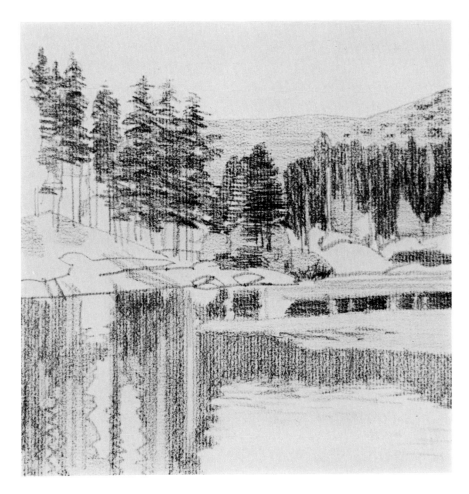

Step 3. The medium gray tone is now drawn on the reflections on the lake, using vertically drawn strokes done with a 2B grade pencil. These vertical strokes follow the texture of the paper, which intensifies the effect. I darken the reflections near the shoreline, using more pressure on the pencil while drawing. Next, I render tone over the trees, keeping the texture fairly smooth by evenly spacing the drawn lines. The pine trees are rendered by using zigzag strokes, which creates the correct effect for the boughs. Some foliage indications are now drawn on the mountain.

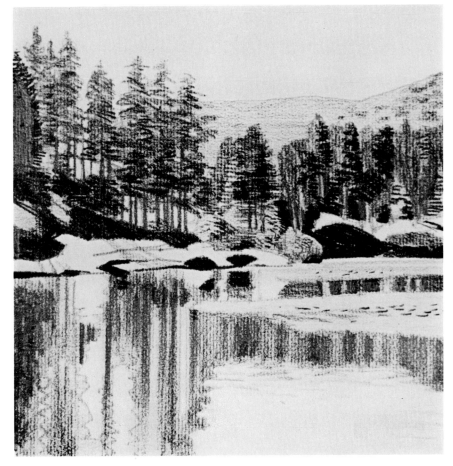

Step 4. Using a soft, 5B grade graphite pencil, I carefully draw in the darkest tones. The dark rocks and patches of ground are rendered and their reflections are also drawn in the water. I darken the tree trunks and add dark accents throughout the foliage area using short strokes to simulate the boughs of the pine trees. I darken the reflections in the water slightly, finishing the drawing. The three tones used here are quite distinct in spite of the blending used in the drawing. Notice how the white paper has been utilized for the snow-covered ground areas and that much of the water and all of the sky have also been left white.

Step 1. Various grades of charcoal pencils are used on common drawing paper for this demonstration. The basic sketch is begun by using a 2B grade charcoal pencil to draw the various elements of the scene. Since this is quite a complicated picture, I draw more of the details than I normally would. The perspective is also critical in this scene, and care must be taken to draw the buildings and bridge correctly. After finishing the basic drawing, I add a very light tone to the sky, using strokes drawn with an HB grade pencil. These strokes are drawn by using the pencil very lightly over the paper surface so the charcoal is deposited on only the raised texture. A tone is also applied to the bridge.

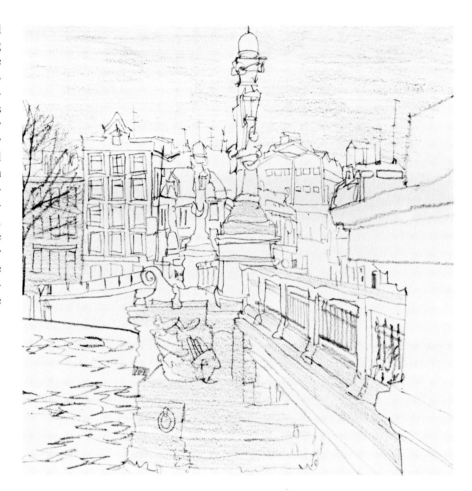

Step 2. Using the 2B grade charcoal pencil, I add a medium gray tone over the sky tone, suggesting cloud formations. Medium gray tones are drawn on the bridge and the lamppost structures. A tone is also drawn on the river, leaving some white accents to serve as reflections. Tones are now rendered on the background buildings and I also begin to fill in a few of the windows with a darker tone. These medium gray tones seem dark; they will appear lighter when the darker tones and solid blacks are added to the drawing. The drawing also appears quite rough and sketchy, but will pull together as more details and tones are drawn in.

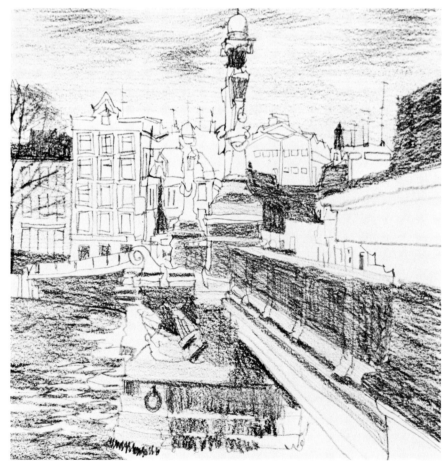

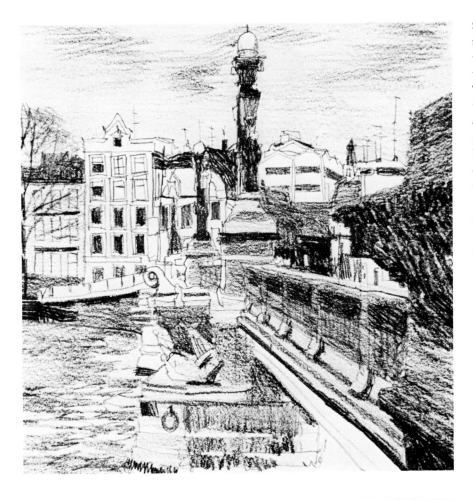

Step 3. The third value in the picture, the darkest gray tones, is now added with the 2B grade charcoal pencil using boldly drawn pencil strokes. The textural structure of the technique used in this drawing helps to unify the overall picture. In other words, I have not combined smudged strokes or highly blended tones with the rendered strokes used in this drawing—the technique is uniform throughout. A few darks are spotted on the lampposts and the shadow area has been indicated on the bridge railing. I fill in more of the windows on the buildings.

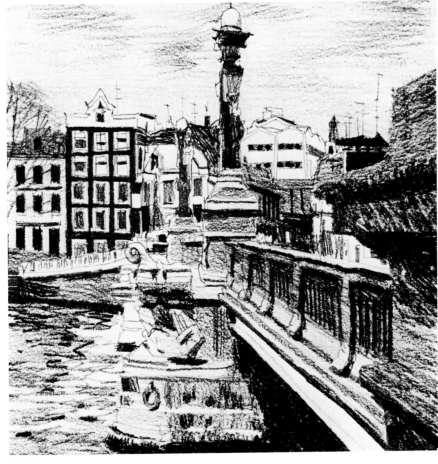

Step 4. To draw the last value, I use a softer, 4B grade charcoal pencil. This pencil is perfect for drawing very black tones, but care must be exercised, because the point can break more easily than the other grades of pencils. Details are drawn on the base of the bridge, and the reflections in the river are added. The shadow under the bridge is drawn next. I sharpen the point of the pencil with a razor knife, then point it with a sanding block to make it easier to render some of the fine details on the railing of the bridge. More details are drawn on the buildings and a few solid black tones are spotted throughout the background, completing the drawing.

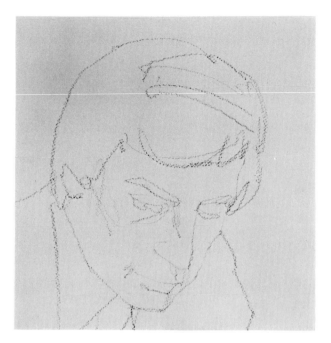

Step 1. With a wax pencil I do a quick, basic outline sketch on rough watercolor paper using boldly drawn lines. I clearly define the elements in the head and face. Some of the areas where the shadows will fall are indicated. Even a spontaneous sketch technique such as this requires planning.

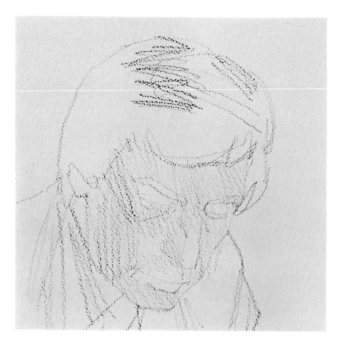

Step 2. A light tone is next added over the shadow areas of the face, using quickly drawn pencil strokes. A light tone is also used on the highlight area of the hair, then shadow tones are drawn on the shirt. These tones appear quite consistent because the same amount of pressure has been used on the pencil while drawing.

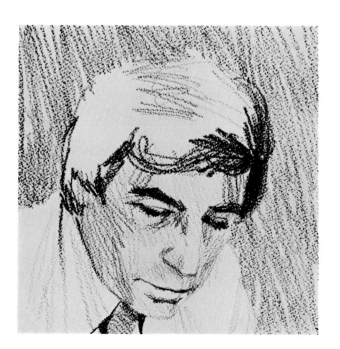

Step 3. I add a medium tone on the background with quickly drawn, scribbled strokes of the pencil. A few of the darker accents, such as the eyes and eyebrows, are used on the face and also on the hair. Care is required when drawing the facial details, so these are delineated slowly. I draw in the shadow area under the tie and collar.

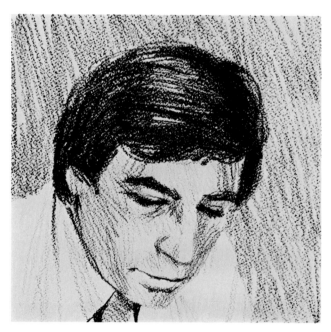

Step 4. The hair is now completed by using more pressure on the pencil while drawing to achieve the dark tone. When drawing the hair I utilize pencil strokes, following the form and shape of the head. I sharpen the pencil to a fine point with a razor knife to enable me to draw in the finer details more easily. Finally, the tone on the left side of the face is darkened for more contrast.

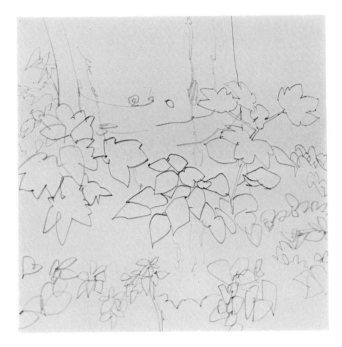

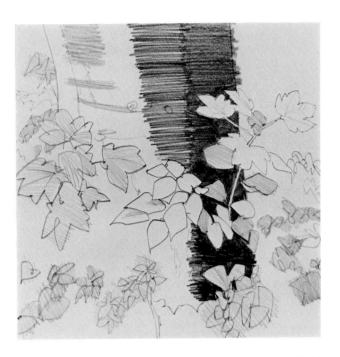

Step 1. Because the hatching technique of drawing usually involves the use of finer lines, the ideal choice of paper is a smooth surface. It is much easier to create evenly drawn, fine lines on this kind of surface. The drawing is started by doing a sketch in outline form, first delineating the tree trunk, then the leaves, and finally the other foliage, using a sharpened HB grade graphite pencil.

Step 2. With a softer grade pencil, the 2B, I indicate the light tones, using lines on the leaves to render the shadow areas. With short, horizontal strokes, I add light tones to the left side of the tree and the medium gray tones to the right side by using more pressure on the pencil. Notice that I am careful to draw around the leaves and the stems, leaving them silhouetted against the background.

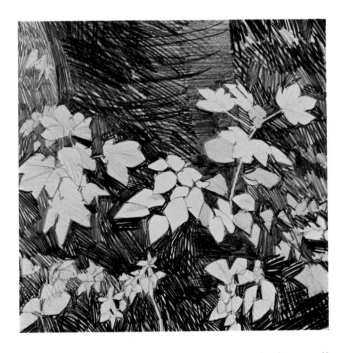

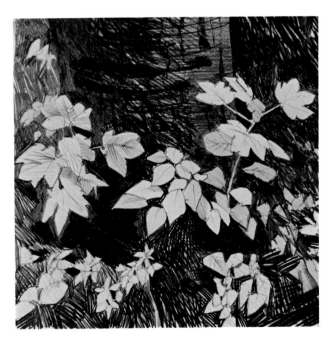

Step 3. Using random pencil strokes, I draw in the overall background. Notice that there is a variation in this tone because different pressure was used on the pencil while drawing. The dark side of the tree is drawn in, also using random pencil strokes, some of them drawn over one another, creating a crosshatch effect. Horizontal curved strokes are drawn over the tree trunk to create a bark texture.

Step 4. To draw in the darkest tones, I use a 4B grade graphite pencil. I add the black tones on the dark patches of the tree trunk and the shadows from the leaves. The white areas in the background are toned down a bit by drawing over them. More darks are drawn on the leaves and deeper shadow tones are added. Notice the variety of hatched tones possible with this technique.

DRAWING ON TONED PAPER

Step 1. This is a very effective technique that can be used for a variety of subjects, but it works best with subject matter that is strongly lit from one side with some reflected light in the shadows because the contrast shows the paper to the best effect. When choosing the background tone of the paper, it is best to use a medium or neutral gray tone rather than one that is too light or dark. I used a textured charcoal paper for this drawing, but a smooth surface would work also. Here I use a black chalk pencil to do my basic drawing, working carefully and making sure that the proportions are correct. I try to accurately draw in the subtle curves that exist throughout the figure. I indicate where the shadow areas will fall, then draw in the base that the model is leaning on, using the edge of a triangle as a straightedge.

Step 2. I now carefully shade in the shadow areas and the hair using a simple, medium gray tone. I then darken this tone in certain areas, such as under her right arm and along the left side of the body. A dark shadow from the model's knee is drawn in and the hair is darkened. The finer details such as the eyes, nose, and mouth are modeled a bit more using a finely sharpened pencil. I usually draw in the shadow areas first when employing this technique, adding the highlights with a white pencil last.

Step 3. Using a white chalk pencil, I carefully begin to draw in the highlights on the figure. Where the highlights appear stronger, I draw in a much brighter tone. Where they are less pronounced, such as on her thighs and stomach, I use a more subdued tone. The strongest highlights are indicated by using more pressure on the pencil while drawing, while the lightest tones are created through using less pressure. Notice how much form this drawing has at this stage even though it has been drawn quite simply.

Step 4. The drawing is now refined more by crisping up the details as well as darkening some of the shadow tones using the black pencil. The darks are positioned on the shadow areas so that they help to create the effect of the reflected light. I use a white pencil to accent the reflected light under her upper forearm. The base that the figure is leaning on is defined a bit more by drawing white pencil strokes over this area, creating a surface. I darken the hair a little, completing the drawing. You can see that using black-and-white tones over a medium gray creates a striking effect with a great deal of form.

Step 1. The best paper surface to use for washes or dissolved tone techniques is a rough watercolor paper. The pencils that can be dissolved the easiest are graphite or wax pencils. This drawing is done on rough watercolor paper using graphite pencils. For the basic outline drawing I use a soft 4B grade pencil, quickly sketching the scene with a few gray tones indicated. The lines help to characterize the various elements. Notice that the smooth, curved lines that depict the beach contrast nicely with the textural lines used to draw the foliage on the mountain. The lines of the bushes and trees not only outline these objects, but create a texture as well.

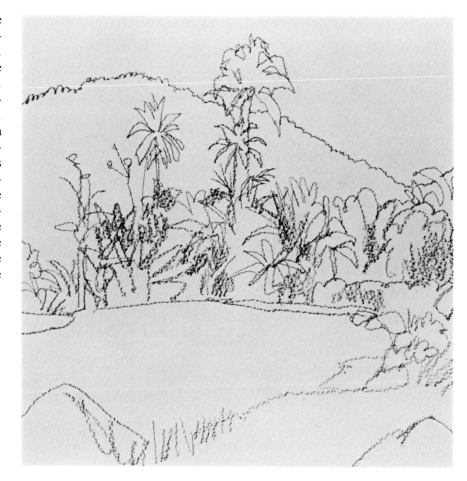

Step 2. With an HB grade graphite pencil, I draw a light tone across the surface of the lagoon using horizontal strokes. Dark tones are added over this light tone using a 4B pencil, indicating reflections. Next, the background mountain is rendered by filling in the area with vertically drawn strokes, using the 4B grade pencil. The horizontally drawn strokes on the lagoon create the feeling of the water surface, while the vertically drawn strokes on the mountain emphasize its height. I indicate a few darker trees, then draw in the foreground grassy area using randomly drawn strokes. The shadow tones are drawn on the rocks in the foreground.

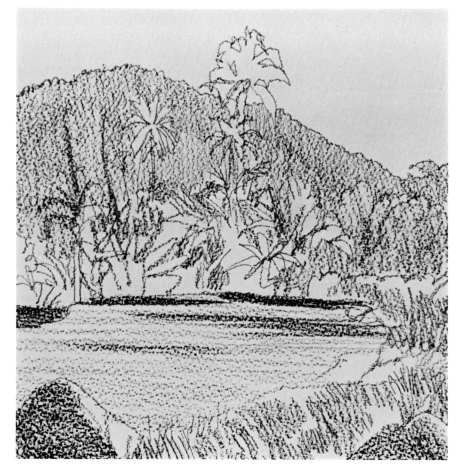

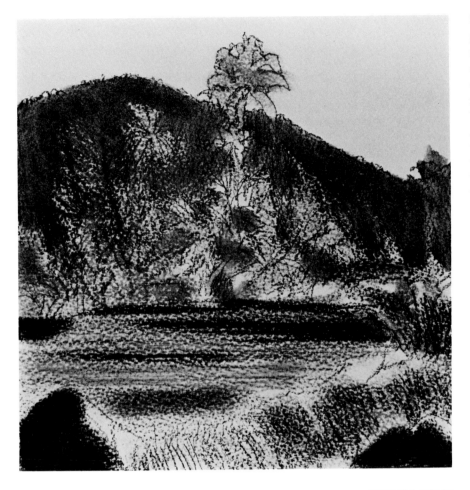

Step 3. I now dissolve some of the pencil tones using a rag that has been dampened with turpentine (a rubber cement solvent could also be used to accomplish this). The tones on the mountain in the background have been dissolved more than the other areas because I purposely used a rag more saturated with turpentine. The tone seems to be too dark at this point, but it will appear lighter as the pure blacks are spotted throughout the area. The tones are less dissolved on the water and on the grassy area because the rag was dryer when used over these areas. The rocks in the foreground are very black because the graphite has dissolved more, filling in the paper texture with solid tone. You should practice this technique to learn how to achieve proper control over the amount of dissolution of the tones.

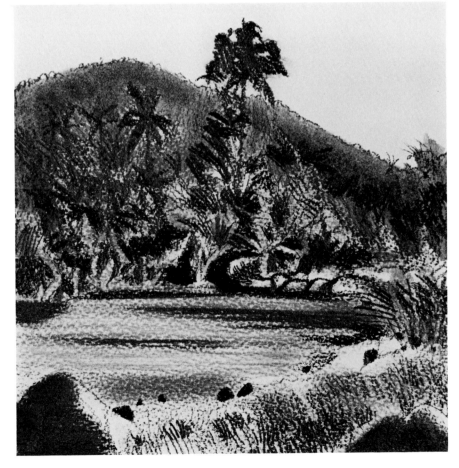

Step 4. The 4B grade graphite pencil is used to draw in the foliage details and the tree shapes in the background. These solid black tones produce definition and form in this area. I draw in some rock shapes along the far edge of the lagoon, then add a few bits of foliage on the foreground beach at the right. A series of smaller rocks, drawn using solid black, helps to separate the beach from the water. This is an interesting technique, one which is well-suited for outdoor sketching and can be used to draw a variety of subjects. It is naturally more suited for outdoor scenes that include trees and foliage than those that include architectural subjects. Portraits and figure studies are also good subjects for this technique.

Step 1. This technique is quite unique as it involves the removal of tones from a drawing with a pliable, kneaded rubber eraser. This type of an eraser can be formed into any shape with the fingers, enabling it to be used to erase small areas or even to create white lines. The charcoal pencil, used on charcoal paper, is best for this technique. I first draw a basic outline, using an HB grade charcoal pencil, then I draw a gray tone over the whole picture area with a 4B grade charcoal pencil. This tone is then smoothed out by rubbing it with a rag. The area on the far right has been left unsmudged so you can see how the pencil strokes were applied.

Step 2. I next add the very dark tone using a 4B grade charcoal pencil by carefully drawing strokes across the paper in a vertical direction. I have kept this tone quite dark and even, but allowed a little paper to show through to create a texture. A solidly drawn, black tone would have no life. In the center and on the left, I add medium gray tones, again using vertically drawn pencil strokes. I indicate the lamp, building details, dark shadows, and the suggestions of figures. The overall effect at this point is of a strongly lit background, framed at the sides and bottom by shadow tones. As I draw, I use a piece of tracing paper under my hand, so that I don't smear the charcoal.

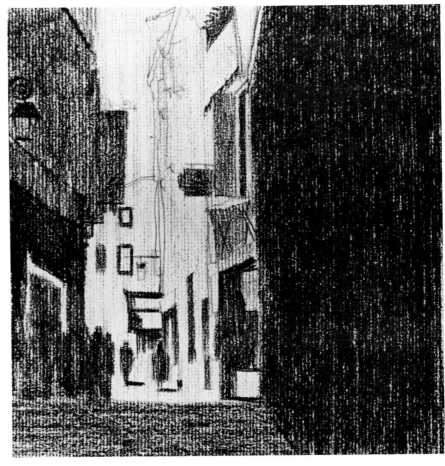

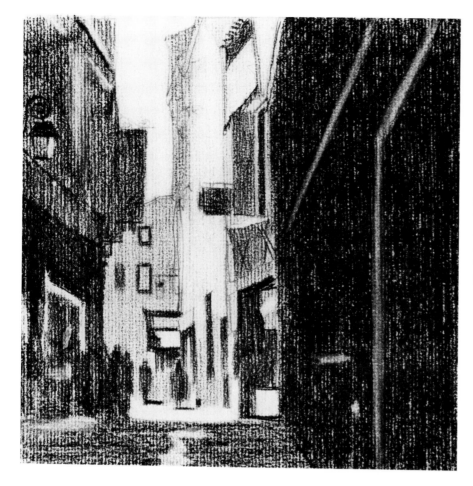

Step 3. I form a kneaded rubber eraser to a point with my fingers and use it to pick out white areas in the tones on the right-hand building, which is the one in shadow. The puddle in the center of the street is also lifted out using the eraser. I remove the tone from the sky as well as the sunlit patch on the street with the eraser. The tone is removed from the building in the center, which is in direct sunlight. The eraser is also used to indicate a few architectural details as well as the reflected area on the street lamp. A slight tone is erased under the group of people standing in the street.

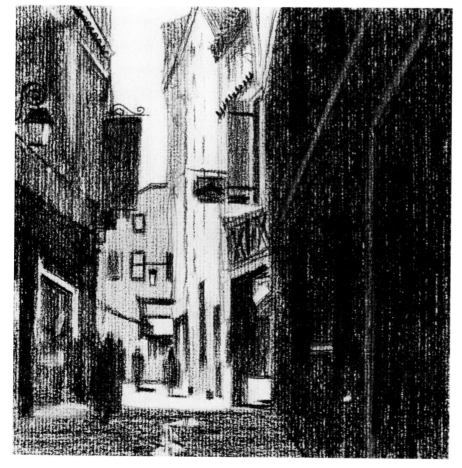

Step 4. I sharpen the 4B grade charcoal pencil and point it with a sanding pad. This is done so that it will be easier to add the smaller details. Using the sharpened pencil, I draw in the windows, mouldings, and other architectural accents, being very careful not to smear the drawing while working. I draw the storefront areas in solid black, then subdue the white erased lines on the right-hand building by rubbing my finger over the area. This type of a drawing may prove difficult for you at first, but practice this useful technique on different subjects. Make sure to study your subject matter carefully before starting—planning just where the tones will be is very important in this type of a drawing.

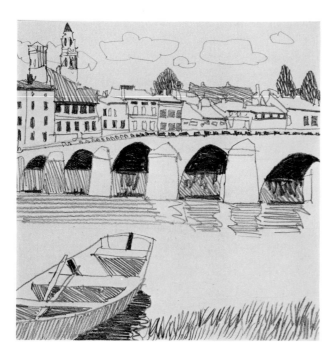

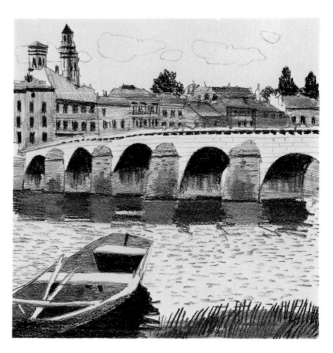

Line Dominates. This sketch is done on common drawing paper using HB, 2B, and 4B grades of graphite pencil. It is basically a line drawing with the tonal areas created through drawn lines, devoid of any blending. The direction of the drawn lines can be quite important as they can suggest planes or textures, as is apparent here on the water and grass areas.

Tone Dominates. HB grade charcoal pencil on common drawing paper was used for the lightest tones, while the medium grays were drawn in with a 2B grade charcoal pencil. All these tones were created by carefully blending the pencil strokes while drawing. Some of the tones were also blended slightly by rubbing them with my finger. The blacks were added with a 4B grade pencil.

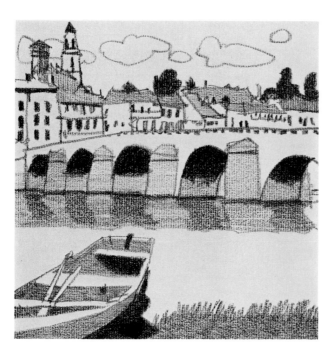

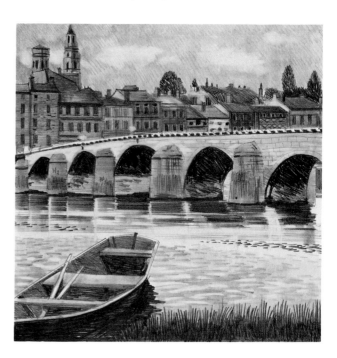

Decorative Style. This highly stylized rendition was drawn with a wax pencil on charcoal paper. I carefully added the light gray tones to my basic outline drawing, then the black accents. The grays are drawn in by lightly stroking the pencil across the paper, using an even, controlled pressure. This ensures a flat tone, which is an important part of the overall effect.

Sharp Focus Realism. For this drawing I use HB, 2B, and 4B grade graphite pencils on smooth paper—the best combination for doing finely detailed work. In a realistic drawing such as this, the tones must be built up gradually by working slowly. After rendering the tones, I carefully blended them using the corner of a paper tissue. The white accents were picked out using a kneaded rubber eraser.

PART TWO

INK
DRAWING

Pleasures of Ink Drawing. Ink is a fascinating medium, one which is simple and encourages bold, direct work. The ink medium, having the definite limitation of allowing the artist to work only in black and white (except, of course, when using colored inks) compels the artist to eliminate the nonessential details and concentrate on the essence of the subject. This is especially true when reducing the drawing to simple lines without tones. The importance and function of line cannot be ignored as it is the basis for most art and a vital part of your work as an artist. Lines can be created with a unique quality; they can be subtle, gentle, graceful, bold, vigorous, agitated, or undulating. Lines can also suggest shape and create mass and form as well. While this book deals with techniques, remember that this is secondary to a good knowledge of drawing, and your first concern should always be in this area. The problems of drawing are closely related to ink techniques, however, and ink rendering is one of the many possible ways to draw. The term drawing covers a wide range of techniques and includes line drawings, tone drawings without line, and any combination in between, including wash tones. Markers also add a whole new dimension to the ink medium and they are very well-suited for doing preliminary sketches for pen or brush drawings.

Drawing Pens. There are many types of pens and holders available. Each type of pen nib has it's own range of flexibility, which enables it to create different lines than other pens. The harder you can press down on the nib, the broader the line you can draw. Certain types of pens, which are designed for doing lettering, are also suited for doing drawings. These are available in a variety of shapes and sizes: flat, square, round, or oval nibs; each one capable of creating unique lines. Certain types of technical and fountain pens, designed especially for artists, can also be used for drawing.

Brushes. The best brushes to use for ink drawings are the highest quality red sable watercolor brushes. Red sable is very expensive, however, so there is a more moderately priced, white nylon substitute. A number 3 or 4 is good for line work and a number 7 is fine for painting washes. A larger flat, wide brush is useful for wetting the paper surface when doing wash drawings (a cheaper brush will serve the purpose in this case).

Inks. You should use black India ink for most of your drawings. It is a permanent waterproof ink. A water-soluble black is also available, which is excellent for adding washes to India ink line drawings. Colored inks are brilliant, creating vibrant tones, and they are a pleasure to use, working well on most papers. Colored inks can be easily used to achieve flat tones, and they blend well. Other paints, such as watercolors, are more difficult to use.

Markers. There are many different kinds of markers and marker pens that are excellent for doing sketches or drawings. Most come with waterproof ink, but some types have water-soluble ink. Both types can be utilized for special effects. Color markers also come in various styles, but the most versatile type has the multi-faceted, wedge-shaped nib.

Introductory Demonstrations. These four-step demonstrations will introduce you to the different ink techniques, covering thin pen lines, broad pen strokes, brush lines and strokes, and drawing with the different markers. Various ways to achieve tone are also shown.

Demonstrations. Eleven major demonstrations are included, each having seven clear, concise steps. I have attempted to show a variety of techniques and the use of different tools on various paper surfaces, illustration boards as well as scratchboard. The techniques covered are pen outline with hatching, using broad pen strokes, varied strokes, pen used with brush, line and wash, wash tones without line, line and colored inks, line and colored markers, and colored ink washes.

Special Techniques. In this section I cover drawing from photographs, and simplifying subjects into two, three, and four distinct values of tone. Techniques such as working with water-soluble ink, drawing on toned paper with black-and-white ink, scribbling, drybrush techniques, and the use of scratchboard are also explained. Various ink drawing styles are also covered in detail.

Pens. There is a vast selection of pens available and each type of nib has it's own unique quality. Some nibs are even designed with a useful ink reservoir feature, enabling an artist to draw longer without refilling. This type of pen is available in several sizes and in four basic styles—round, square, flat, or oval-shaped points—and each is capable of producing unique lines. Normal style nibs are designed to produce fine, medium, or very bold lines; some types are flexible enough to be able to create a wide range of lines using only one pen point. There are also many types of holders available, and some nibs require special ones for proper fitting.

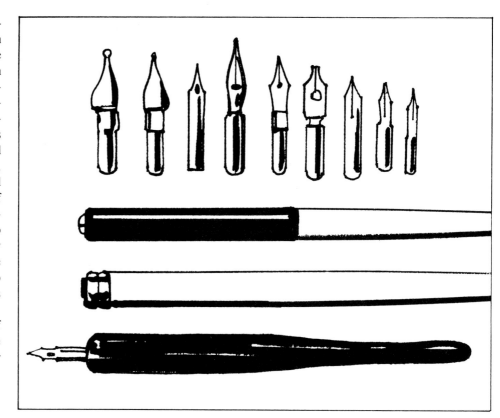

Markers. Markers are available in a multitude of shapes and sizes, and are also equipped with a wide variety of drawing nibs. Some are capable of producing very fine lines, others medium and bold lines, while some are capable of drawing a variety of lines with the same nib. The nibs are usually pointed, bullet-shaped, or of multi-faceted, wedge-shaped styles. The latter type is the most versatile, capable of producing an amazing variety of lines. This type of nib is also the best for rendering large, flat areas of tone. The shapes of the marker pens themselves vary a great deal—some are shaped like regular pens, others are tubular or flat-shaped. Most contain permanent ink, but some use water-soluble ink.

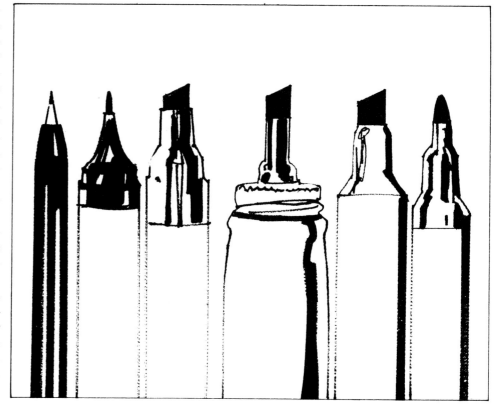

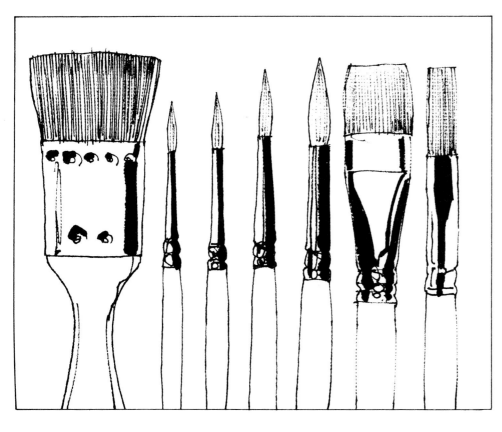

Brushes. The highest quality brushes are usually made of red sable hairs and are quite expensive. These fine brushes are the best, but there is a less expensive, white nylon substitute available. Other cheaper brushes will not hold up very well under prolonged use. Brushes are available in various sizes and shapes: pointed, oval, flat, chisel-shaped, or round. You will find the pointed type most useful for ink drawing because it can draw fine lines. You could start out with the number 3 or 4 and a larger one, number 7. These brushes are very expensive, and must be cared for properly. Another type of brush you will need is a 2″ or 3″ wide, flat camel hair brush, which is useful for wetting large areas or painting in larger washes of tone.

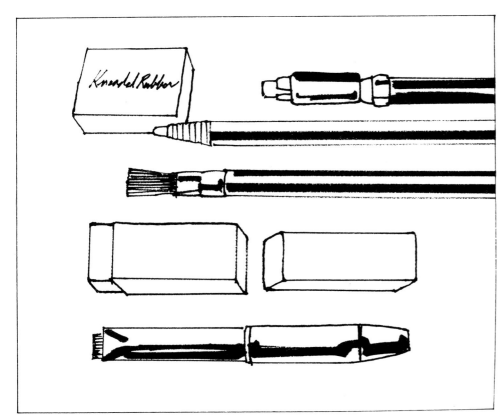

Erasers. There are many good erasers available, and some are capable of erasing ink lines. The handiest eraser for general use is the kneaded rubber type. It cannot be used to erase ink lines, but it is perfect for erasing the pencil underdrawings and can be used to clean up the paper surface after an ink drawing has been completed. Vinyl and soft rubber erasers can also be useful for general cleanup use. For erasing in tight areas, a peel-off type or technical eraser, which uses refills, is a good choice. Some pencil-type erasers are equipped with a small plastic brush for cleaning away eraser crumbs. For touch erasing jobs, such as removing ink lines, the fiberglass eraser is best, but can only be used on more expensive, durable papers.

Common Drawing Paper. The most commonly used paper for drawing has a standard, medium surface texture. It is found in art stores around the world, available in separate sheets or in bound pads of varying sizes. This paper is called "cartridge paper" by the British. Common drawing paper is good to use for pen and brush ink drawings and even drybrush effects can be accomplished on its surface. This drawing shows some of the effects and lines that can easily be achieved using this paper with pen, brush, and India ink. Because the surface texture is very slight, the pen is capable of drawing over the paper in any direction without catching on the surface. For this reason, quickly drawn pen sketches can be also done using this paper. The kinds of quickly drawn lines I am referring to can be seen on the shadow areas of the pears, which were drawn with a crowquill pen. A number 6 red sable brush was used to indicate the black shadows as well as the dark division between the light and shadow areas on the pears. The soft, drybrush edges on the brushstroke-rendered shadows is accomplished by using a brush that is not fully loaded with ink, but rather dry. Most types of pens can be used with this paper surface, and it is well-suited for brush drawings. Average erasers are no problem, but the paper is not durable enough for fiberglass erasures.

Smooth Paper. This paper surface is ideally suited for doing pen sketches as well as highly detailed ink renderings. Most any pen, from the finest to the boldest, will perform very well on this surface. Smooth papers, however, are not as suitable for brush drawings. The smooth surface does not catch or offer resistance to the brush, allowing it to move too freely over the surface. This reduces control slightly. When you become accustomed to the smooth papers, brush drawings are possible, but the surface offers a completely different feel than a textured paper. Even when using the pen, care must be exercised while drawing so the pen will not slip in the wrong direction. To achieve the proper control in this drawing, I drew the outlines of the pears in sections with a common drawing pen, using short strokes rather than a single, flowing line. The real advantage of the smooth surface is that very highly detailed, finely drawn renderings, as well as quick sketches, can be accomplished with ease. Textured surfaces can often cause the pen nib to catch or snag, spattering the ink. In the drawing, the pears have been shaded using very freely drawn pen strokes without any danger of the pen catching the paper surface. The shadows were added with a number 7 red sable brush. Notice that the edges here are much crisper than those on the drawing done on common drawing paper.

Rough Paper for Pen and Brush. While pen drawings can be accomplished on a rough paper surface, it is more suited for use with a brush. Because of the surface texture, a pen can easily catch on the paper causing spattering. If a pen is used on a rough paper, the best approach is to work quite slowly, which alleviates the problem. The advantage of working on a rough surface is that many interesting textures can be created through the use of the drybrush technique. Of course, it is also the perfect surface for wash tones. On this drawing, I first drew in the outline of the pears, working slowly so that the pen would not catch on the surface. The shadows were drawn with a brush. It is much easier to draw a textural line or edge on this paper. To achieve a crisp, hard edge, a fully loaded brush should be used. Practice working with this paper until you better understand its advantages and limitations. You can even learn how to execute quick pen sketches on rough paper after you learn to understand the rougher papers better.

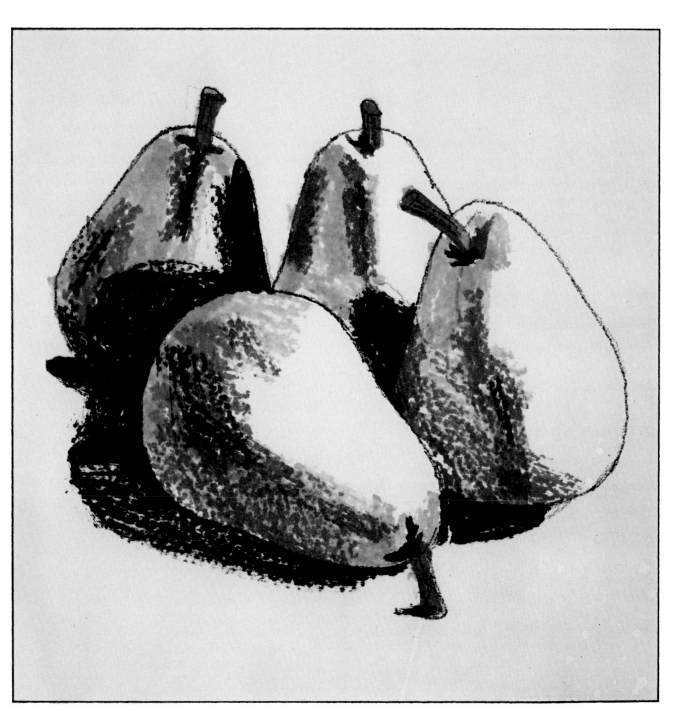

Rough Paper for Markers. While markers work well on most paper surfaces, you may be surprised to learn that they are especially suited for use on the rougher surfaced papers. In fact, the effects achieved are much like those accomplished when doing watercolors. For this drawing, I first did an outline drawing of the pears using a nonpermanent, fine-pointed marker pen. This type of ink will not dissolve when permanent markers are used over it, which is an advantage because the underdrawing will not be lost. Gray markers are used to build up the tones, the lighter tones first, then the darker ones. After building up the tones, the black shadows are added. Notice that the interesting textures in the drawing are quite similar to those achieved using a drybrush technique. When using markers over this surface quickly, a drybrush effect occurs, but when used more slowly, solid tones result. This particular technique is excellent for doing quick studies or sketches outdoors. Marker sketches and drawings should also be attempted on other paper surfaces so that you will understand the different effects that can be accomplished.

Thin Pen Lines. A variety of tones can be created with thin pen lines. Most compatible for drawing with thin pen lines is a crowquill pen, which produces thin lines easily, and a smooth paper surface, because it responds so well to the pen. The tones in this drawing vary according to how closely they are drawn together and if they overlap. Very fine lines and delicate shading are possible with this pen.

Broad Pen Lines. The best type of pen for drawing bold lines has an ink reservoir and a round or oval point. This drawing, done on a smooth surface, utilizes bold, linear strokes of the pen. The pen was used very much like a thick sketching pencil, first sketching the outlines, then adding the form and shadows with quickly drawn pen strokes.

Brushstrokes. For this sketch I used a number 7 red sable brush on drawing paper. This paper has a slight surface texture, which makes it quite suitable for brush drawings. I first carefully inked in the outline of the jugs, then added the tones using brush strokes that follow the form of the objects themselves. The heavy black accents and the shadows were drawn in last.

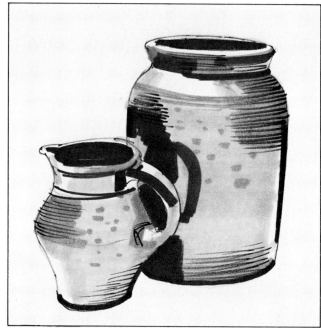

Marker Strokes. This sketch was drawn on common drawing paper using black and two shades of gray. The outline was drawn first with a fine marker pen, then the light tone was added, followed by the darker gray tone. The heavy black accents and shadows were drawn in last, using a bold marker. Notice that without the tone, this drawing would look very much like the broad pen or brush drawing.

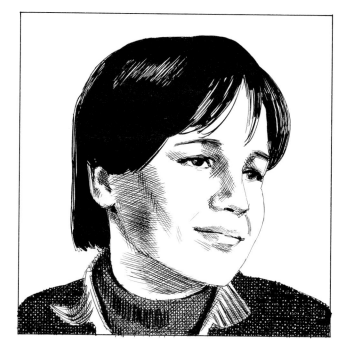

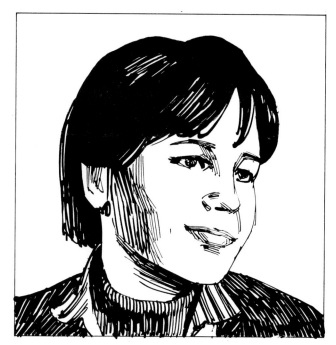

Hatching. This drawing was done on common drawing paper using a crowquill pen for the lines and a brush to render the solid black areas. When drawn over one another in a crosshatch method, lines create tones. Their values are determined by how thick the lines are and how closely together they have been drawn. You can see how thick the lines are in the darkest tones on this drawing.

Varied Line Thicknesses. Drawings can be done using lines of different weights with pens of varying sizes utilized to create these lines. In this sketch, done on a smooth paper, I used a regular pen point for the outline, facial details, and finer shaded areas. A larger, round-pointed pen was used for the darker tones, which required much heavier lines.

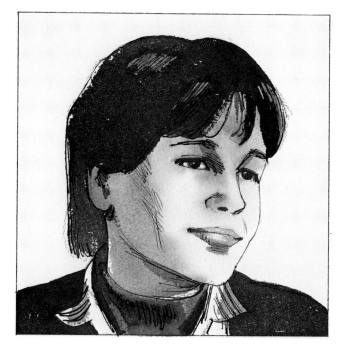

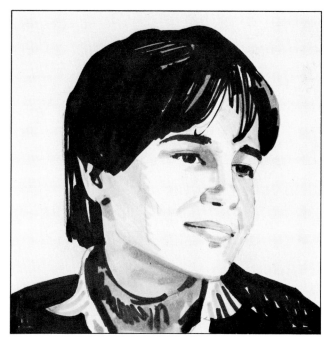

Pen Line and Wash. Water-soluble ink washes are excellent for adding tones to India ink drawings. The best paper to use for this method is rough watercolor paper. The ink is diluted with clear water to the desired tone, then it is washed over the appropriate areas on the drawing. Additional tones can be added or blended over the first wash while the paper is still damp.

Marker Tones. For this drawing, markers were used on common drawing paper. The light tones were rendered first over a light graphite pencil drawing, then the medium tones were added in the shadows and on the sweater. The blacks were added last. Markers are a spontaneous medium and they should be drawn quickly, without overworking the tones, to retain a fresh appearance.

Step 1. Drawings done with a fine pen are much easier to do on a smooth-surfaced paper than on a paper with a pronounced surface texture. When attempting a complicated subject with pen and ink, it is best to first do a pencil sketch on the paper that you will be using. This sketch will serve as a handy guide for doing your ink rendering. Here I use an HB grade graphite pencil for the underdrawing, first drawing in the long branches and vines, then adding the leaves, flowers and other foliage. All are drawn in outline form.

Step 2. Now, using a crowquill pen—the best choice for drawing thin lines—I begin to ink in the drawing using India ink. Uniform, black lines are created with India ink, which dries waterproof. Other inks create lines that are gray and can smudge if not waterproof. Because of the overlapping branches and leaves, this is a rather complicated subject. Great care must be exercised during this stage to ensure a drawing that will not have to be corrected. As this is not a quick sketch, but a detailed rendering, it must be inked more carefully. After the outline drawing is complete and the ink has dried completely, I erase the pencil underdrawing with a kneaded rubber eraser.

Step 3. On the river behind the foliage, I draw a tone, covering the whole background before proceding with the rest of the inking. This tone, with its carefully drawn horizontal lines, is fairly even because the lines are of equal weight and uniformly spaced. To darken the top portion, I add more horizontal lines, some drawn over the others, creating a slight tone variation on the water. Drawing horizontal freehand lines can be difficult for the beginner, but practice will help you master this in a short time. The lines used for a tone like this need not be perfectly drawn, as you can see in this drawing.

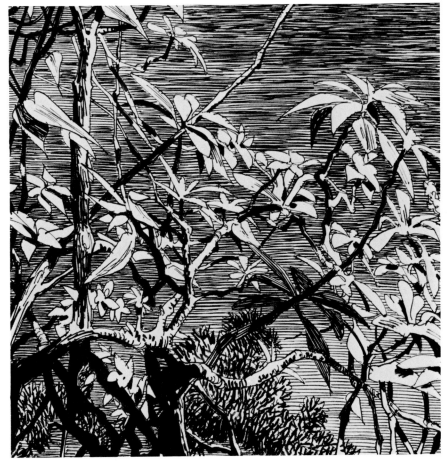

Step 4. Using the pen, the darkest tones are added to the branches, filling them in so they are solid black. This also can be done with a brush. I wait before continuing, as it takes some time for the ink to dry completely. The background tone appears too light, so another series of lines is drawn over the area, darkening the tone sufficiently. I also darken the upper area of the water by drawing in more lines, many of which overlap, creating a rippling effect in the river. Using short, zigzag strokes, I draw a leaf-like texture over the bushes. The leaves in shadow are drawn and some texture is added on the bark of the thicker branches.

Step 1. Planning is an important part of any ink drawing so I begin this scene by first doing an accurate pencil sketch with a 2B grade graphite pencil on common drawing paper. Because the scene has so many elements, the pencil underdrawing will be invaluable when doing the ink rendering. Notice that in my pencil drawing it is quite easy to determine which areas are the rocks and which consist of foliage covered areas. This is clear because of the different lines used to delineate the various elements. The squiggly lines are easily identifiable as foliage areas. When drawing the rocks in the foreground, I have indicated the division between light and shadow.

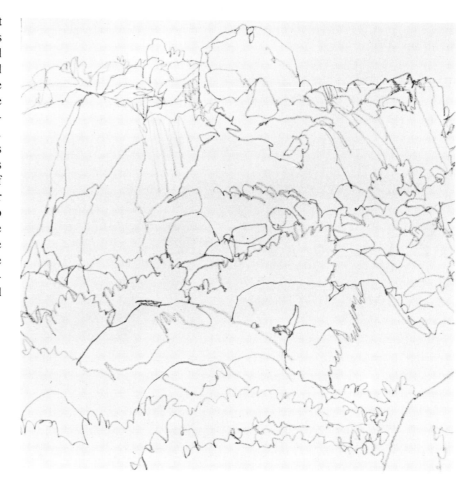

Step 2. There are several types of pens suitable for drawing bold lines. Some pens are equipped with an ink reservoir, which holds more ink, enabling an artist to draw longer without refilling. Some of the choices of points are round, oval, flat, square, or chisel-shaped. Some normal pens are quite flexible and can also be used to draw bold strokes. I decide to use a pen that has a flat, chisel shape. This will enable me to draw bold strokes as well as finer ones, depending on which way the pen is held while drawing. I ink in the basic drawing using the flat edge of the pen, which creates bold lines. Some of the shading on the rocks is done using the pen in a manner to draw finer lines.

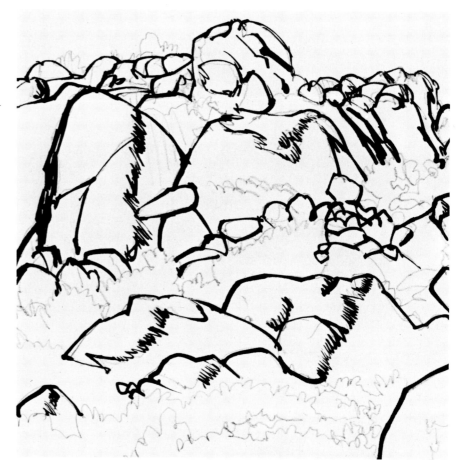

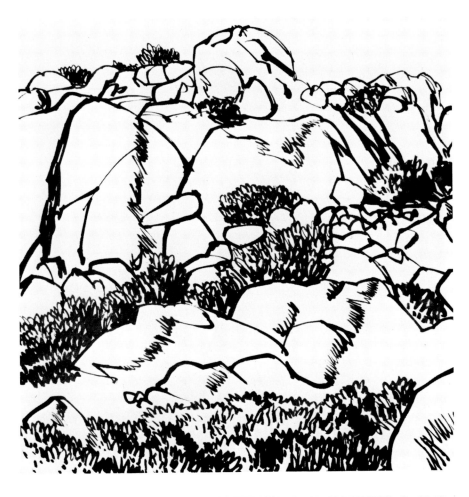

Step 3. The tone is now added to the foliage covered areas, simulating the texture of leaves by drawing zigzag strokes. I have also spotted black shadow areas throughout the foliage. Because the ink has built up in these areas, I must be sure it has thoroughly dried before continuing the rendering. The scene is now developing, with all the rock formations and foliage areas clearly defined. When the ink has dried completely, I erase the pencil underdrawing with a kneaded rubber eraser.

Step 4. I add the medium gray shadow areas on the rocks, drawing with the pen in a horizontal direction to create finer lines. Many of these lines are drawn so they follow the form, which helps to create the illusion of depth. When drawing these tones I began at the top and worked down, eliminating the possibility of smearing the freshly inked lines. I next add some textures to the rock formations using short strokes and dots of ink. Then the foreground grassy area is finished by drawing with short vertical strokes. The shadow areas are darkened by drawing overlapping pen strokes. Notice that much of the outline that was first drawn has disappeared, the various elements separating through tones.

Step 1. Drawing with a brush and India ink is possible on most papers, but I prefer a rough surface so that the textures can be utilized as part of the picture. When doing brush drawing you should use only the finest quality brushes as the cheaper ones are difficult to use and will not hold up very well. For this drawing I use a red sable number 4 watercolor brush with India ink on a rough-surfaced watercolor paper. Before doing the inking, I first do a pencil sketch of the scene with a 2B grade graphite pencil. This drawing is done quite simply, but depicts the scene accurately.

Step 2. Using the number 4 red sable brush with India ink, I carefully begin rendering over the pencil sketch, outlining the various elements in the scene. I spot in a few shadow areas on the ground and on the rocks, then add the pine needles to the trees by drawing short strokes with the brush. I indicate some bark texture on the trees using less ink in the brush, resulting in a drybrush effect. This same effect is utilized when drawing in the division separating the light and shadow areas on the large rock. The foreground bushes are drawn in and shadow areas are also indicated.

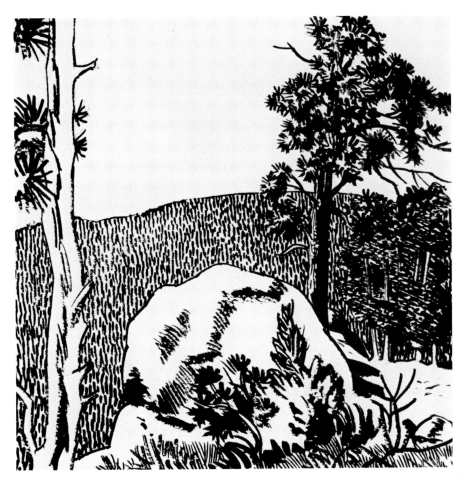

Step 3. I draw in the foreground grass using finer brush lines. Then, over the background mountain, I draw a series of vertical strokes to depict the texture of the distant trees. I next draw a leaf texture over the trees on the right side of the picture, and the shadow areas are drawn over this tone. Notice that I have been careful not to ink over the tree trunks, letting them remain white. I draw all of the foliage and shadows on the large pine tree on the right, then the trunk of the tree is rendered in shadow. The picture is developing well at this point, and is almost completed.

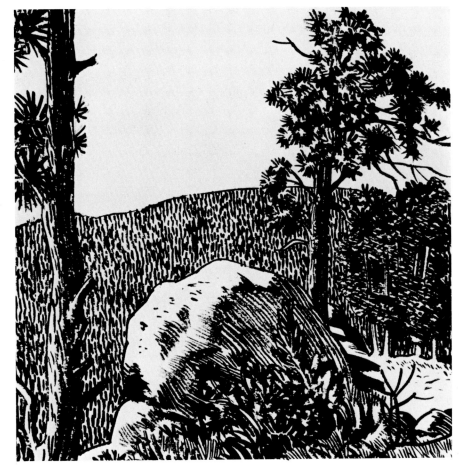

Step 4. I now draw the shadow area on the large boulder in the foreground, using carefully inked lines that follow the form. I darken the division between the sunlit area and shadow using a brush more loaded with ink to achieve a dense black. Details are drawn in the foreground bushes, completing this area. Next, I darken the tree trunk on the left, leaving a little paper texture showing to create the effect of bark. I also add brush strokes on the sunlit side to simulate the ridges of the bark. I add more strokes to the mountain in the background to create a variation in this tone. Notice how all of the different textures used help define the various elements.

Step 1. Marker pens are very handy drawing tools that can be used on most paper surfaces with ease. The pen used for this drawing is the type with a medium sized fiber tip and nonpermanent ink. The tip is firm, but soft enough to make it possible to draw lines that vary in weight. The basic line drawing is done directly on smooth-surfaced paper with the marker pen.

Step 2. The medium gray tone on the background wall is now drawn using random strokes while working, simulating the unevenness of the wall. While the lines are drawn freely, I am careful not to render over the door area. The wood grain texture is drawn on the wooden door. This obscures the lines that separate the wooden boards, so I redraw them, using heavier lines.

Step 3. The top section of the door was constructed of darker wood, so this area is drawn with closely spaced lines to create a dark tone. Some of the stones in the wall are also dark, and are drawn using a crosshatch effect. The use of these various textures will help to clarify the different elements in the drawing. The dark beam is drawn above the door.

Step 4. Shadows are added around the door, and under the hinges and door latches. A bit of texture is added to the wall area, finishing the drawing. The marker pen is a perfect drawing tool for outdoor sketching as it carries its own ink supply and doesn't need sharpening like a pencil. Try out a number of types until you find the size and tip you prefer drawing with.

Step 1. Broad-tipped markers are available in a variety of styles. For this demonstration I use a bottle-shaped marker with permanent ink and a multi-faceted, wedge-shaped nib— a very versatile drawing tool. I begin by first doing the basic drawing with a 2B grade graphite pencil on common drawing paper. The foreground tree is drawn first, then the background is added.

Step 2. It is impossible to draw fine lines with this marker nib, so the drawing is inked in with boldly rendered strokes without many details. Different weights of lines can be achieved by using the various edges of the wedge-shaped marker nib. The thinnest lines on this drawing were done by using the very front edge of the nib, the heaviest lines were done using the widest edge.

Step 3. Using the broad side of the nib, I draw in the middleground underbrush areas. These appear quite dark, but some paper texture is left showing through. I next add tones to the buttes in the background, indicating the shadow areas by using linear strokes. More bushes are spotted in by drawing short strokes with the widest edge of the nib. I erase the pencil underdrawing with a kneaded rubber eraser.

Step 4. I now darken the upper branches of the tree so that they are silhouetted against the background. More darks are added to the middleground bushes and dot textures are drawn on the ground to simulate stones and rocks. This is a very fast sketch technique that can be used to draw just about any subject, but you must work in a simple, bold manner, without drawing many details.

Step 1. I begin by doing a basic outline sketch using a 2B grade graphite pencil on common drawing paper. This drawing is done quite simply, but all of the elements in the scene are clearly defined, including many of the details such as the branches on the large tree, the windows, and the gutters on the houses. The irregularities on the foreground wall have also been indicated by roughly outlining these areas. Careful planning is mandatory before beginning the ink rendering, as a well-thought-out preliminary pencil sketch will make the job of inking much easier.

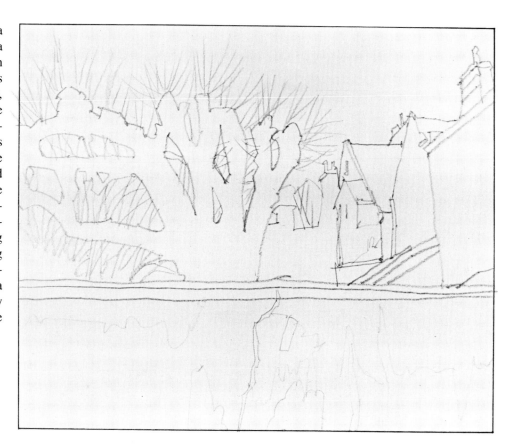

Step 2. Using a standard pen nib in a holder, I begin to ink the pencil drawing by outlining the various elements. I draw rather freely, taking care not to actually trace the pencil underdrawing to prevent the finished rendering from looking labored or too rigid. At this point the ink outline is completed, but I do not erase the pencil underdrawing lines. They will still be useful as a guide for rendering the tones.

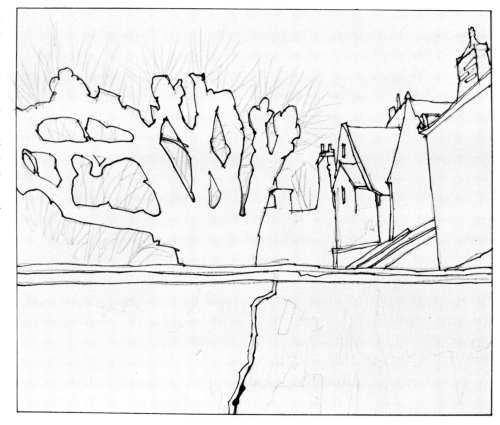

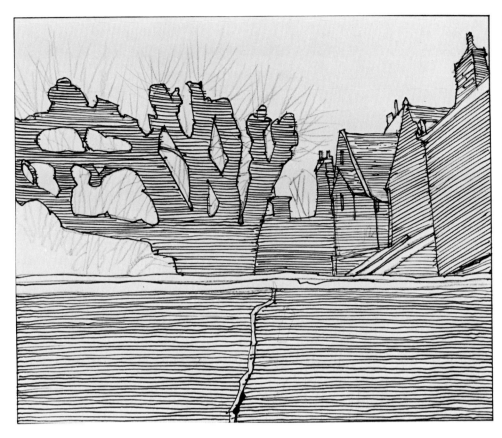

Step 3. Next I add a light tone to most of the drawing, using carefully drawn horizontal ink lines. The lines are parallel but freely drawn, as it is unnecessary to be too precise when drawing this tone. The reason for this is that other lines will be drawn over this tone and any unevenness will be negligible in the finished drawing. On the houses at the right side I have drawn the lines that follow the perspective of the buildings, helping to create the illusion of depth in the picture.

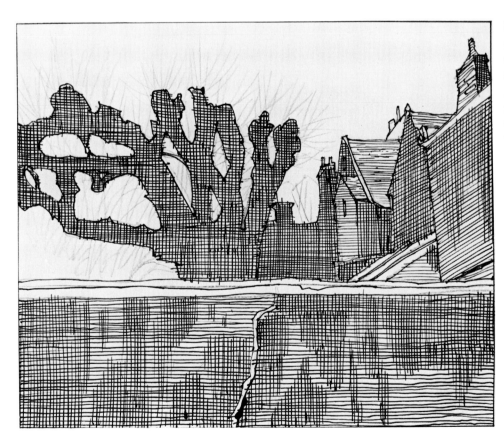

Step 4. When utilizing the crosshatch technique, tones are built up by drawing lines over one another at right angles, creating a new tone that is twice as dark as the first tone drawn. The newly drawn lines must, of course, be drawn about the same weight and the same distance apart as the first group. On the areas where I want a darker tone, lines are drawn perpendicular to the first group, creating the tone. I allow these lines to dry thoroughly before going on to the next stage.

Step 5. I decide to darken the tone on the tree, the buildings, and certain areas of the foreground wall. To achieve a third value, a darker tone, another group of lines is drawn over those previously drawn, but this time they are drawn at a forty-five degree angle. Working with this technique enables an artist to exercise a great deal of control when building up tonal values. The values are determined by spacing of the lines and how thickly or thinly they are drawn. As a rule, lines spaced closely together create a darker tone than lines spaced further apart. Continuing the rendering, I now add incidental textures to the buildings using short pen strokes.

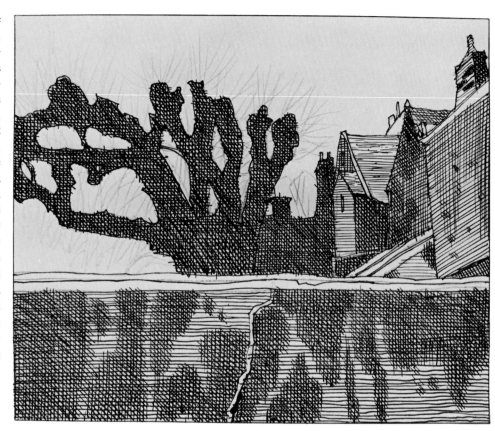

Step 6. The tree is darkened more by drawing another group of lines over those previously drawn. These are again drawn at a forty-five degree angle, but this time from the other direction, that is, from right to left. Next, I begin to build up some of the tones on the wall in the foreground by drawing short strokes over these areas. Some of the darkest accents in the scene are now added to the windows, roof shadows, and the shadow of the tiles on the top of the foreground wall. The addition of these black accents will help me to judge the gray values in drawing better.

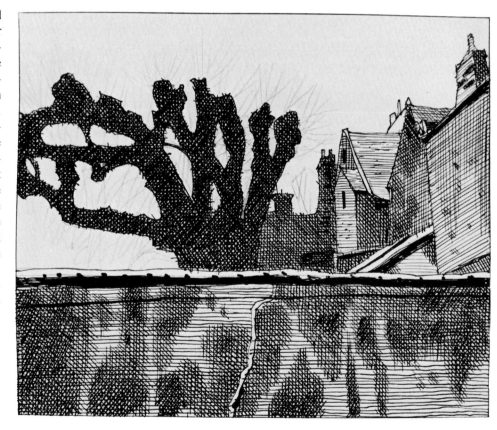

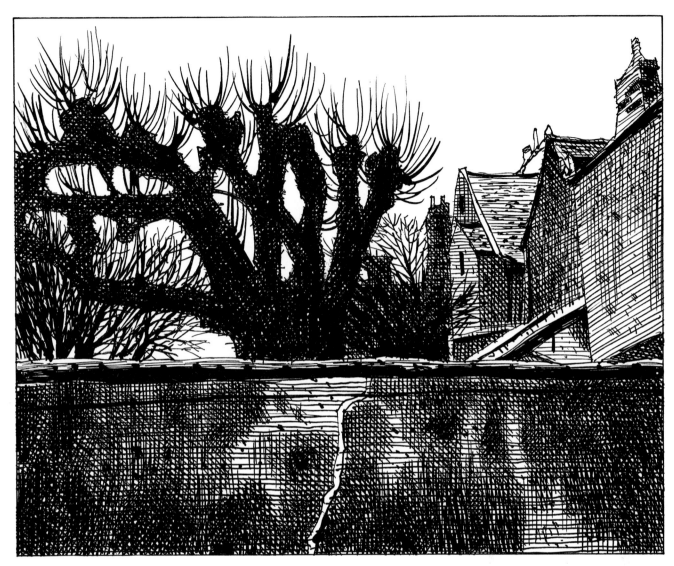

Step 7. Additional textures are drawn on the walls and roofs of the buildings with randomly drawn strokes of the pen. The wall in the foreground is darkened by drawing more lines over most of the area, then textures are drawn over this tone to give the wall an ancient look. The branches of the trees are drawn next, using curved strokes of the pen. The addition of the branches makes the large tree appear too light, so I darken it further by drawing over it with more pen strokes. A slight texture is drawn onto the tiles on the foreground wall with horizontally drawn strokes, finishing the drawing. The pen used for this drawing is a normal drawing pen with a medium point, which creates a heavier line than those achieved when using a crowquill pen. While there are many ways to create tones in pen drawings, the crosshatch method is one of the most unique and it affords a great deal of control. The method of building up the tones is easily understood and a vast range of tones is possible through controlling the thickness and spacing of the lines drawn. This technique is probably the closest thing to what might be called a formula in drawing because of the system which is used to build up the different tonal values. It is a very interesting technique to experiment with and also reproduces very well, which explains its popularity in the commercial art field.

Step 1. When doing an ink drawing it is always helpful to do a light pencil sketch of the subject first. This can be a simple kind of a diagram, but should be quite accurate in terms of perspective and proportions. This sketch will make your job easier as it serves as a guide for the inking. Notice that everything on my pencil sketch has been well delineated and it includes many of the building details. The masses of foliage and clouds have been indicated by outlining these areas. On the clouds I have also shown, through shading, just where the shadow areas will fall.

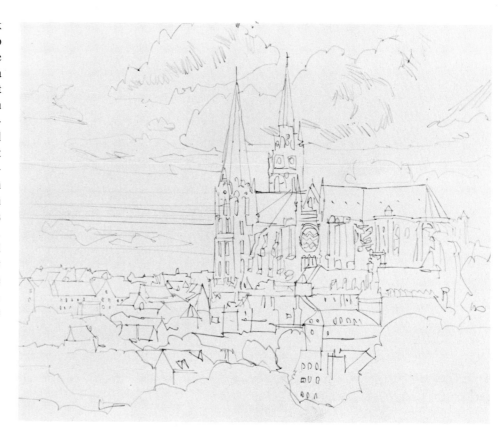

Step 2. I am working on very smooth-surfaced paper, which is ideal for working with pen. The pen I have chosen for this drawing is called a crowquill pen. I have decided to use the crowqill pen because it is capable of drawing very fine lines, important when drawing a subject that has many details. I use India ink and begin by carefully doing an outline drawing of the cathedral. Next, I start to add the details on the church, such as windows and roof lines. I am careful not to smear the wet, freshly drawn lines while I work. I start to draw in a few of the rooftops on the other houses.

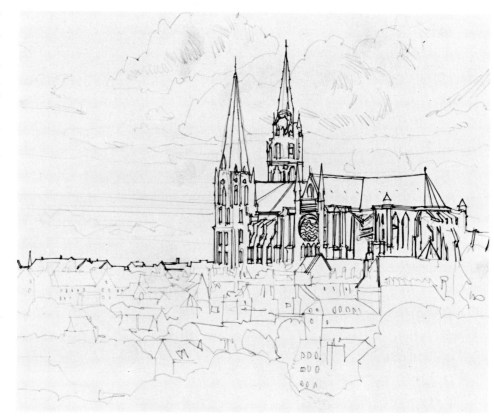

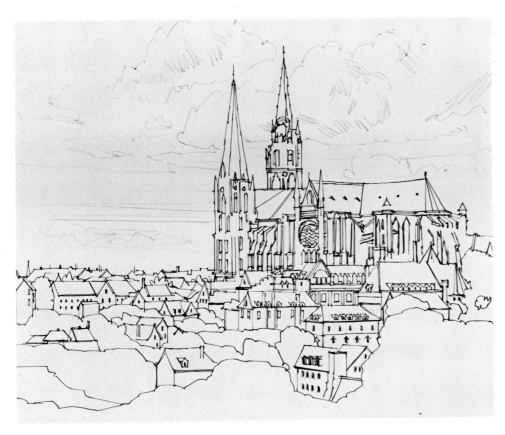

Step 3. I continue drawing with the crowquill pen, finishing the rooftops. Then I outline the foliage areas and add windows, chimneys, and other architectural details to the houses. The drawing is still completely in outline form at this stage. All the areas should be delineated in this manner before rendering any gray tones. To avoid any confusion before adding the tones, I erase all of the pencil lines so the inked outline is clearer. I wait before erasing, to be sure that the ink has completely dried, so that there is no danger of smudging.

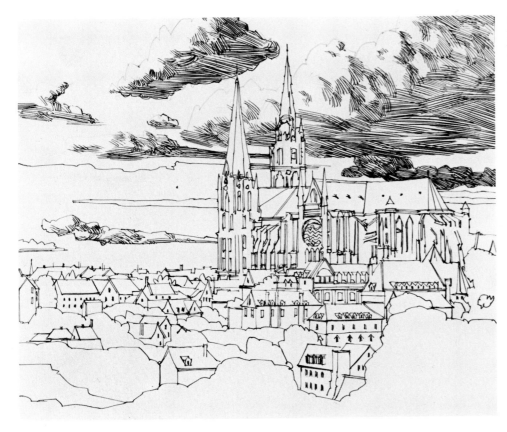

Step 4. I want to keep the cloud edges soft, so I do not outline them in ink. The edges of the clouds will be formed by the light sky tone. I now add darks to the bottom parts of the clouds, drawing some of these lines so that they follow the form. For most of this shadow area, however, I use random strokes to create an interesting texture. When I finish inking the clouds I don't erase the pencil lines as I will need them as a guide for drawing the sky tone.

Step 5. I add more darks to the bottom of the clouds, then render in the lower dark band of clouds. For this, I use random pen strokes to achieve an interesting textural effect. The sky tone is put in next, using carefully drawn horizontal lines. Notice how this light tone forms the edge of the cloud without any outlining. I begin to work on the church towers and start to draw a few shadow areas on the surrounding buildings. These shadows are composed of evenly drawn, carefully spaced lines, which create the illusion of tone. After waiting for the ink to dry completely, I erase the pencil underdrawing.

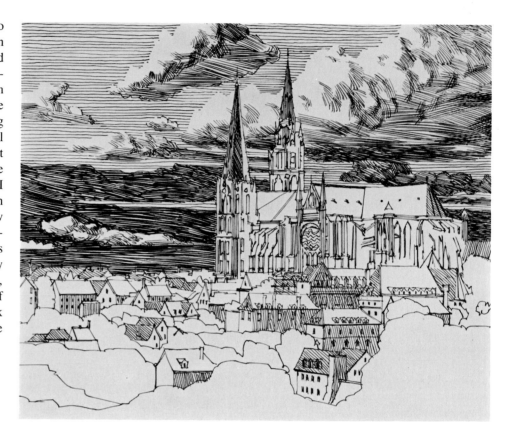

Step 6. Now the darkest areas are added, the roofs and the shadows that define the architectural details on the church. These are done with pen strokes, which are drawn closely together creating a dark tone. I draw a few horizontal pen strokes on the sunlit parts of the church roof to indicate a slight surface texture. A medium gray tone is drawn over the foliage areas. To simulate a leaf-like texture here, I utilize short, zigzag pen strokes. On the ground area in the lower left part of the drawing, I have used a crosshatch technique to separate this area from the surrounding tone.

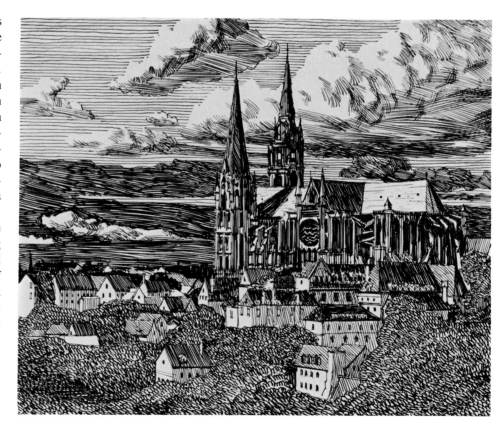

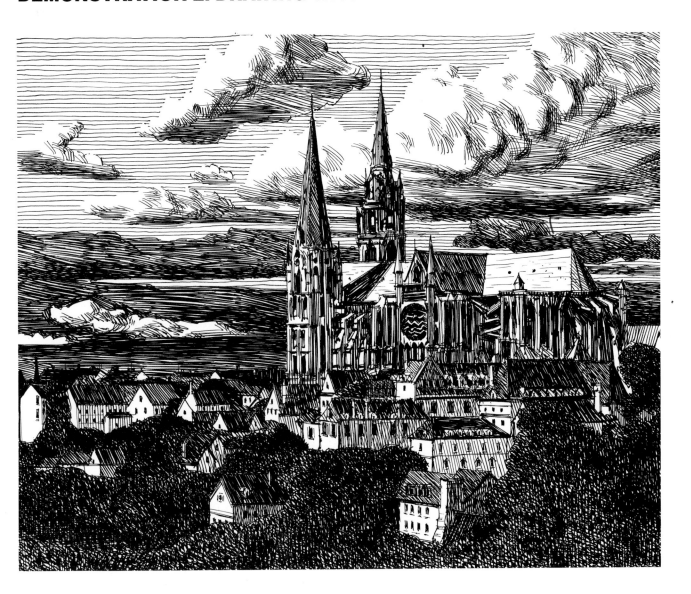

Step 7. I feel that the trees and foliage should be darkened considerably. I begin to do this by first drawing vertical lines across the trees, continuing until the whole area is covered. I blacken in a few of the tree shapes and add many shadow areas by spotting darks in with pen strokes. A few more of the roofs are darkened by shading them, completing the drawing. There are several things to keep in mind when doing pen and ink drawings. If you are not drawing from nature, you should have good reference material to work from. Always start out by doing a pencil sketch of the subject right on the paper or board that you will use for the ink rendering. For finely detailed drawings, it is best to use a smoothly surfaced paper and a pen such as the crowquill, which is best suited for this type of work. After doing an outline pen drawing over the pencil sketch, add the lighter gray tones. Then render the medium and darker tones, always building up your tones gradually so as not to overwork your drawing. Remember that you can use varied pen strokes to enhance your drawings with interesting textures. This might seem a little difficult at first, but you can practice drawing various textures until you become familiar with all the possibilities. Be careful to allow the ink to dry thoroughly so there is no danger of smudging your drawing as you work. As you progress with pen drawing techniques you will want to try other paper surfaces. While the pen moves easily on a smooth surface in any direction, a paper with a surface texture can cause the pen to catch or snag the surface. A paper with a soft surface will require more delicate handling as the pen point can easily dig into the surface, causing blotted effects. This is quite common with the cheaper grades of paper. When doing pen and ink drawings it is best to use only the highest quality papers. If you make mistakes in your drawing, do not paint out the mistake with white paint, as this will be too apparent. There are gritty ink erasers that can be used, but for difficult, stubborn areas, a fiberglass eraser works best. I should mention that ink erasing is only possible on the finest quality papers, the cheaper grades simply won't hold up under this kind of treatment.

Step 1. Different sizes of pen points can be used on the same ink drawing, but the artist must be familiar with the various types of pen nibs to know what each is capable of so that the right pen point can be used for the effects desired. For this demonstration I use a regular drawing pen (the kind used for writing), and a reservoir-type pen with a larger round point for drawing bolder lines. I begin by first doing a basic drawing of the scene with an HB grade graphite pencil on common drawing paper. The large tree trunk in the foreground is drawn first, then the leaves and foliage. The other tree trunks and background are added last.

Step 2. With a regular pen point I ink in the pencil outline drawing. Notice that basically two kinds of pen lines are used to indicate the trees and the foliage. Those used on the tree trunks are even and straight, while the lines used to draw the foliage are short, zigzag pen strokes. When doing this outline pen drawing, the pencil underdrawing is not meticulously traced—although it is followed fairly closely, the lines are quite freely drawn. Tracing every nuance of the pencil underdrawing would result in a rendering that would be too rigid and have an overall mechanical look.

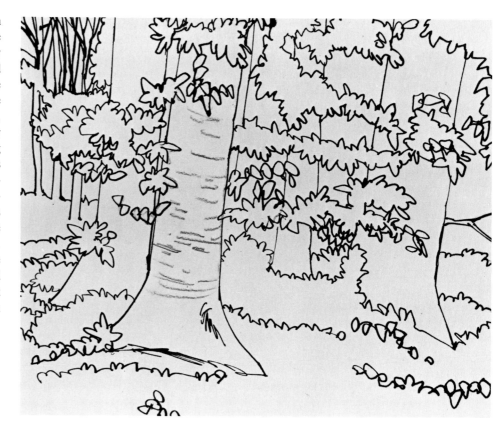

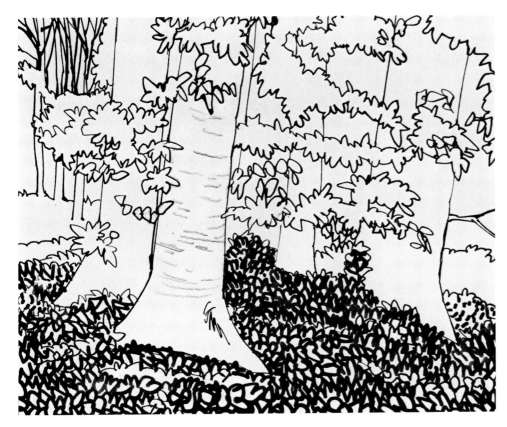

Step 3. After the ink lines have dried completely I draw in the leaves on the forest floor, using the reservoir-type pen, which is capable of producing heavier lines. The strokes used for drawing simulate a leaf texture and also create a medium gray tone over the area. Pen lines, even those that create textures, will be fused by the eye to create gray values. The darkness of these lines is determined by how heavy the lines are drawn and how closely they are spaced.

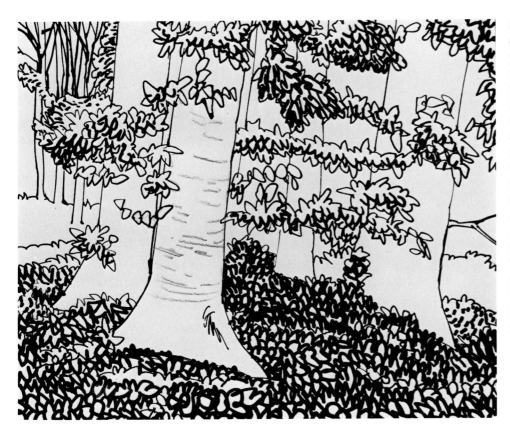

Step 4. The foliage is drawn on the trees using the bolder pen, with strokes that are leaf-shaped. These lines create a pattern that forms a gray tone. Because I intend on having a dark background, I am very careful not to draw the foliage areas with too much texture, which would cause them to be too dark. It is better to keep tones on the lighter side when drawing in ink, as they can always be darkened by building up the tone with more lines. Tones that have been rendered too dark cannot be lightened, so the gradual building up of tones is recommended.

Step 5. I next draw vertical strokes on the tree trunks, adding the dark tones with the regular pen point. I now draw horizontal strokes to create the bark texture, using the small pen. For the solid black tones I use a brush with ink, a much better method than using a pen, as it is much faster and puddles of ink will not form. When using the pen to cover large areas with solid black, the ink usually builds up, taking quite long to dry, increasing the danger of smearing.

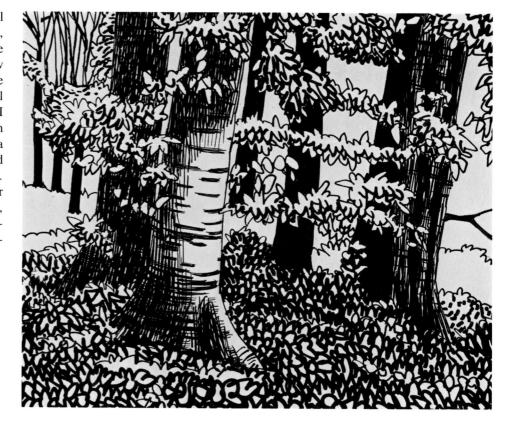

Step 6. Using short pen strokes and working slowly, I add texture to the background area. I use zigzag pen strokes to create the overall leaf texture. I am careful to keep the lines from overlapping into the leaves on the trees so they remain silhouetted against the gray background. The regular drawing nib was used to render this tone. The lines were drawn uniformly, resulting in a flat tone.

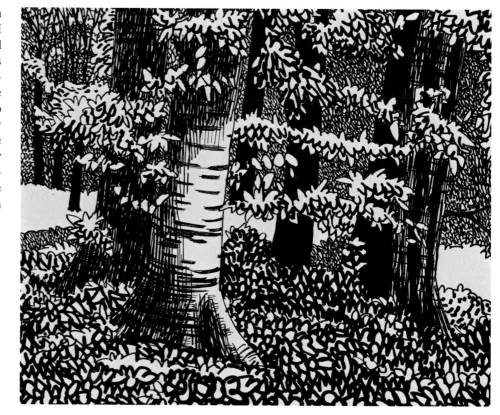

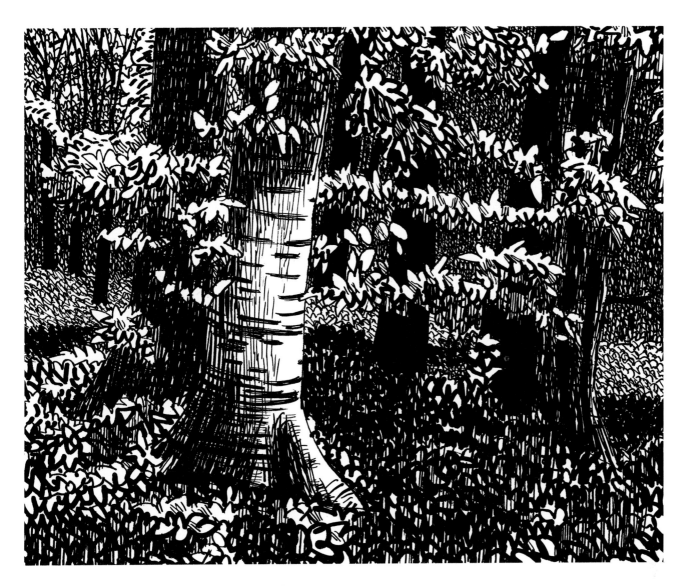

Step 7. Using the regular drawing pen, I add a light tone to the area in the middleground, again using leaf-like pen strokes to create a texture. I use vertically drawn lines to produce the shadow tones over the leaves on the ground area. Over these tones a brush is used to paint in the darkest shadows throughout. A few shadow tones are now added to the leaves in the trees, then the background is darkened even further by drawing vertical lines over the whole area. A dark strip is added across the center of the picture, which silhouettes this area against the lighter background, completing the drawing. This interesting technique has unlimited pos-

sibilities because of the great variety of pen points available for drawing. Just about any subject can be rendered using a variety of pen lines, utilizing fine, medium, and bold pens, in the same drawing. There are some pens available that are very flexible, enabling them to be used to draw a great variety of lines from very fine to extremely bold. Using this type of flexible pen, however, requires a great deal of control, and this can only be accomplished through practice and doing exercises. For the beginner, the best choice would be to use different size pens to create the various line weights desired in the drawing.

Step 1. A variety of pen strokes can be used in the same drawing. For this demonstration, I use two different types of pens, a crowquill for very fine lines and a nib with a flat point to draw thicker lines. While the crowquill is capable of drawing lines of varying weights, it is much easier to draw uniform, heavy lines with the flat pen. I begin by doing a pencil sketch on a smooth-surfaced paper using an HB grade graphite pencil, first drawing the hills, then the various tree shapes.

Step 2. With the crowquill pen I use short strokes to draw in the sky tone. The strokes are fairly evenly spaced and are drawn about the same weight, creating an even tone throughout. Notice that I have drawn around the cloud shapes, leaving the white paper showing through. I could have drawn this tone by using lines in any direction, but chose to draw them at this angle because I felt it would add perspective to the sky, making the drawing more interesting.

Step 3. Now I outline all of the elements in the scene using ink, drawing very freely but using the pencil underdrawing as a guide. The inking is done with the crowquill pen because I still want finer lines at this point. The large foreground trees are drawn first, then the middleground group. Next, the lines indicating the hills are drawn in. The trees and bushes in the background are added last. You can see that everything has been drawn quite freely and that I have indicated a few of the tree branches with very sketchily drawn strokes.

Step 4. When the ink has dried completely, I erase the pencil underdrawing with a kneaded rubber eraser. If the ink lines have not dried thoroughly the eraser will smear them, ruining the drawing. Next, I draw horizontal pen strokes over the trees, using the pen with the flat point as it is capable of producing heavier lines. The flat pen, being less flexible, assures that the lines will be more uniform. The texture was chosen after careful consideration, having to decide which kinds of pen strokes would best depict the pine trees.

Step 5. Compare the strokes used on the trees, which were drawn to create a texture, with the ones used for the sky tone, which were drawn to create an even, uniform tone. The lines drawn on the trees were also drawn less carefully and often overlap, creating an unevenness that simulates the boughs of the trees. A texture is now drawn over the trees in the background using the finer crowquill pen because the trees in the background are much smaller. The strokes are exactly the same as those used for drawing the texture over the larger trees.

Step 6. Next, more tones are added to the trees to darken them. Shadows are drawn throughout the foliage areas as well. The crowquill pen is used here as it allows a little more control than the heavier, flat pen. The strokes are drawn in very carefully so that the effect produced is uniform throughout. The white paper showing through creates just the right amount of texture, which resembles pine trees. A little variation is added to this tone by darkening certain areas of the trees, contributing to the realistic effect.

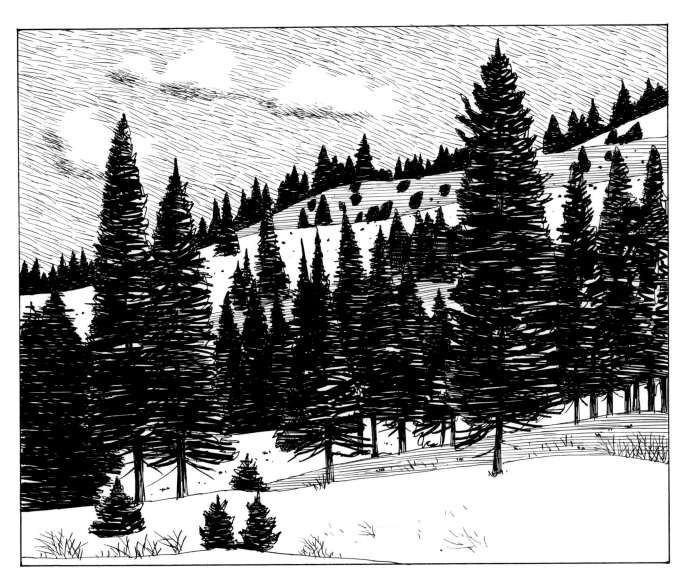

Step 7. The background row of trees is now darkened, so they separate better from the others. To clarify the various planes and ground areas I draw tones in the appropriate areas separating them from the adjacent planes. This is done by drawing thin horizontal lines over the areas, creating a flat tone. The choice of which areas to add the tone to was critical and the decision to use the tones on the smaller areas was correct as this accentuates the snow effect more. A few more twigs are drawn in the ground areas and some dots are added throughout, suggesting detail as well as creating a texture. Using very finely drawn pen lines, the darker areas are drawn

on the clouds, suggesting shadows and adding some form. Finally, shadows are drawn on the trunks of the trees, finishing the drawing. Notice that I have used several kinds of pen strokes to do this drawing. Some have been finely drawn and are uniform to create an even tone, while other strokes have been drawn much heavier and less uniformly to depict a texture. Study the different pen strokes carefully, then practice drawing various kinds of strokes, trying to create uniform tones and also unusual textures. These kinds of exercises should also be done on different paper surfaces: smooth, medium, and rough.

Step 1. Pen and brush are an excellent working combination. The outlines, tones, and textures can be drawn with the pen, and the heavier lines and solid blacks can be done using a brush. To begin this drawing, I first do a basic pencil underdrawing on common drawing paper, using an HB grade graphite pencil. I first draw in the largest flower, starting with the pistil, the central area, and then the petals. Some of the ribbing on the petals is indicated as well as the smaller petals in the pistil area. The flowers in the background are drawn last. As this pencil underdrawing will be used as a guide it should contain as much visual information as possible.

Step 2. The important thing to remember about a pencil underdrawing is that while it can be very roughly done, it should be accurate regarding shapes and proportions. To begin the ink rendering, I use a crowquill pen with India ink, carefully outlining all of the elements in the picture, using the pencil underdrawing as a guide. The crowquill is a good choice of pen, since it has the capability of producing a wide range of lines and is especially suited for fine line work. The brush will be used to draw in the heavier lines and black accents. When inking the detail in the center of the flower, I use pen strokes to create the leafy texture.

Step 3. After the ink has dried thoroughly, I erase the pencil underdrawing with a kneaded rubber eraser. It is best to remove the underdrawing when it is no longer needed as the graphite smudges quite easily. With a number 4 red sable brush I draw the shadow detail in the central area of the flowers, using short strokes drawn with the flat edge of the brush. Notice that I am carefully drawing with the brush as the accents are indicated. I accent the ribbed parts of the petals, using the brush with less ink to create a drybrush effect. Adding the black accents at this stage is important, as this will help me to judge the values of the gray tones, which will be drawn next.

Step 4. Before rendering the gray tones I decide to block in the background, using a number 4 brush. Overlapping strokes are used, creating a texture because of the white paper showing through. This texture in the background helps to convey the impression of details in the shadow areas. While inking in the background, I am careful not to brush over the petal shapes, so the edges are inked first, then the background is filled in. At this stage the drawing appears quite contrasty, but this effect will be minimized as the gray tones are added. As this subject is quite complicated, it demands a great deal of planning regarding where the tones should be drawn.

Step 5. Adding the gray tones is a very critical stage of the rendering. I begin by adding the light gray tones to the petals, using quickly drawn pen strokes. The lines are drawn parallel, but lengthwise on the petals. Certain areas on the petals have been left white, creating a sunlit effect. Next, a gray tone is added to the pistil area, using vertically drawn lines. The white texture in the black background is toned down by drawing lines over the whole area. Notice that instead of finishing any single part of the drawing I work over the whole picture, gradually building up the gray tones so they will fit in with the dominant background.

Step 6. The medium gray tones are now carefully drawn with the crowquill pen. More strokes are also drawn on some of the petals to darken them slightly. Then the shadow areas are indicated. Some of the shadows are rendered using crosshatch strokes, but I am careful not to draw the tones too dark as they would then merge into the background. The shadow side of the pistil areas on the flowers are also built up using vertically drawn pen strokes. The background texture still seems too strong, so more pen strokes are drawn over this area, toning it down slightly. Comparing the previous stage with this drawing dramatically shows the change the picture has undergone through the addition of a few tones.

Step 7. If you study the flower petals you can see subtle variations in the gray tones. This is not easy to accomplish and requires great care, as it is a matter of planning and then building up the various gradations slowly. I now add darks to strengthen the ribbing on the flower petals using a number 7 brush. A few more shadows are added throughout the drawing, working carefully with the brush so as not to render these accents too strong. On the finished drawing it should be apparent that each tool has been used to advantage. The pen was used for drawing the outlines and the gray tones, while brush was used to draw the heavier lines as well as the solid black areas. When examining the various stages the drawing has undergone, it should be obvious that planning is very important and also that tones should build up gradually, preferably working against the darkest areas. In this drawing it was essential to first put in the dark background so that the gray values could be determined easier. This is a commonly used pen and brush technique and works well for drawing any type of subject. It is especially suited for those subjects that are very contrasty and include lots of black. Most any paper can be used for the technique but the rougher surfaces require more care when working as the pen can catch on the texture.

Step 1. A perfect method for doing an ink drawing with a tone is to combine pen lines with wash tones of water-soluble ink. To begin, I use an HB grade graphite pencil on common drawing paper, sketching in a very rough diagram of the woman to establish accurate sizes and proportions. The oval shape of the head is drawn first, then lines are added to indicate positions of the features and define the angles of the shoulders. These lines are useful for doing a more precise drawing, which I begin by delineating the hand. The shape of the hair and outline of the face are drawn next, then details such as the eyes, nose, and mouth are indicated. You can see the final pencil drawing superimposed over the basic lines.

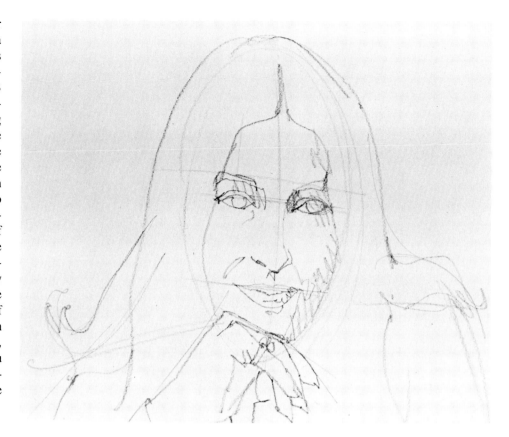

Step 2. Using a normal pen point in a holder, I begin to ink the pencil drawing using India ink so there will be no danger of the ink dissolving when washes are used over the lines. The pencil underdrawing is carefully followed so that the features and subtle shapes will be drawn accurately. The shape of the hair is drawn around the face and then the shadows are sketched in quite loosely. The hand and the arms are drawn next, again being careful to duplicate the subtle curves and shapes in these areas.

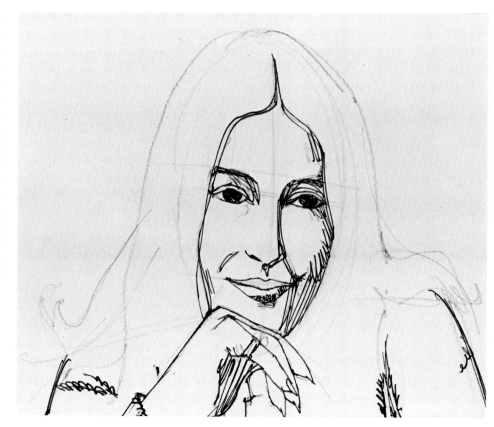

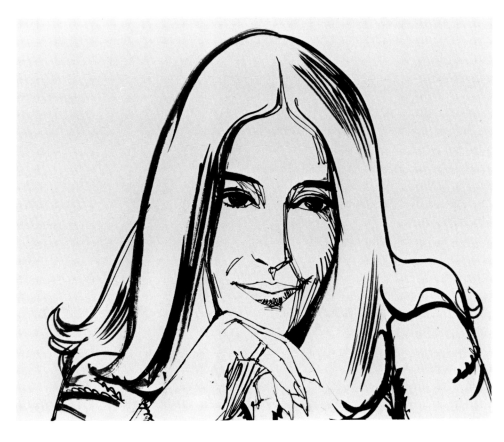

Step 3. With a number 5 red sable watercolor brush, I draw in the dark accents around the face, the folds of the sweater, and the outline of the hair. Some texture is drawn in the hair as well, using quickly drawn brush strokes. I work on the eyes and eyebrows next, carefully drawing in the heavy lines with the brush point. This enables me to achieve crisper accents than could be accomplished with the pen. The brush is also more suited for rendering areas such as the hair, because thicker, more flowing lines are required.

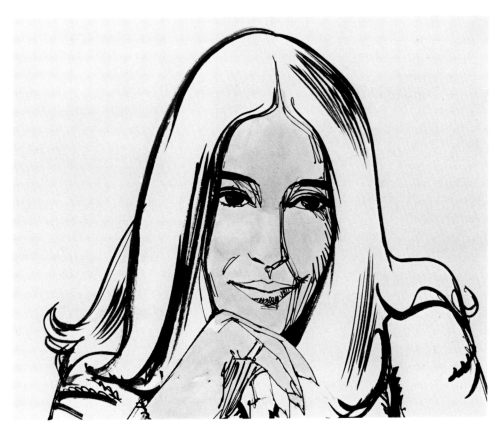

Step 4. In a ceramic mixing tray I mix a small amount of water-soluble ink with clear water to create a light gray tone. Before painting this tone on the ink drawing, however, I first test it on a piece of scrap paper to make sure the value of the tone is correct. This can best be determined when the wash has dried, as they appear slightly darker when wet. The tone can be adjusted by either adding more water-soluble ink to darken it or by adding additional water to lighten the value. I now wash this light tone over the face and hand using a number 8 red sable watercolor brush.

Step 5. When the wash has dried completely, a darker tone is added over those areas of the drawing. The reason for waiting for the first wash to dry is to prevent these tones from blending together. Notice that the darker wash tone has dried unevenly—this was caused by the pigment accumulating more in the gullies formed by the wrinkling of the dampened paper. These uneven tones will be no problem because darker tones and textures will be painted over them.

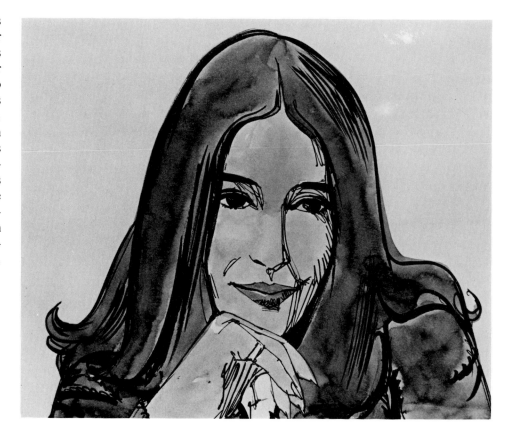

Step 6. Using undiluted, water-soluble ink, I paint in the hair, leaving certain areas where the lighter washes show through to form the highlights. To achieve the texture on the sweater, I flatten the brush on a piece of paper, splitting the ends a bit, then carefully render brush strokes. If you look very closely, the resulting pattern can be seen.

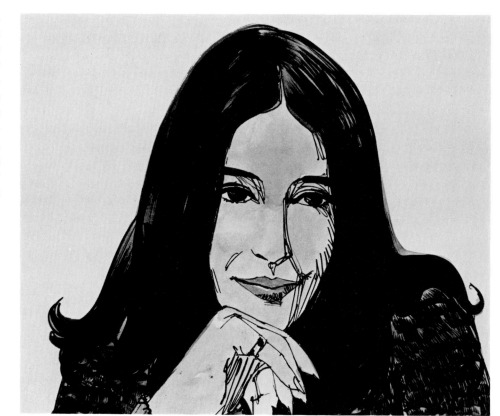

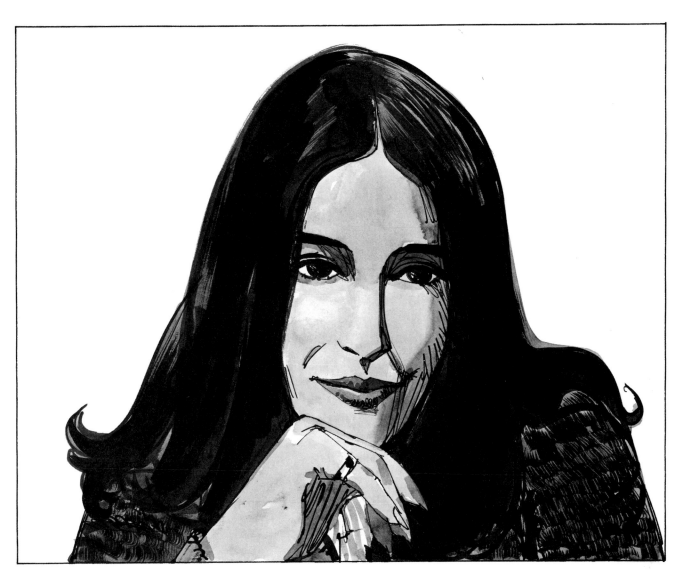

Step 7. The medium gray shadow tones are added to the face, creating more form. When this wash is painted on the face, the edge of the tone is softened slightly by dampening it with a wet brush. Shadows are painted on the hand and the pattern is indicated on the blouse, completing the sketch. This is a fairly simple sketch as it has no background. I recommend that beginners wishing to try this technique first pick subjects such as portraits or still lifes, which can be done without a background. As you develop, you can attempt more complicated subjects that include a background. Another variation on this technique would be to use only the brush for the line drawing, eliminating the pen. Wash drawings, consisting of only tone and no lines, can also be done. All paper surfaces work well with this technique, but it is more difficult to paint flat washes on a smooth surface. Since papers will buckle or wrinkle from the dampness of the washes, it is best to use mounted papers or illustration board when working with this technique.

Step 1. Markers are very handy, effective drawing tools, which lend themselves to all kinds of sketching and drawing possibilities. They have the advantage of drying rapidly and are easier to use than painting mediums. I personally find them most useful for producing tone or color sketches that can later be used as guides for doing more finished drawings or even paintings in other mediums. For this demonstration I use number 1, 2, 3, and 4 gray markers plus black. The drawing is done on a rough watercolor paper. I wanted to work on a rough surface as tones can be built up easier on this surface. With a light number 2 gray marker, I draw an accurate sketch of the figure.

Step 2. My sketch is clearly defined and the proportions are correctly drawn. Now, with a number 4 medium gray marker, I add a few of the accents on the figure—on the hair, under the breast and arms, and over the areas where the shadows fall. Notice how dark the medium gray appears because of the absorbency of the watercolor paper. This same tone would appear much lighter when used on a less absorbent paper, illustrating the importance of really understanding the various paper surfaces. I begin to indicate the areas on the figure where the shadows will appear, using a number 2 gray marker.

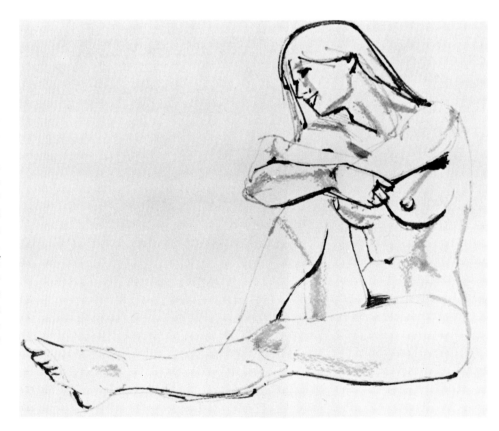

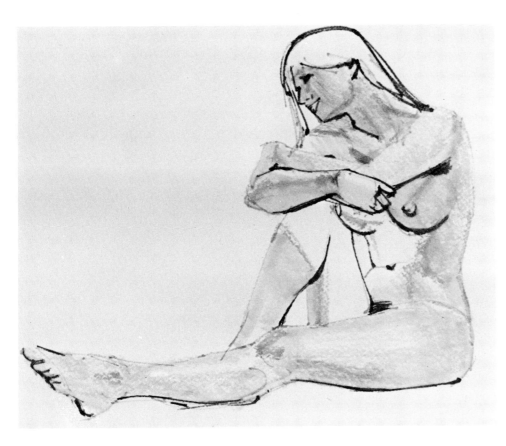

Step 3. The lightest tones on the figure are filled in with a number 1 gray marker. Notice that in some cases I have allowed the white paper to show through, which creates a lighter tone in these areas. This is accomplished by using very little pressure on the marker while drawing. The effect is apparent on the woman's face, arms, and legs. Where more pressure has been used while drawing, or wherever I have gone over a tone a second time, the tones are darker. These tones can be seen on the face, torso, knee, and thigh.

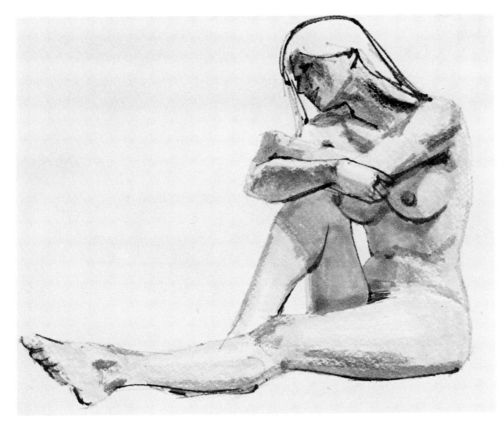

Step 4. A medium tone is added next, using a number 2 gray marker. At first, I thought a number 3 gray marker would be the right choice, but it was too dark because of the absorption of the paper. Notice how dark this tone appears on the side of her neck. When adding the remaining tones, I am careful to consider just where the shadows will fall on the figure. These tones are drawn in quite rapidly. In a few cases, such as on the torso, arms, and leg, I have used less pressure when drawing the edges of these tones, creating a drybrush effect.

Step 5. The darkest tones are now drawn on the shadow areas with a number 4 gray marker. The tone is rendered by stroking the marker gently over the paper surface. This prevents the ink from soaking in too much, which would cause the tone to be too dark. I use the edge of the multi-faceted marker nib when drawing in the finer details on the face. A shadow is now drawn under the figure. Notice how the drawing appears more solid and has more form because of the strengthening of the shadows. Some of the gray tones now appear too light and these must be darkened slightly.

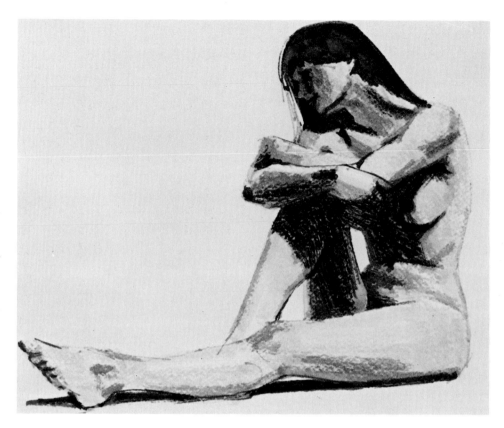

Step 6. Using the number 2 gray marker I adjust some of the lighter tones, carefully building them up so they are more compatible with the dark shadow areas. This is done gradually and the tones can be seen along the side of the body and on the legs. To lighten the dark shadows a bit, I use a number 2 gray marker over them, dissolving and softening some of the dark strokes. While it is generally true that marker tones can not be lightened, in some instances it is possible, depending on the paper surface used. On a rough surface such as this, tones can be lightened slightly if they have not soaked too deeply into the paper surface.

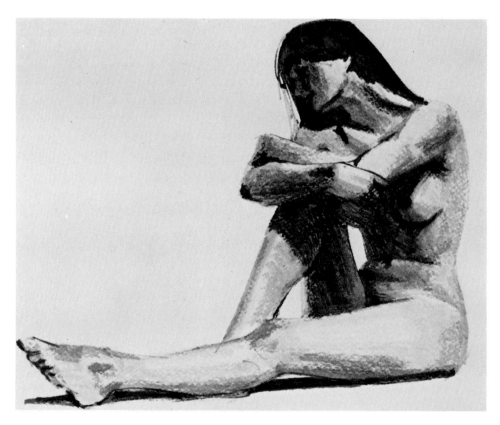

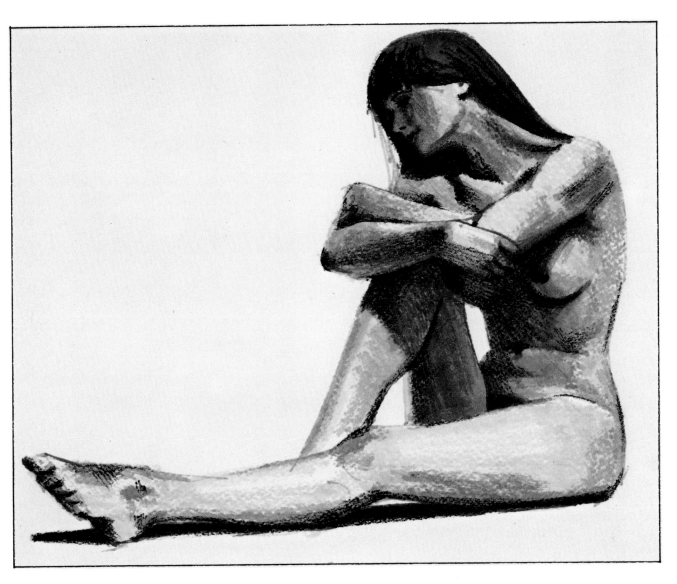

Step 7. With a black marker pen, the type with a bullet-shaped nib, I now begin to add the details on the hair and accent the features in the face. Using the pen so that the point barely touches the paper surface, I carefully render in subtle dark tones over the shadow areas. The effect when using this method is very similar to a drybrush technique. The shadow under the figure is darkened with the same pen, rendering it almost solid black. I work over the whole drawing, clarifying shadow areas on the body and also adding more detail to the hair. If this drawing had been done on a different paper surface, the overall result would have been quite different. On this drawing, the watercolor effect is largely due to the fact that a rough-surfaced paper was used. On a smooth surface, the marker tones could not have been built up in the same way, and any blending of the tones would be limited. Markers are very similar to the watercolor medium and are at their best when used quickly with boldly drawn strokes, resulting in a very spontaneous effect.

Step 1. An excellent method for adding color to India ink drawings is to use washes of colored inks. Similar to watercolor, but much brighter, colored inks result in brilliant, fresh renderings. They are quite manageable to use as the washes can be controlled easily. I begin by first doing a drawing with an HB graphite pencil on a medium-surfaced illustration board. I complete the drawing, clearly defining all of the elements. I prefer using mounted papers when working with washes as there is no chance of the surface wrinkling when it is dampened with water. The medium and rough surfaces are much better for this medium, as the smooth surfaces do not take washes well.

Step 2. When using washes over ink drawings you must be sure to use waterproof India ink for your basic pen drawing, as other types of ink will dissolve when washes are used over them. A regular drawing pen is used to do the ink rendering, starting with the outline, the foliage, trees, foreground rocks, and landscape areas of background. Various kinds of lines are used to indicate the different objects: loop-like lines for the bushes and other foliage, smooth lines for the landscape areas and rocks. With a number 4 brush, the textures and shadows are drawn in the bushes and rocks. Notice how these strokes have a different feeling from those done with the pen.

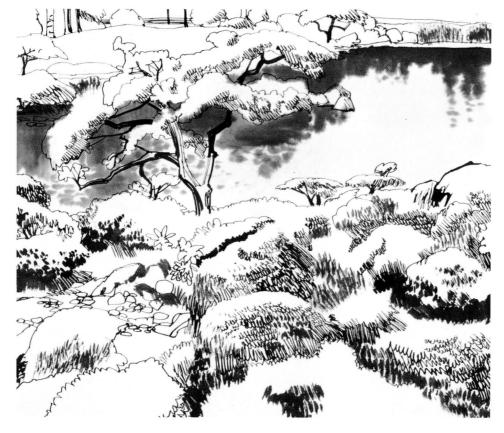

Step 3. Using a soft, wide brush, clear water is washed over the lagoon area, then a very pale blue tone is painted over the dampened surface. Pre-wetting the paper assures that the color will spread evenly without forming any hard edges. A tone of olive green is mixed, then painted on the still damp wash tone, blending slightly to create the effect of a reflection. It is important to keep in mind that colors dry slightly lighter than they appear when wet, something that must be considered when mixing colors.

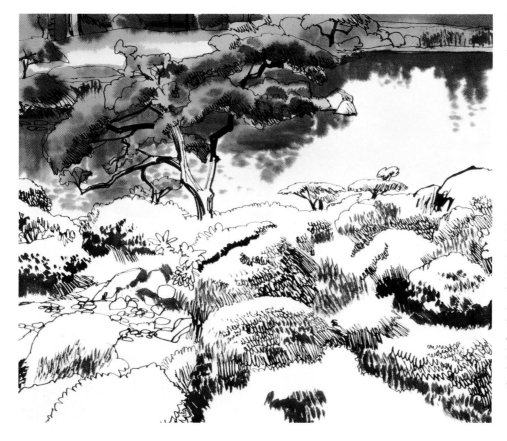

Step 4. A light yellow color is washed over the background at the top of the scene, then a mixture of lemon yellow and grass green is painted over the trees. A few olive shadow tones are added over these washes while they are still damp so the colors will spread, creating a softer effect. The spreading of washes can be controlled in two ways: the dampness of the paper (the most important factor) and the amount of ink on the brush. If the paper surface is quite wet, the washes will tend to spread more, while on a slightly dampened surface the washes can be relatively contained. A brush fully-loaded with ink will cause the wash to spread more; less liquid will not spread as much.

Step 5. Now, on the lower portion of the picture, I paint a brighter mixture of cadmium yellow and grass green warmed slightly with a small amount of persimmon red. The softness of the edges of the washes is due to the fact that they were painted over the dampened paper surface at just the right moment. The brilliance of the colored inks is very apparent here—even the darker green washes are quite lively and intense.

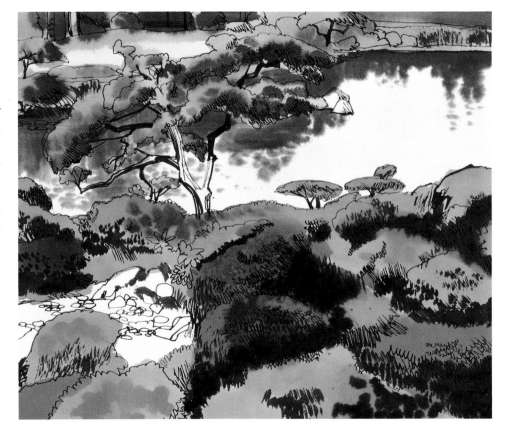

Step 6. The gray stones in the lagoon near the foreground are painted using a mixture of water-soluble black ink and blue. While this area is still damp I add the darker tone to indicate the shadow areas, this same color being used to paint in the trunk of the larger tree. I mix a dark green and paint in the background shadow and some of the bushes. This darker tone helps to clarify these areas. Notice that the darker green wash has crisp edges. This is because it was painted over an area that was completely dry and the color could not blend into the surrounding area.

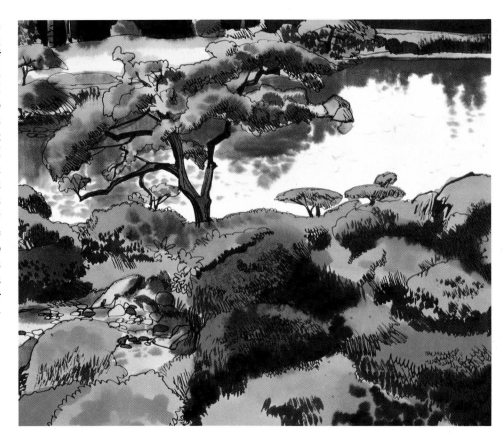

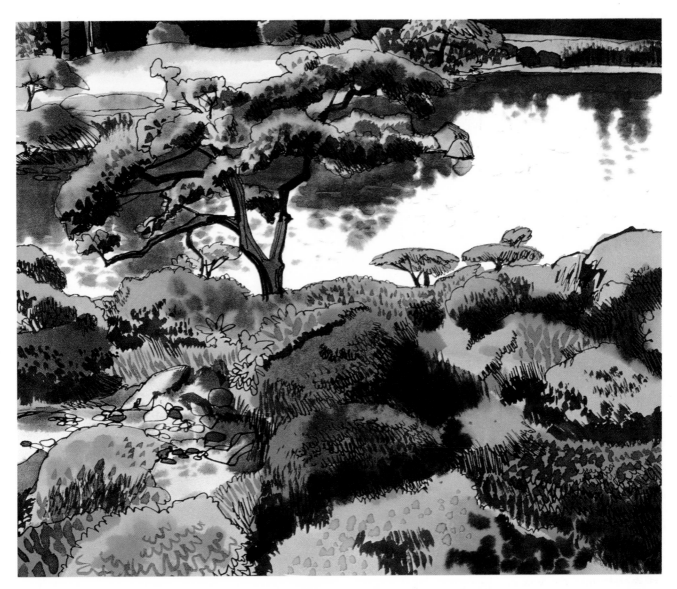

Step 7. I add a slight texture to the water, using very finely drawn brush lines. The color of the reflections in the lagoon is too brown, so this is corrected by washing a tone of dark green over them. The resulting tone is now too close to the tone in the foliage of the large tree. A dark shadow tone is added to the tree foliage to correct this, enabling it to stand out better from the background. When a color or tone is changed on a painting it invariably necessitates changing adjacent tones or colors that have been affected by the new addition. More shadow tones and textures are added through-

out the foliage using small brush strokes painted with a dark green color. I now paint in the orange flowers to add a few brighter touches to the scene. All of the foliage details and textures were painted using a number 7 watercolor brush. Colored inks are more brilliant than other color mediums, but they do have a serious flaw: they are not permanent and are subject to fading. For this reason inks are used more for commercial work and illustration where fading is not an important factor. However, inks are very interesting to work with and unique effects can be achieved with them.

Step 1. Markers are a medium that works well on just about any surface, although very different effects can occur depending on the absorption of the particular surface used. An excellent surface for markers is the smooth surface, although it reacts to markers quite differently than the other papers. For this demonstration I use a different kind of a smooth surface called scratchboard. It responds to markers like the smooth bristol boards, but has other interesting qualities. The main advantage scratchboard has over other boards is that the surface can be scraped with a special tool to achieve special effects. This also allows the artist to make simple corrections. A fine-tipped marker pen is used for the basic drawing.

Step 2. The marker used for the drawing has a fine tip with water-soluble ink, which is perfect for doing the basic drawing as the drawn lines will not dissolve when permanent markers are used over them. The shadow tones on the women are sketched in and I begin to add the color by using a yellow marker on the dress of the woman at the right. To paint in the colors, I am using permanent markers with multi-faceted, wedge-shaped nibs. Many different kinds of lines as well as large areas of color can be rendered with this versatile nib. I should mention that when working with markers it is important to recap them tightly after use to prevent the ink from drying.

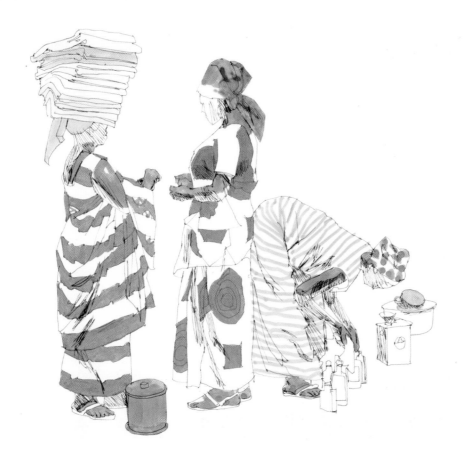

Step 3. I add more bright color patterns on the other women's dresses, using red magenta markers. An aqua color is drawn on the cup in the tub on the ground. Now, light blue and pink tones are added over the folded sheets on the woman's head and a bright yellow is used on her headband. On the center woman's headband I use sepia and blue; where the colors overlap they combine to create a shadow tone. I begin to add the sepia color to the flesh areas and use it to color the can in the foreground as well.

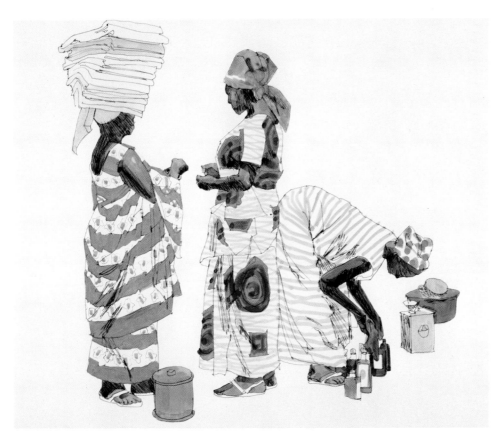

Step 4. I finish putting in the flesh tones, then use a darker brown for adding the shadow tones on the skin. I add color to the bottles as well as to the tub and the can on the right side. The pattern on the woman's dress in the center is accented by adding a brown color over the magenta. A small pattern is now drawn on the dress with the red strips. Outlines are drawn around the pattern with the fine-line marker pen.

Step 5. To draw the shadow tones on the dresses I use a number 6 warm gray marker, adding these tones very carefully. The fact that the marker ink is transparent makes it quite easy to indicate shadow tones over color areas which show through the tone. Shadow tones are also added to the cans and tub on the ground. I use the gray marker to draw in the shadow tones on the folded sheets on the woman's head at the left, then the shadow tone is drawn on her bandana. I now add the pattern on the center woman's bandana, using a dark brown.

Step 6. Darker grays are drawn on the folds of the women's dresses with a number 8 warm gray marker. The shadows on the flesh areas of the figures are darkened with the same tone. Great care must be exercised when drawing in the finer details—they are best executed by drawing with the corner edge marker nib. Highlights are now added to the flesh tones by dissolving some of the color with a light gray marker. The same method is used to create the light lines on the pattern of the center woman's dress. On a hard, smooth surface, light colored markers can be used to dissolve darker tones.

Step 7. As the drawing has been done on scratchboard, more details can be added by using the scraping tool. Also, the edges of the drawing can be cleaned up by scraping away the imperfections. The special tool used fits into a pen holder and is used very much like a pen to etch or cut lines into the color tones. Large areas of tone can also be removed with this tool, but it is best to use it sparingly, limiting the scraping to the addition of a few white accents or to clean up the edges of the drawing. Using the scraping tool, I add white dots on the pattern of the center woman's dress. I work carefully, as errors are difficult to repair. Tiny lines are scraped over some of the highlight areas on the skin to brighten them more. Now the edges are cleaned up by scraping around most of the drawing with the tool. This interesting technique can also be done using inks or other painting mediums instead of markers. Scratchboard also offers great possibilities for experimentation, as other kinds of tools and even sandpaper can be used to create textures or remove areas of color. The subject used for this demonstration is fairly simple as it has been done on a white background. Beginners should first work against a white background. You can attempt more difficult subjects later.

Step 1. Colored inks are a very fresh medium, quite similar to watercolors, with the exception that ink colors are generally brighter and more vibrant. When using colored inks it is best to work on medium or rough surfaces. The mounted papers are preferable as they are not subject to wrinkling when washes are used over the surface. I begin by drawing a simple diagram of the scene using an HB graphite pencil. The lines indicating the foreground hills are drawn in, then the various planes of the landscape and the background mountains are added. The lines dividing up the scene are essential, as they are the basis for the final pencil underdrawing.

Step 2. I develop the pencil drawing further, defining the various planes in the picture, then adding many of the important details. The foliage areas are drawn throughout the scene, as are the rocks and boulders. I also indicate the shadow areas on the mountains in the background. These details, while roughly drawn, are sufficient to guide me when the colors are painted in, enabling me to concentrate on the tones and effects I want to achieve in the rendering. This type of underdrawing can also be done with a brush, using a light, neutral wash tone for drawing the lines.

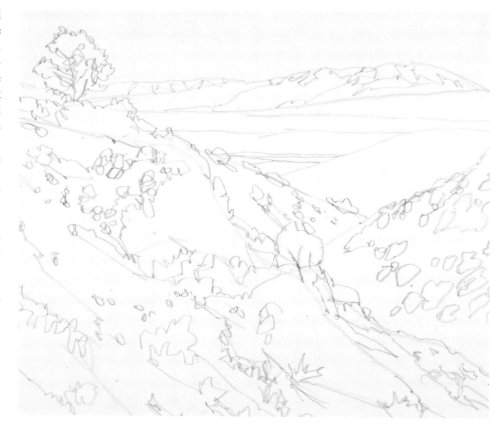

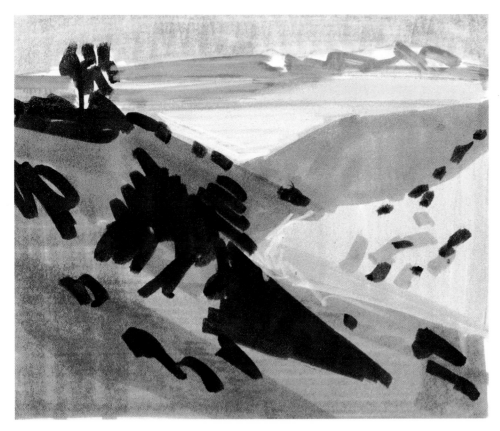

Step 3. Before proceeding with the color rendering, I decide to do a color sketch, an important step as this guide will be useful when doing the painting. Any preliminary work, such as an accurate pencil underdrawing or a color sketch, will ensure a more successful end result. The simplest, fastest method for doing preliminary color sketches is to use markers on layout paper. Notice that on this preliminary color sketch I have used very simple, bold strokes to indicate the various tones of color in the scene. No matter how simply or roughly done, sketches can prove invaluable. Two or three can easily be done, then compared before making a choice.

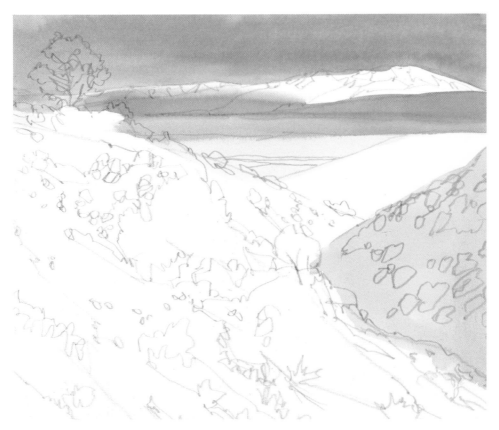

Step 4. To start the color rendering, I first wet the sky area of the paper surface using a wide, flat brush with clear water. While the board surface is still wet, I wash in a turquoise color with a number 7 red sable watercolor brush. Painting over previously dampened areas assures a fairly even, uniform tone of color. The ground areas are painted next, using tones of yellow and light brown. A mauve color is then painted over the mountain in the background. Notice that some of this tone has a hard edge. The soft, blended portion occurs where the wash is painted over a damp part of the paper.

Step 5. I mix a tone of water-soluble black ink, brown, and a slight amount of yellow, then paint this color over the shadow area on the hill at the left. A darker tone, which I created by adding more black to the previous mixture, is painted over this, after allowing the first wash to dry slightly so the tones do not blend together. The side of the hill at the right is painted using a brown tone and the mountain in the background is painted blue, with some of the white paper used as areas covered with snow. I next add a neutral gray tone over the central background area. The bushes on the sunlit hill in the foreground are indicated using a medium-toned wash mixture of brown and black.

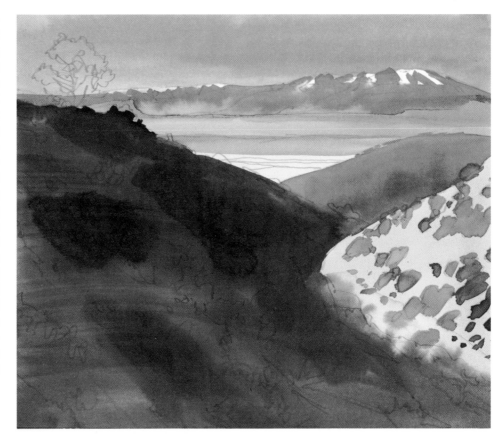

Step 6. A dark shadow tone is mixed from black and a slight amount of brown. This tone is painted over the hill on the left and dark blobs and brushstrokes of the same color are used to indicate the details in the shadows while the wash is still damp. The tree at the top of the hill is also rendered and the shadows of the bushes on the sunlit hill are painted in. While the wash on the foreground hill is still damp, I paint in various details such as brushes, rocks, and numerous ground textures. With the same dark brown tone I paint the shadow area on the background mountain and also on the bright patch of ground near the center of the picture.

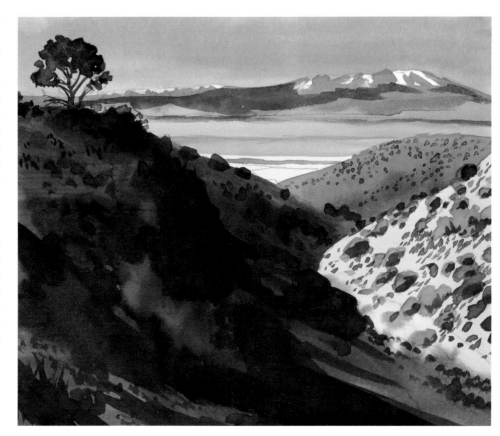

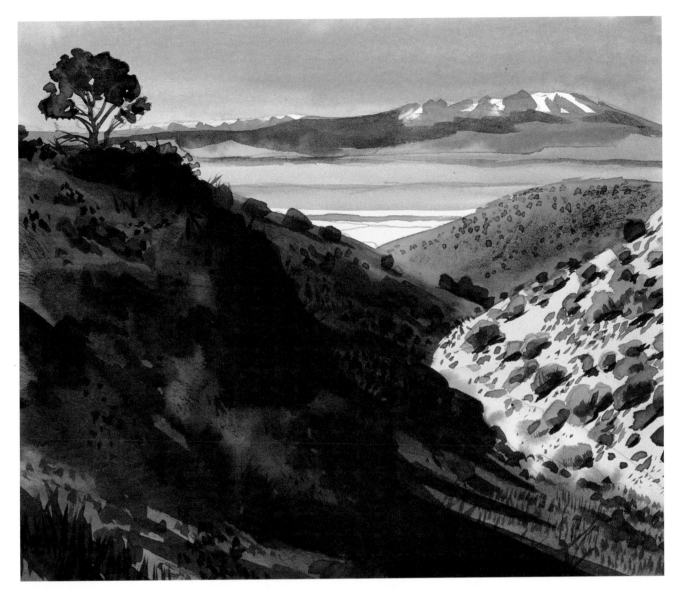

Step 7. Grass textures as well as more rocks and bushes are painted into the shadow areas. In the foreground on the right, small brush strokes are used to indicate more grass. The shadows under the bushes on the sunlit hill are darkened with a wash mixture of brown and black and smaller shadows and dots are indicated throughout the area to simulate the ground texture, finishing the rendering. While the finished painting is not exactly like the preliminary color sketch, it has been based on it and is quite similar. As I worked, the painting was livened up by using more intense colors than were indicated on the marker sketch. The shadow areas in the painting are also much stronger. The color sketch served to give me a direction, a point of departure from which I was able to develop the finished rendering. This is a very fresh, colorful technique and is suitable for painting just about any subject you might care to do. I should mention that when painting in washes it is best to work on a flat, level surface as this prevents the washes from running down the paper. One reason this painting has a fresh look is that it has been done simply and not been overworked, which can often result in muddy colors. The drying of the washes can be facilitated by using an electric hair dryer. Washes can be partially dyed, then painted over for special effects.

Step 1. Markers can be used to do sketches or paintings with effects that are very much like watercolors, especially when they are used on papers with a rough texture. Markers are fast, convenient tools to use for painting, but the results can vary greatly, depending on type of paper used. On smooth surfaces the results are quite different from when they are used on rougher papers. On smooth papers, the lines and tones are smooth and flat; on a rough surface, the lines would be broken and the tones textured. For this demonstration markers are used on medium-surfaced illustration board. I begin by first doing the basic drawing with a number 3 gray marker, as it is best to do the initial drawing with a neutral color.

Step 2. I render the pale blue on the sky area, then use this same color on the water. Both tones are applied using quickly drawn strokes. Because the marker ink dries quite rapidly, working quickly when rendering larger areas of color assures a flat, uniform tone. Something to remember when working on an absorbent surface such as this, is that tones appear darker than they would on harder, smooth paper surfaces. On less absorbent papers, not as much ink soaks into the surface and the colors appear lighter. Only by working on various papers will you understand how markers react to each surface.

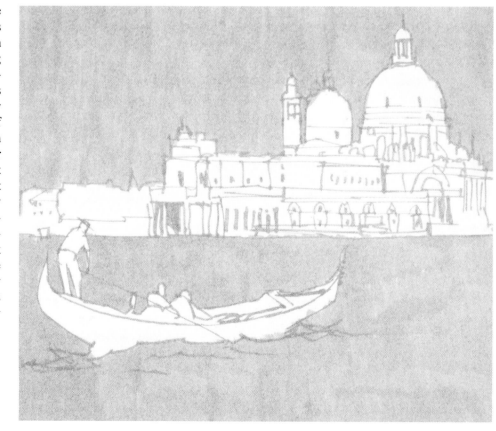

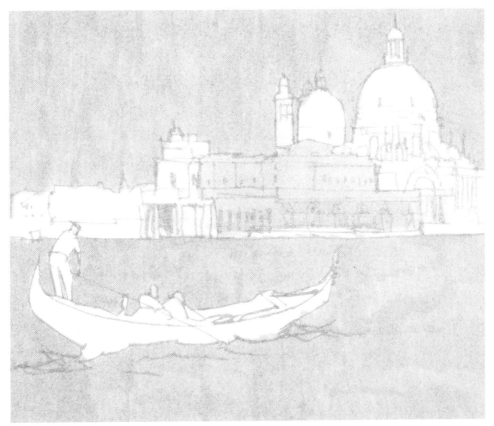

Step 3. A flesh color is painted on the buildings, again working very quickly so that the tone dries evenly. As I have mentioned, there is the possibility of hard edges forming between the drawn strokes if they are drawn too slowly, causing an unsightly linear pattern throughout the tone. Next, a very light gray tone is added to the adjacent building, using a number 2 gray marker.

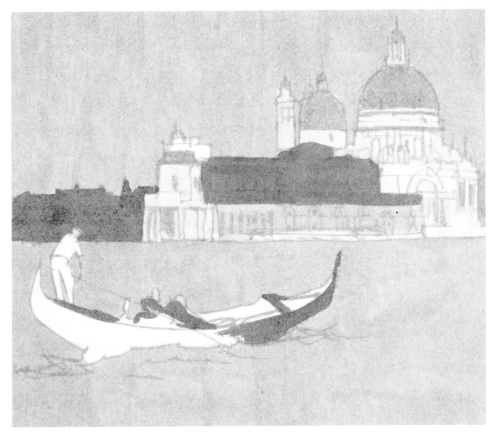

Step 4. A darker number 5 gray marker is used over the domes and roofs of the buildings. Some of the building details are now drawn with the same marker. A pale sepia color is painted on the buildings with bold strokes, using the widest facet of the marker nib. I use the same color for the lighter tones on the gondola. These tones appear too strong at this stage but will be subdued, fitting in better when the darker tones are added to the sketch.

Step 5. To create the pattern of the waves on the water surface I use a pale olive color over the blue. Boldly drawn strokes are used to indicate the reflections on the waves in the foreground and the shadow under the gondola. On the left in the background, I block in the shapes of trees with the dark green color. A number 2 gray and a flesh tone are next used over the water area in the background to simulate the reflections. When the accents are added to the buildings, the reflections on the water will be darkened further.

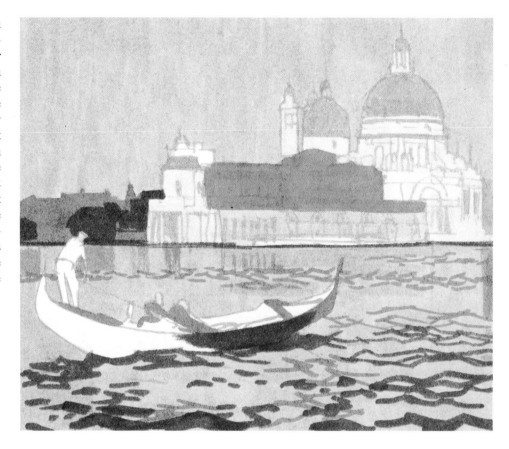

Step 6. The scene is now taking on the characteristics of a watercolor painting. Both markers and watercolors are ideal for doing sketches like this. To add the darkest tones, I use a number 9 gray to draw in the rest of the gondola and the people. This is done by carefully drawing with the sharp point on the edge of the marker nib so the details are easier to indicate. With the lighter number 6 and 3 grays, I begin to draw in the details and shadows on the buildings.

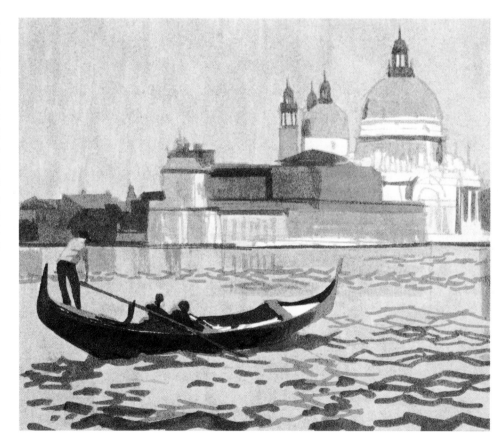

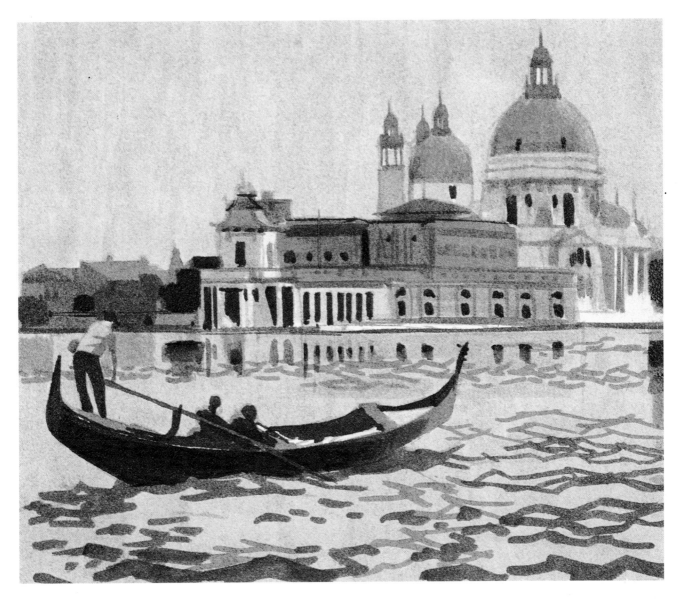

Step 7. The windows of the buildings are drawn with a number 9 gray marker. The reflections on the water are darkened using the same marker. Some of the dark areas in the reflections are softened by using a lighter gray marker to blend the edges. Darker tones are added to the front of the buildings to indicate the shadows, using a number 6 gray marker. The near-black accents are added with the number 9 gray. A blue color is added to the domes on the buildings and the edges of these tones are softened with a number 1 gray marker, helping to create form. The sketch is now finished, using only a few colors and simple marker strokes. The reason that the sketch resembles a watercolor is that it has been done quite rapidly, using boldly rendered strokes without much detail. Like watercolors, markers should not be overworked, but should be handled in a very direct manner. Markers are ideal for doing simplified sketches, because it is difficult to render fine details or thin lines with the wedge-shaped nib. When beginning to use markers, start out by first doing sketches with black and gray markers. As you gain confidence and experience, you can advance to more complex subjects, doing them in color. Your first efforts should be done on a good quality layout paper, then try other surfaces.

Finding Dominant Colors. This is a photograph of a very complicated scene composed of not only bright colors, but subtle shadow tones as well. I did a color sketch of the scene using markers, attempting to retain the general effect, yet simplifying the colors. Markers are an excellent choice for doing quick, fresh color studies, which can later be used as a guide when doing drawings or paintings. I first drew the scene in pencil, then, using this as an underlay, I rendered the sketch with markers on a overlay of layout paper. Layout paper was used as it is semi-transparent and the pencil sketch remains visible through the paper, making it easy to render over. If the sketch is not successful, the pencil drawing can be placed over a fresh sheet of layout paper and redone. I have indicated the strongly sunlit areas using bright colors. The sky has been exaggerated by rendering it brighter and a warm green color is used over most of the background foliage. The water lily pads and water in the foreground have been drawn using cooler greens and blues, emphasizing the shadow effect. I use a darker gray marker for the shadows and details. The scene has been broken down to seven colors: light and dark yellow, flesh, light and dark blue, warm green, and dark gray. A color drawing or painting could now be done, using this sketch as a guide.

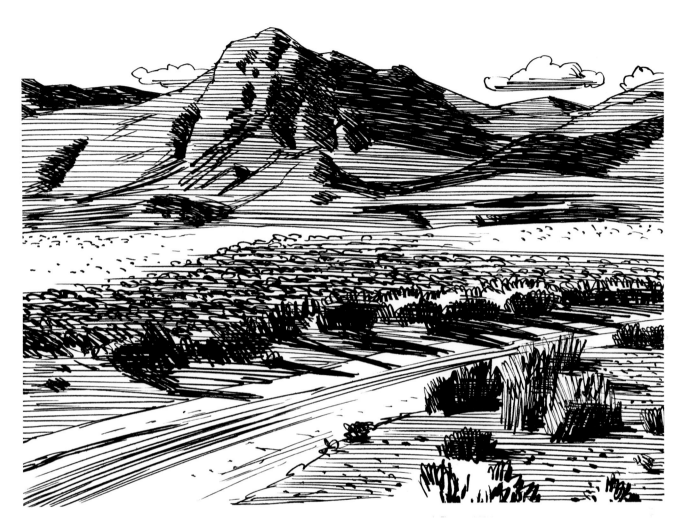

Two Values plus Paper. This drawing, done with a crow-quill pen on common drawing paper, is an interpretation of the photograph reduced to two gray tones and the white of the paper. As the darker tone would be used on the shadow areas, the key to the simplification was to determine just which areas would be pure white and where the light gray tones would appear. I decided that the sky, middleground area, and the road in the foreground would be pure white. All the other tones would be a light gray, and darker tones would be used for the shadows. I used horizontally drawn lines for the light gray tone. In the middleground area I darkened the tone by adding a texture to simulate foliage areas. The dark gray tones are made up of lines drawn very closely together, most of them overlapping, creating an interesting textural quality. You can see the three distinct tones used here: the white of the paper, the light gray, and the darker shadow tone. Some of the tones have been altered slightly because of the lines and textures drawn over them to indicate the bushes and foliage.

Three Values plus Paper. This drawing is done on common drawing paper with a crowquill pen and number 4 red sable brush. In simplifying this scene, I first determined that the pure white areas should be the sky, the light portion of the arch as well as the area directly behind it, and the details of the ruins on the right side of the picture. The rest of the scene would be made up of a light gray value, a medium gray, and black. I felt that the road in the foreground would work better in a light gray value because if I used the same value as the photograph, the whole drawing would appear too dark. I began by drawing the first value, the lightest gray tone, working over a basic pencil underdrawing using a crowquill pen with India ink. This tone can be seen to the left of the arch, through the arch, on some of the ruins at the right side of the drawing, and on the street in the foreground. The second value, the medium gray tones, was then drawn on darker portion of the arch, on the wall next to the road, and throughout most of the background using the same pen. The third value, the solid black, is added next, using a number 4 red sable brush. I silhouette the trees on the hill against the background and carefully draw in details on the arch.

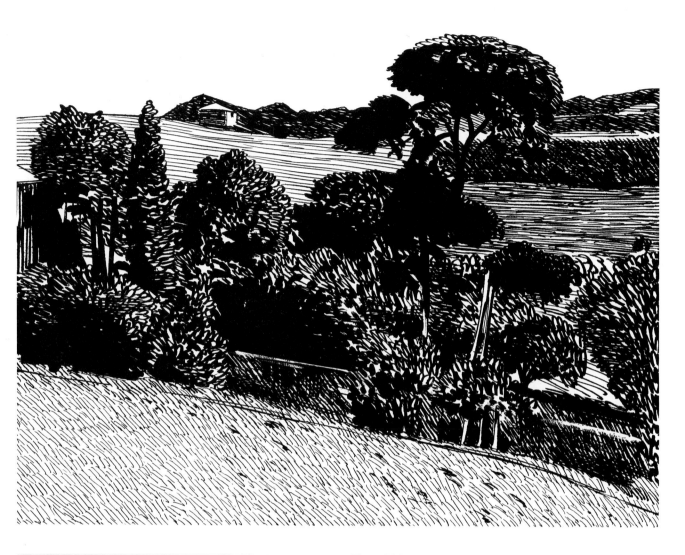

Four Values plus Paper. This snapshot was simplified into five different values of tone: three distinct grays, solid black, and the white of the paper. A crowquill pen was used to draw the tones and a number 4 red sable brush was used for the solid blacks. The lightest gray tone is drawn on the background hill and the sloping ground in the foreground area. The background hill is done using horizontally drawn lines to create the tone, while the foreground area tone utilizes a grass-like texture comprised of short pen strokes. The second gray tone is darker—it appears on the background hill to the right, just above the halfway point on the drawing. The third, and darkest, gray tone appears throughout the mass of foliage in the middleground and on the background trees. This tone has been drawn differently, using zigzag and loop-like strokes to create the foliage area textures. As the trees recede into the background, the textures become smaller, allowing the tones to become more uniform. The fourth value is the solid black, and this is used to indicate the shadow areas and a few accents throughout the scene.

Step 1. This demonstration is drawn on common drawing paper using only three tonal values plus the white of the paper. It is a complicated scene with architectural elements and requires an accurate basic underdrawing. This drawing is done with an HB grade graphite pencil, starting with the foreground lamppost, and then the middleground area with the statue. Next, the figures and the background buildings are drawn in. I also add most of the details such as roofs and windows on the buildings. The paving stones, which create the pattern on the sidewalk, are carefully drawn in, maintaining the correct perspective.

Step 2. To begin the ink rendering, I add the lighter tones on the buildings in the background with a crowquill pen and India ink. A few tones are drawn on the lamps in the foreground. The lines formed by the paving blocks are drawn in—a job made easier because I can use the pencil lines as a guide. The inked lines, however, must still be drawn carefully so that they are the same weight and spaced fairly evenly to create a uniform tone. The railing on the background bridge is drawn, then a few pen strokes are added on the foreground area to the right to indicate the pattern of the paving blocks.

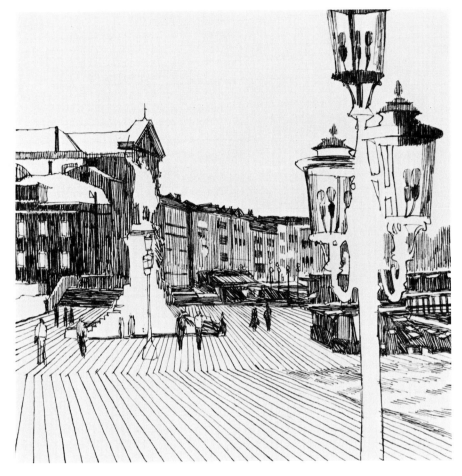

Step 3. I now add the second tone, the medium gray value, making certain that the tone is uniform by spacing the drawn lines evenly. Actually, the same kinds of pen strokes have been used to render the medium tones as the light value, but the lines are slightly heavier and they are drawn closer together to create a darker tone. Compare the medium tone on the buildings at the left with those in the center of the drawing. The heavier lines were achieved by using more pressure on the pen while drawing. Using the medium tone, I now indicate the remaining elements in the scene. I sketch the awnings and other details on and around the buildings. I begin to add more darks to the lamps.

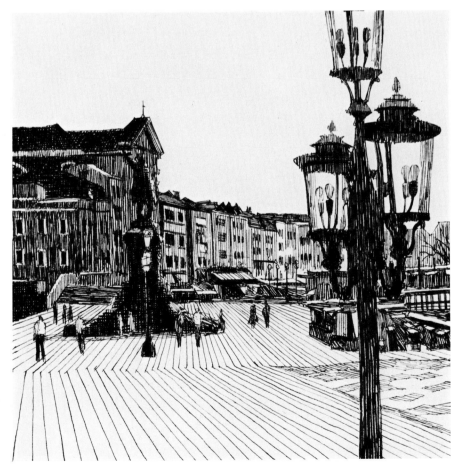

Step 4. The darkest tone, the third value making up the scene, is drawn using lines drawn very closely together, almost creating a solid black. In some of the areas, such as on the statue and the roof of the larger building, I use a crosshatch technique, drawing lines at right angles to one another. This creates a uniform, dark tone that has a slight surface texture. The right-hand edge of the statue has been left light to indicate the sunlit areas. The lamppost is filled in next, using vertically drawn pen strokes that overlap to create a dark tone. More details, such as the windows, some tree branches, and solid black accents of shadows, are drawn. The paving stones on the right are outlined with a fine pen line.

Step 1. When attempting a complicated pen drawing, it is beneficial to first do a tone drawing or sketch that can serve as a guide for doing the rendering. Black and gray markers are perfect for doing studies such as this and this demonstration shows how I approach the problem. For this drawing, I use only three grays and black on a smooth-surfaced paper. The scene is drawn in with a number 1 light gray marker that has a multi-faceted nib. The lighter tones are now indicated and the cloud shapes are roughed in.

Step 2. With a number 3 gray marker, the second value, I render the background mountain and the foliage areas throughout the scene. I am working very quickly and without hesitation—the best way to handle markers. The marker ink dries very quickly and working slowly will cause edges to appear where the rendered strokes overlap. While practicing this technique, try to develop a fast, bold working style. Working with markers will help you to think fast, enabling you to analyze your subject matter quickly. In this respect, markers are very much like watercolor.

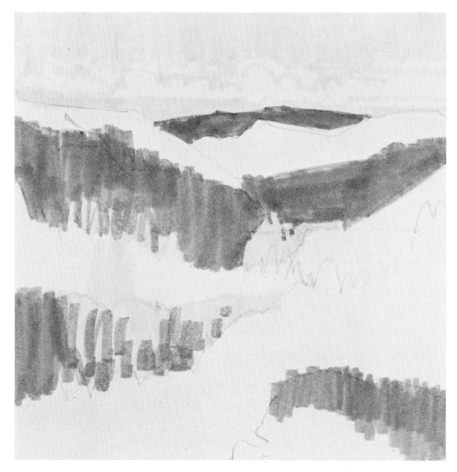

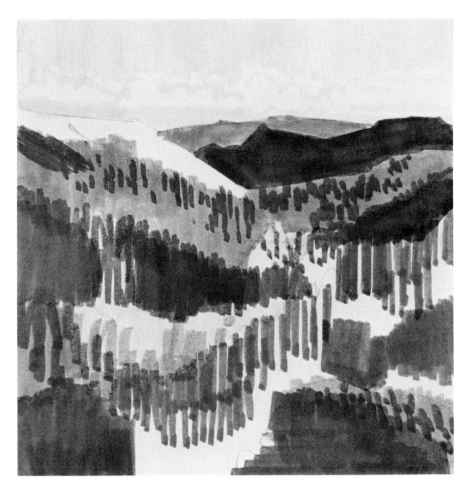

Step 3. The third gray value in the scene, the darker gray, is now drawn on the mountains in the background. I work quickly to ensure a flat tone. Darker gray areas are spotted throughout the rest of the picture, with some short as well as longer vertical strokes used to create the foliage textures. Notice that there is a slight variation in this darker tone. This slight change of value occurs when you work quickly over certain areas and slowly over others. More ink soaks in when a tone is drawn in slowly, resulting in a darker tone. The same thing can happen if you go over a tone twice with the marker ink.

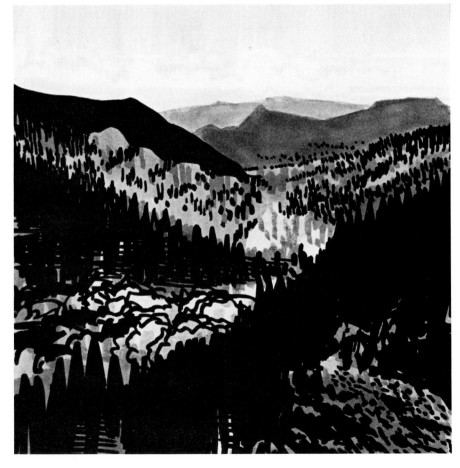

Step 4. When the fourth value—the solid black—is added, the whole scene will be pulled together. The background mountain on the left is drawn, leaving the rocky areas below in the medium gray tone. I use the edge of the marker nib to draw in the pine trees in the middleground areas, using horizontal strokes to create the foliage textures. Next, the dark mass of foreground trees is rendered using boldly drawn strokes. I use the fine edge of the nib to draw the tree textures throughout, sometimes changing the kinds of strokes to indicate the various types of trees. Short marker strokes are used to draw the textures in the lower right foreground, completing the sketch.

Step 1. With a fine-line marker pen, I draw the basic outline sketch of the scene on rough watercolor paper. While the sketch appears loosely done, I have nevertheless made an effort to create an interesting composition through the positioning of the camels and the background buildings.

Step 2. Using the fine-line marker pen, I draw in the shadow areas on the camels. The strokes used here are quickly drawn, which creates a lighter gray line because the marker pen touches only the raised parts of the paper surface. Notice that while drawing these lines I frequently changed the direction of the strokes to create an interesting texture on the shadows.

Step 3. I fill in the background with horizontally drawn strokes, then random strokes over this tone for a texture. The buildings in the background are darkened by drawing lines over one another to create a crosshatch effect. The tone appears dark because the lines are drawn closely together.

Step 4. I now add shadows under the camels, then spot in shadows of pebbles and stones on the ground area. Darker tones are drawn on the foreground camel and the harness and reins are indicated using solid black. Dark accents are also spotted on the camels in the background, completing the drawing.

Step 1. An excellent method for adding tones to India ink drawings is to use water-soluble ink washes. This medium works quite well on most paper surfaces. I start this drawing by sketching with a technical pen directly on common drawing paper. I first draw the trees then add the background buildings and the branches.

Step 2. When I am certain that the ink has dried completely, I add a wash of clear water to the picture area behind the trees, using a wide, soft brush. Then I dilute a few drops of water-soluble ink in a ceramic mixing tray to mix a tone, which is then washed over the dampened area with a number 6 red sable brush.

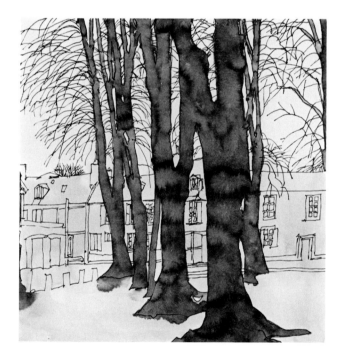

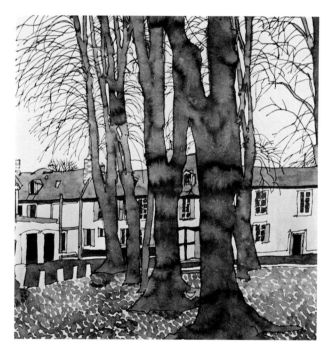

Step 3. I mix the darker tone using less water to dilute the ink, then I wash this tone over the tree trunks with a smaller, number 4 brush. The variation in the tone has occurred because the paper buckled from being wet and the washes became concentrated in the valleys of the paper. This unevenness was a happy accident, resulting in an interesting tone.

Step 4. I now add tones to the roofs and shutters on the houses. Then, with a number 4 brush, I draw the grass area in the foreground, using a pattern of dabbled strokes. With pure black, water-soluble ink I paint in the dark door and window areas. This is a very simple, but excellent technique for sketching outdoors.

Step 1. A very effective technique involves the use of black-and-white ink lines on toned paper. This method can be used to draw many kinds of subjects, but it is especially suitable for drawing detailed landscapes. On a sheet of medium gray charcoal paper, I sketch the scene with a 2B grade graphite pencil. This is done quite simply, indicating only bold, outline shapes, but a few details have been drawn on the cows in the foreground. Notice that the areas that will be white have been drawn with a white wax pencil. The soft 2B grade graphite pencil was used for the basic drawing because it will erase easily later.

Step 2. Using a pen, the type with an ink reservoir, I start to render the medium gray tones in the scene. This is done using a linear sketch technique, which simulates the foliage texture. I next draw in the group of buildings quite carefully, then add trunks to some of the trees. The grass texture is added to the foreground by drawing in short pen strokes to achieve the necessary texture. Shadows are drawn under the cows and some of the trees.

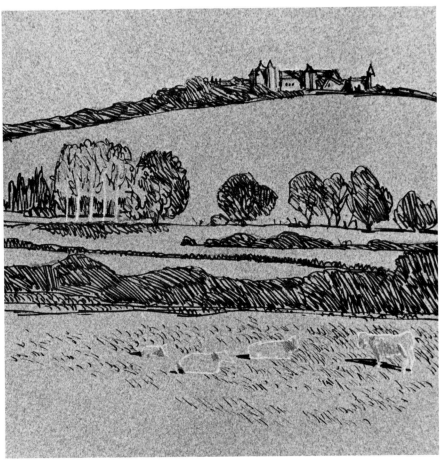

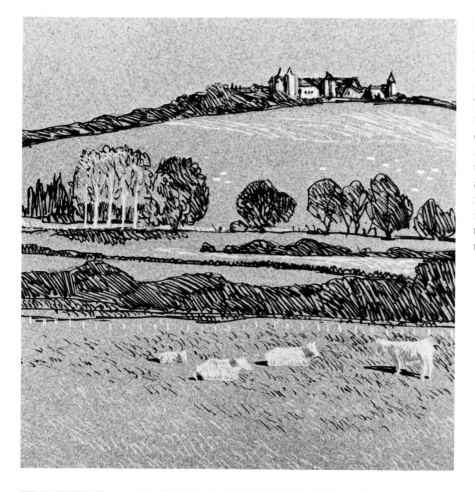

Step 3. White ink can be used for the white lines on this type of drawing, but I mix a little white gouache paint to the consistency of ink and use this to draw in the light areas of the scene. The white is drawn on the buildings, then on the background hill, using the diluted white paint in the pen. In the middleground I draw in the white tree trunks and some of the lighter ground areas. In the foreground, I indicate the fence posts and fill in the cows, leaving some of the paper showing through for the shadows. A grassy texture is drawn on the foreground.

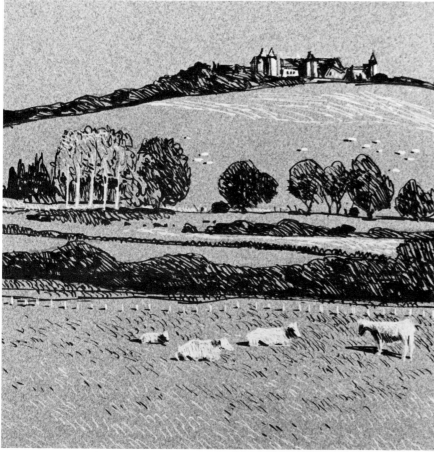

Step 4. Because this paper has a very soft surface, which could easily be damaged by the pen point, I use a number 4 red sable brush when adding solid black areas. I darken the shadow areas on the buildings and the foliage in the background with the brush. Shadows are now added to the middleground trees and also on the cows. A few more textural lines are drawn in the foreground grass area with the pen, completing the sketch. This is a simply done, but effective presentation of the scene.

Step 1. To properly achieve a dry-brush effect, it is necessary to draw on a paper surface that has a definite texture. The more surface texture, the more pronounced the drybrush effect will be. The subject matter is also a consideration. If it has considerable texture and minute details, such as pebbles, sand, or rough ground surfaces, it would be quite suitable for this technique. I do the basic outline drawing with a number 4 red sable brush on rough watercolor paper, using India ink. Where the brush was wetter, as on the center of this drawing, the lines are more solid than those where the brush contained less ink.

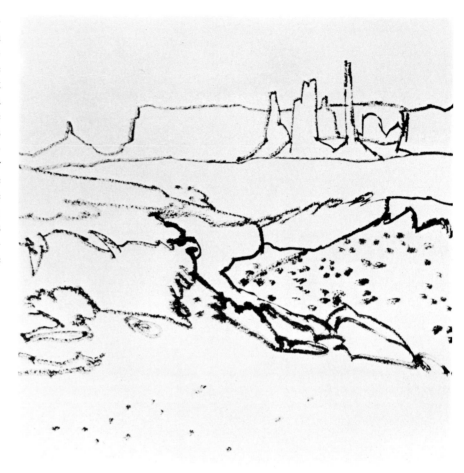

Step 2. I add the medium gray tone by drawing with a very dry brush, just scraping it over the paper surface. The brush is dried by first dipping it in the ink, then wiping it on a piece of scrap paper, which removes some of the ink. A brush with some of the ink removed creates this effect because the ink is only picked up by the raised portions of the paper surface. I carefully brush this tone over the foreground and middleground areas. The brush was used with more ink in the central part on the edge of the cliff, creating a darker tone. I next draw in shadows of bushes in the central area of the scene.

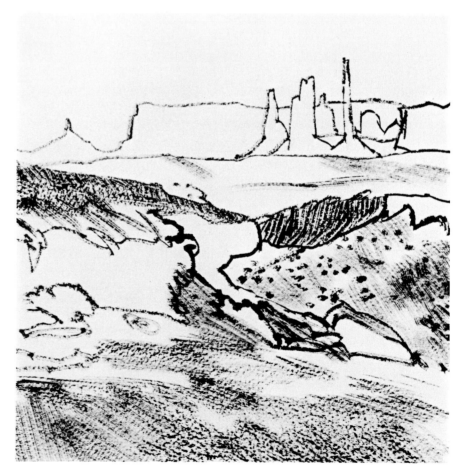

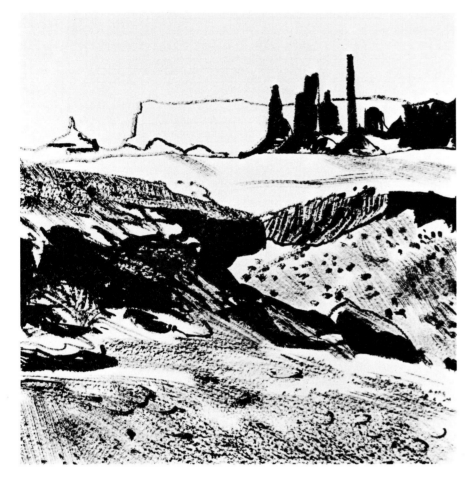

Step 3. In order to establish the values of the other tones, the solid black areas are added next. I can then better judge the tones that are between the light gray and the black areas. The blacks are carefully drawn with the brush, and other details are added, such as more bushes and rocks, to break up the foreground area a bit. You can see that this technique is especially suited for this subject.

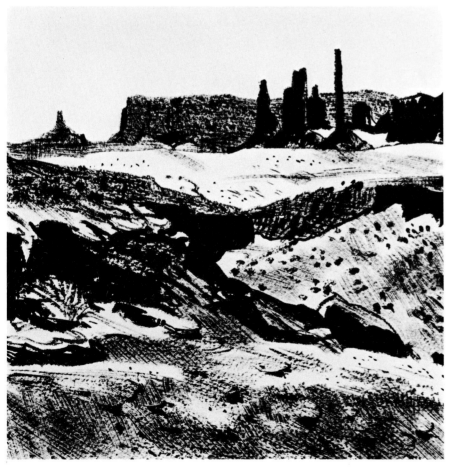

Step 4. The darker gray tone is drawn into the background mesa and butte. I also darken a few of the tones in the central area of the scene. Generally working over the drawing, I add more shadows on the rocks and vegetation. Some of the drybrush tones are darkened by going over these areas again with a slightly wetter brush. I add textures to the sandy patch of ground just ahead of the cluster of rock columns, indicating the distant bushes. This is a simple drawing, but it requires a good deal of planning to ensure that all of the textures and tones will work together well. You should practice rendering drybrush tones and textures on a sheet of scrap paper before attempting them on a finished piece of drawing.

Step 1. One of the most unique drawing surfaces is scratchboard, known a scraper board in the United Kingdom. This unique surface is coated with a pigment or clay that takes ink very well, but does not allow the ink to penetrate the surface too deeply. This coating also enables lines and tones to be carved into the surface with a special knife, creating effects similar to that of a woodcut or wood engraving. To begin this drawing, I first traced a previously drawn pencil sketch onto a piece of scratchboard. Then, using a number 4 red sable brush with India ink, I rendered all of the areas on the drawing that would eventually appear as tones. This was done in solid black, except for the light tone on the jar at the left.

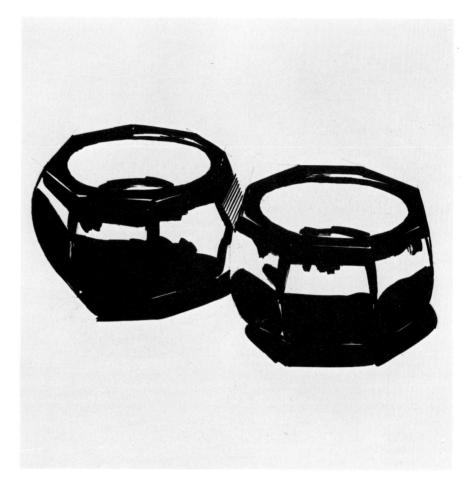

Step 2. I should emphasize that more care and planning are required to do a scratchboard drawing properly than with other types of ink drawings. Also, as you work, you must allow the ink to dry thoroughly before using the scraper tool, or the surface will not respond properly. To scratch the tones, I use a special cutting tool that fits into a standard pen holder like a pen point. I begin to add white lines on the black ink tones, drawing them parallel to create a uniform tone. The value of the tone is determined by how thick the scratched lines are and how closely they are spaced. I use the edge of a plastic triangle to scrape the lines in straight. I add white lines to the bottom edges of the jars for greater definition.

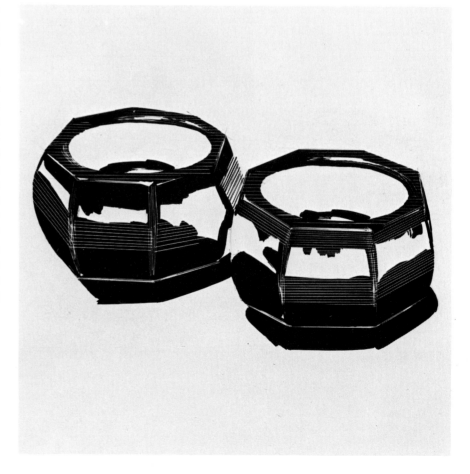

Step 3. I add a lighter tone of gray on the lower section of the jars by scratching the lines more closely together. In certain areas vertical lines were scratched over the horizontal ones. The effect achieved is one of a reversed crosshatch, white lines on a black background. The lightest tone on the left-hand jar is lightened even more by using this method. It is quite difficult to determine at this stage whether the tones are correct. However, the tones at the bottom edge of the jars next to the black shadow look very good. In order to visualize the tones better, the existing white areas must be filled in with black.

Step 4. I render the black areas using a number 4 red sable brush. The interiors of the jars are inked first, then the interesting glazed pattern is added on the upper portion. Now that the black areas have been rendered, I can see that the gray values work quite well. I add a few subtle tones, then scratch more lines for the interior highlight areas. The shadows from the jars are softened a bit by scratching lines along the outer edges. This interesting technique works best for still life subjects or scenes. It is not really suitable for portraits or figure studies, but it is excellent for drawing animals that have fur or a heavily textured skin.

Line Dominates. This drawing is done using only lines—the few tones indicated are formed by lines that are drawn closely together. On the foliage, a different kind of line has been used; one that creates a leaf texture as well as a tone. This is a good, basic sketch technique and was done with a regular pen on a smooth-surfaced paper.

Tone Dominates. This drawing consists primarily of tones, which are made up of drawn lines. The eye fuses the closely drawn lines, creating tones and minimizing any linear quality. Even the basic outline drawing has disappeared because of this illusion. This drawing was done on a smooth paper, with a crowquill pen for the lines and a brush for adding the solid blacks and accents.

Decorative Style. This pen drawing is done in a very flat, decorative manner, using water-soluble ink washes for tones. First the line drawing was done, then the tones were painted using very flat washes. India ink was used for the basic pen drawing because it is permanent, assuring that the lines would not dissolve when the washes were applied.

Spontaneous Style. This is a quickly done technique that can be used for on-the-spot sketches. The drawing is done on a rough watercolor paper using a broad pen and a brush with India ink. The scene was first rendered in outline, then the tones were added using water-soluble ink washes painted on with a number 7 red sable brush. The washes were added after first dampening the paper surface with clear water.